LEONARDO'S BRAIN

Understanding da Vinci's Creative Genius

LEONARD SHLAIN

LYONS PRESS
Guilford, Connecticut
Helena, Montana
An imprint of Rowman & Littlefield

To my incredible wife, Ina Gyemant

Lyons Press is an imprint of Rowman & Littlefield

Distributed by NATIONAL BOOK NETWORK

British Library Cataloguing-in-Publication Information available

Library of Congress Cataloging-in-Publication Data available

ISBN 978-1-4930-0335-8 (hardcover)

♾™ The paper used in this publication meets the minimum requirements of American National Standard for Information Sciences—Permanence of Paper for Printed Library Materials, ANSI/ NISO Z39.48-1992.

CONTENTS

Note to Reader

On September 6, 2008, our father entered emergency surgery and was diagnosed with stage 4 brain cancer and given nine months to live. The prospect of losing our father, a simultaneously larger-than-life and loving and fully present figure, took our breath away. Up until that fateful day, he had been diligently finishing this book that he had worked on for seven years, *Leonardo's Brain*.

Our days were spent eating meals together, searching for silver brain-cancer bullets, shuttling between radiation and daily blood transfusions, and writing this book. So whether we were reading or talking about his book, or the tumor we were trying to shrink in his head, we were always talking about *Leonardo's Brain* in one form or another.

These days were especially high-definition. He reached out to people he hadn't seen in years, and they would pick him up at home, take him out for a fabulous lunch with a glass of wine, and reconnect. After this, he would sit in the blood transfusion chair at the hospital and then go home and get back to writing. He was trying to download all his ideas and knowledge before it was too late.

He finished the book on Monday, May 3, 2009. It was akin to watching a long-distance runner cross the finish line. On Thursday, May 6, we spent the evening selecting quotes from a large list of favorites he kept in a document, placing two or three atop every chapter, like putting dewdrops on the leaves of a Japanese tea ceremony orchid.

On Friday, May 7, Ina, his wife and our stepmother, called all three children and his two best friends to his bedside. She said he had something he wanted to tell all of us. We gathered around him, but this time he couldn't speak. Still, we could see the thoughts dancing in his eyes. He looked frustrated at not being able to find words, but then he started to look amazed. He kept saying "Wow." Then he started to slip away.

He died Monday, May 11, 2009, at 5:40 a.m.

Leonardo's Brain is not only one of his grandest intellectual journeys, akin to his books *Art & Physics, The Alphabet Versus the Goddess,* and *Sex, Time, and Power,* but it also kept him alive.

He loved more than anything else to share. As his children, we are honored to share this book with you.

Kimberly (Shlain) Brooks, Jordan Shlain, and Tiffany Shlain

Author's Note

Dear Reader,

In the months before September 6, 2008, I noticed that I was having trouble buttoning my sleeves with my right hand more than my left, even though I am right-handed. When I came down for breakfast that morning, I could barely speak. My alarmed wife, Ina, called my son, Jordan, a doctor, who scheduled an emergency MRI. I emerged to find my friend Brian Anderson, a neurosurgeon, at my bedside. He told me in a serious voice that I would need emergency brain surgery in two hours.

The brain tumor was large and malignant. Even though I knew that the tremendous difficulty I was having speaking and moving my right side was as a result of brain swelling secondary to the surgery, at the time I was not so sure I would recover. Thankfully, I did.

The reason I am telling you of this development, dear reader, is to let you know that I am determined to finish this book. Tiffany Shlain, my youngest daughter, who lives near me, has assured me that she will be there for any help I need. Most of it is written, and the last few chapters are in my head. I had planned to make this book as accurate as possible, and to meticulously go over every fact and date to ensure that there are no errors. Alas, there is not enough time left for me to guarantee that, so I ask for your tolerance if the book slips on a detail, or if an endnote is missing.

I have poured myself into this book by reading and synthesizing an enormous amount of background information about Leonardo and the evolutionary development of the brain. In this book I aim to present original theories that weave together the different aspects of Leonardo's life (and brain) that have not yet been considered by previous scholars from the fields of psychology, art history, and science. In doing so, I hope to stimulate new thinking about Leonardo and humankind alike.

Leonard Shlain
Mill Valley, California
April 2009

Great art can communicate before it is understood.
—T. S. ELIOT

It seems to me that in the question of truth and beauty one finds what is really the deepest root of the relationship between science and art.
—DAVID BOHM, QUANTUM PHYSICIST

The artist is the antennae of the race.
—EZRA POUND

PREFACE

Another book about Leonardo da Vinci? Is there no end to authors, poets, historians, art critics, scientists, and psychiatrists rooting around in this cultural giant's extensively overexamined life? Can we not let this poor soul's psyche rest in peace? I would answer, "Well, not yet." Scholars have scrutinized both Leonardo's life and work with a perspective particular to each of their specialties and interests. I intend to scrutinize Leonardo utilizing the knowledge others have gained, but seen from a perspective none have previously employed—that of a general and vascular surgeon with an abiding interest in brain science, and, in particular, the division of functions between the two hemispheres of the brain. I am convinced that many of the mysteries of the human condition are a result of this split-brain duality. It forms a paradox best represented by the English first-person singular "I." This perpendicular straight line with no subsidiary parts seems the perfect icon for the self-contained human being "I." The vertical stroke creates a division between everything within the waterproof bag we call our skin, and everything on the other side of that bag.

But neuroscientists have learned that what we think of as the singular "I" can more accurately be construed as a sharp line cleaving the two, sometimes competing and sometimes cooperating, halves of a person's cerebral hemispheres. In truth, we are Siamese twins conjoined at the corpus callosum—the broad band of fibers that connects the right and left halves of the brain in all vertebrates. Each of the halves of a human brain can generate opinions, perceptions, likes, and dislikes different from those of its yoked twin across the way. There is a long history in literature and art of two personas existing within one body, epitomized by Robert Louis Stevenson's two characters operating within the confines of one body that sometimes manifested as Dr. Jekyll, and other times as Mr. Hyde. Only recently has it been possible to assign to each of them their own individual anatomical mailing addresses.

Despite the many different theories about how the brain processes information and generates the sublime mystery of human consciousness, no neuroscientist disputes the fact that the human brain differs from those of other animals in the unparalleled degree to which its two cortical hemispheres have specialized their functions.

Human creativity, I will argue, must be intimately bound up in this unique arrangement. But why are some individuals more creative than others? If, as many have conjectured, the brains of the truly creative are wired differently than those of the plodding masses, then it is a worthy exercise to compare the wiring diagram of an average person's brain with that of a creative genius.

But how would a researcher choose among the many creative people presently alive? Some would opt for the latest winner of the Nobel Prize in Physics. Others would propose the greatest contemporary composer. Still others would advocate that the head encircled by the magnetic doughnut should be the winner of a prestigious art prize, such as the Rome Prize.

Rather than attempt to contrast the average brain with a renowned contemporary creative genius, I have decided to choose the one individual whom the majority of inhabitants of the Western world would agree was the most creative person who ever lived—Leonardo da Vinci.

Ah, but someone is quick to point out that the exact site where Leonardo was buried in France is presently unknown. Besides, his brain decomposed along with the rest of him nearly five hundred years ago. These are not insurmountable obstacles. Twenty-first-century strides in neurocognitive research will allow me to investigate one of the mysteries about Leonardo that remains unexplored: How was Leonardo's brain organized? What extraordinary neuroconfiguration did he possess that allowed him to attain his singular place in history?

To solve this mystery, I must pursue two entirely different stories. One story will be about the life and works of Leonardo; the other will be about the evolution of brains. This two-strand braid will make up roughly the first two-thirds of the book, creating the foundation for the third part of the book, which will explore the effect of brain organization on creativity and suggest new directions toward which the human species is evolving.

An exposition of the environmental pressures that caused the human brain to evolve so differently from the brains of other mammals leads to a discussion of the unique human arrangement of a split brain, with each hemisphere assigned different functions. The ratio of right-hand/left-brain-dominant individuals compared to left-hand/right-brain dominance is 90 percent, a percentage that has remained stable throughout history and across differing cultures. If being right-handed was such an advantage for humans, why are not all humans right-handed? Or, alternatively, why not a fifty-fifty ratio? What was the evolutionary advantage of a dominant cerebral hemisphere in the first place? Why not the ambidextrous model used with great success by the majority of other animals?

The right brain (in right-handers) best processes information that is for the most part emotional and spatial. The left brain (in right-handers) processes information that is primarily rule-driven and temporal. Similar to the Chinese yin/yang symbol, each major side contains within its core a small essence of its opposite. When discussing the brain, distinctions are never black and white. There is considerable crossover in function. Not all language centers are in the left brain, and not all spatial judgments are processed in the right brain. Nevertheless, our present and past can be better understood if we examine human history using this dualistic model.

The right- and left-brain functions are commonly associated with the dualities of masculine/feminine, active/passive, particular/general, focused/holistic, and rational/intuitive. The arrangement of a masculine side of the brain and a feminine side promotes a psychic hermaphroditism in both men and women, making the human sexes unlike any other species. Every man has an *animus* and an *anima* just as every woman has an *anima* and an *animus*. I will apply this understanding of how human brains are organized to speculate on the design of Leonardo's brain.

The final section of the book will build upon the re-creation of Leonardo's brain to launch into a discussion of human consciousness (after all, I am a California author!). The question I will try to answer is whether Leonardo, because of the unique arrangement of his neural cabling, was able to access a qualitatively different state of consciousness than practically all other humans.

I am a synthesizer by nature in an age when the information explosion has resulted in compartmentalized education and highly specialized professions. In an attempt to reverse this process, my passion is to integrate unrelated disciplines. Mimicking Leonardo's diverse interests, *Leonardo's Brain* will draw from a disparate group of thinkers, as well as the principles and discoveries of a wide range of endeavors: Classical philosophers, art historians, modern physics, enlightenment thinkers, sociobiology, paranormal investigations, evolutionary theory, neuroscientific discoveries, and many more will become strands in the complex tapestry I plan to weave. I do not profess to be an expert in any of these fields, but I have spent a considerable amount of time and effort trying to make myself one.

I do profess a certain degree of expertise in matters concerning the brain. As a medical student, I had to learn the intricacies of neuroanatomy and neurophysiology. As an aspiring psychiatrist, I enjoyed studying the puzzle of consciousness and contemplating how the *mind* works. When I decided not to take a psychiatric residency and begin instead a surgery residency to become a vascular surgeon, I had to learn how the *brain* works.

A writer is always refining his ideas, and this book represents the trajectory and culmination of thought that I laid out in my three previous books. Because I am not sure whether or not the reader has read them, I need, on occasion, to repeat a few of their themes. For readers of one or all of my books, an occasional *déjà vu* may surface from time to time.

In *Art & Physics: Parallel Visions in Space, Time, and Light,* I proposed that the visionary artist is the first person in the culture to *see* the world in a new way. Later, or sometimes simultaneously, the revolutionary physicist has an insight of such import that it changes the way we *think* about the world. In that book, I had a chapter on Leonardo, which was the seed from which this book grew. The division between the right and left sides of the brain and its correspondence to the divisions between art and physics figured prominently in that book.

My next book had a similar right-/left-brain theme. *The Alphabet Versus the Goddess: The Conflict Between Word and Image* examined what happened to gender relations when cultures discovered writing,

particularly the alphabet. Every ancient culture worshipped goddesses. Then the three monotheistic religions came into being—Judaism, Christianity, and Islam—each founded on a sacred alphabetic book, and each denying the existence of goddesses. I wanted to understand what event in culture could have been so pervasive that it changed the sex of God. I concluded that learning how to read and write an alphabet reconfigured the brain, bolstering the dominance of the left hemisphere. Reading and writing, unlike speaking and listening, are primarily left hemispheric tasks. Whenever writing appears, women's rights suffer, image information becomes an "abomination," and goddesses disappear. Whenever images regain prominence in the culture over written words, as they did in the Dark Ages, the goddess (Mary) makes a comeback. The Protestant Reformation, coincident with the sharp rise in literacy in the Renaissance, devalued the divinity of Mary; consequently, women's rights suffered. Now, as our culture becomes more image-based, women are making incredible advances. Images are primarily processed by the right brain.

I wrote my third book, *Sex, Time, and Power: How Women's Sexuality Shaped Human Evolution,* because after examining gender relations in the context of the arrival of the written word, I began to wonder why humans had wandered so far away from the mating systems used by the other three million sexually reproducing species. The human female abandoned estrus (the recurring but periodic state of sexual excitation in most mammals) but gained menses, the menstrual flow that in humans exceeds the hundred or so other mammals out of four thousand exhibiting this trait. How astonishing! Although primarily a discourse on the evolution of humans, in this book, once again the split brain plays a prominent role.

This book carries the question even further. Why do we have a split brain in the first place? Realizing that every virtue comes with a vice, I ask the question: Did divided hemispheres that served us well on the African Serengeti in the Pleistocene Epoch now possess a curse that could destroy us? How do we change as a species to extract ourselves from this dilemma? Thinking about the wiring in the brain of Leonardo provides a convenient jumping-off point. He had, from what we know, the most creative brain in history. And he was a vegetarian pacifist. He

overcame his initial aggressive stance toward designing weapons. How do the rest of us achieve greater creativity while becoming more peaceful?

As I have done in my earlier books, I will capitalize the terms Natural Selection and Mother Nature. Also, I should explain where I locate myself on the spectrum of opinion regarding the role of genetics in determining evolution. At one end of the spectrum stand Stephen Jay Gould and Richard Lewontin, who propose that many traits, both physical and behavioral, are the result of Natural Selection's random processes, and not too much should be read into them. They believe these genetic quirks neither help nor hinder the species.

On the other end is the school headed by Jerome H. Barkow, Leda Cosmides, and John Tooby, which maintains that most of what is in the human genome is there to assist humans in surviving the vicissitudes of the environment to reach reproductive age and find a willing mate. If a mutation is deleterious to the survival and reproductive success of the species, it will be culled out of the genome within a few generations. If it is beneficial, it spreads throughout the species. Its rate of disappearance or multiplication depends on how much it is a winner or a loser. On the sliding scale of opinion, I align myself with this camp.

I have poured myself into this book after reading an enormous amount of background information about Leonardo, the development of the brain, and the process of human evolution. I wanted to fulfill Franz Kafka's pronouncement that a book should "be wielded like a pickaxe to shatter the frozen sea within the reader's mind. If the book in our hands does not wake us, as with a fist that hammers on the skull, then it just isn't worth reading." I would prefer a similar, but less violent response. I want this book to stimulate thinking as I present a series of what I think are original theories. And I want it to be an enjoyable read. In writing this book I am attempting to live up to the two major ideals Leonardo set for the rest of us: to conjoin art and science, and to be bold when proposing hypotheses.

Leonard Shlain
Mill Valley, California
March 2008

CHAPTER 1

Art/Science

The good painter has to paint two principal things, that is to say, man and the intention of his mind. The first is easy and the second difficult, because the latter has to be represented through gestures and movements of the limbs—which can be learned from the dumb, who exhibit gestures better than any other kind of man.

—LEONARDO DA VINCI

The true mark of genius is not perfection, but originality, the opening of new frontiers; once this is done, the conquered territory becomes common property.

—ARTHUR KOESTLER

Both science and art form in the course of the centuries a human language by which we can speak about the more remote parts of reality; the coherent sets of concepts of physics and the styles of art are different visions that offset the language of words.

—WERNER HEISENBERG

IMAGINE THAT YOU ARE THE CHAIRPERSON OF A HYPOTHETICAL NOBEL Prize committee that awards only one medal annually. The medal is given to an individual who has created not only a most extraordinary work of art, but who has also made a spectacular contribution to science. The competition would be open to any contemporary or historical figure, as well as the large swatch of humanity that lived before accurate biographical records were available.

The divergent flow of art and science in the historical record provides evidence of a distinct compartmentalization of genius. The river of art rarely intersected with the meander of science. Despite the abundance of fantastic artists and brilliant scientists in human history, the stark monolithic fact is the dearth of candidates who could be considered for their contributions to *both* fields. Who, upon reflection, would you nominate to win the award in the field of both art *and* science?

A disproportionate number of the short list of nominees would most likely emerge from the Italian Renaissance, a period when imaginative theories combined with experimental observation to form a solid basis for modern science, a development drastically reshaping society that intersected with equally innovative approaches to art. However, the historical record might be askew. For example, the twelfth-century Persian poet Omar Khayyam was the author of the acclaimed *Rubaiyat*. Lesser known is his towering reputation as a mathematician who advanced our knowledge of algebra.

Because the concept of the individual is a relatively recent innovation, little is known of specific inventors and artists in many of the world's cultures. We may never know if the Chinese scientific genius who invented the formula to glaze the delicate Sung Dynasty porcelain was also the same person who painted exquisite silk screens or composed deathless poetry. Poor record keeping and a pervasive cultural taboo against individuals taking credit for their personal contributions may have deprived many potential candidates from ever being recognized for their achievements in both art and science. The judges, however, must also entertain the very real possibility that no candidates exist during the majority of these relatively silent centuries.

Those whom we could confidently propose would include the Renaissance architect, sculptor, and mathematician Leon Battista Alberti. His 1435 treatise on geometry and science that explained to painters how to place their figures in proper perspective would make him eligible as a scientist, and one can argue that his beautiful buildings are great works of art. Brunelleschi would surely appear on both lists. His skill in sculpture and his engineering brilliance in raising the dome of the cathedral *Santa Maria del Fiore* in Florence make him an attractive nominee. There would

be no argument on granting the art prize to Michelangelo for his *David,
Pieta,* and the Sistine Chapel. His solutions for many vexing architec-
tural and engineering problems would ensure his scientific credentials as
well. Architect Donato d'Agnolo, more commonly known as Bramante,
would have a fair chance because of his buildings' exceptional grace and
the ingenious solutions he instituted in the field of math, geometry, and
engineering.

Galileo Galilei's many towering scientific contributions would secure
for him the science aspect of the medal. Less well known are Galileo's
masterful literary enterprises. He explained the intricacies of the scien-
tific debates of his time in lucid prose that made accessible to the edu-
cated layperson the excitement of the Copernican ferment bubbling in
seventeenth-century Europe.

After Renaissance Italy, the pickings, however, get progressively slim-
mer. Art and science begin to diverge. There are those who would posit
that this was the result of the hyperinflation of knowledge in all fields of
human endeavor. Johann Wolfgang von Goethe, the seventeenth-century
German writer and poet, was one of the few who tried to breach both
rapidly growing walls that increasingly separated art and science. He
would surely get the nod for his contributions to literature, and his many
investigative experiments advanced the progress of science.

Sigmund Freud made many scientific discoveries, as well as the one
for which he is the most famous: the founding of psychoanalysis. His
attempt to discern the structure of the undercarriage of human conscious-
ness would earn him his place as one of the titans of science. His volumi-
nous writings, clear in tone and rich in imagery, could stand on their own
for literary value, making Freud an attractive candidate for the award.

Alas, upon closer scrutiny, the two committees conferring among
each other would most likely arrive at a consensus for each of the above-
named straddlers. The quality of their contributions in one or the other
of the two fields did not meet the rigorous standards of a Nobel Prize.
If they were known primarily as an artist, their contribution to the field
of science would not quite attain the level of others who were first and
foremost scientists. Similarly, if a candidate's main field of endeavor was
science, his or her artistic creations were not of the same order of quality

as those of the artist contenders. Alexander Pope summed up this strange quandary when he wrote:

One science only will one genius fit
So vast is art, so narrow human wit.

There is only one person who could handily win the prize in both categories: in art, for his innovative paintings, and in science, for the large number of principles he discovered and the plethora of technological inventions he envisioned. This *sui generis* individual was Leonardo da Vinci.

Evolution rarely produces only one of anything. There is no skill, trait, deformity, or clairvoyance that has not been observed in more than one individual. Child prodigy violinists, high school genius mathematicians, and preternaturally athletic sportsmen sporadically attract the public's attention because of the rarity of their traits. But in every case, his or her talent, while extraordinary, was not so singular that there had never been anyone else who expressed the same talent with a similar degree of distinction.

How, then, are we to explain the fact that in all of history Leonardo occupies a solitary niche? His uniqueness has continued to enthrall commentators throughout the nearly five centuries that have followed his death in 1519.

As the 500th anniversary of his death approaches, the pace of interest in Leonardo is actually accelerating. A veritable army of PhD specialists has pored over Leonardo's chaotically organized manuscript pages, translating, collating, and trying to discern what this restless mind has to say to the rest of us. Art critics continue to tease out of his oeuvre so many new and unexpected details; it hardly seems possible the mind of one man could have considered so many factors in planning and making his art, while at the same time immersing himself in myriad scientific pursuits.

Although both art and science require a high degree of creativity, the difference between them is stark. For visionaries to change the domain of art, they must make a breakthrough that can only be judged through the lens of posterity. Great science, on the other hand, must be able to predict the future. If a scientist's hypotheses cannot be turned into a law that can

be verified by future investigators, it is not scientifically sound. Another contrast: Art and science represent the difference between "being" and "doing." Art's raison d'être is to evoke an emotion. Science seeks to solve problems by advancing knowledge. Candace Pert reminds us that in spite of our curiosity about science, we call ourselves, "human *beings*, not human *doings*."

In the realm of science, pure mathematics comes the closest to art in that it often does not have any practical application in the real world. Artists and mathematicians extol the virtues of beauty and elegance. In his classic, *A Mathematician's Apology*, G. H. Hardy wrote, "Beauty is the first test; there is no permanent place in the world for ugly mathematics."

Leonardo's story continues to compel because he represents the highest excellence all of us lesser mortals strive to achieve—to be intellectually, creatively, and emotionally well-rounded. No other individual in the known history of the human species attained such distinction both in science and art as the hyper-curious, undereducated, illegitimate country boy from Vinci.

With so much already written about this singular man, it seems presumptuous to fell another tree in the vainglorious attempt to understand his genius. Yet, I propose to undertake this project from a somewhat unorthodox point of view. I venture into the Leonardo thicket with the intent to reemerge having reconstructed the physical configuration of Leonardo's brain by performing, what will be, in essence, a posthumous brain scan.

Hidden in the historical record is a veritable gold mine of unusual clues regarding Leonardo's brain function. Leonardo was a left-handed, ambidextrous male. He is the only historical figure whom we know wrote backward. Some biographers believe that Leonardo was a gay male who did not indulge his sexual passions. He was both a composer and musician, and spoke and wrote several different languages.

We also have a report that he suffered a stroke in his last years that paralyzed his right hand. The reliable observer who recorded this most telling piece of the Leonardo brain puzzle also informs us that because of this infirmity, the master gave up painting and instead devoted his last years to his scientific investigations. This brief catalog of Leonardo's neurological

features provides a wealth of information from which to begin a speculative analysis concerning the structure of his brain and its unique wiring diagram (his neurocircuitry) that fueled so much of his creativity.

Other tantalizing enigmas concerning the organization of Leonardo's nervous system abound. His neurological peculiarities emerge from the comprehensive historical record detailing his life. (And what a historical record!) Leonardo was a recognized genius during his lifetime, prompting many contemporaries to record their impressions of him. Also, we have a treasure trove from his own hand, with over five thousand pages of his manuscripts remaining. Despite his prodigious urge to scriven, he never managed to publish.

The same maddening pattern to leave projects unfinished also bedeviled his art. He left posterity with some fifteen paintings that we are sure came from all (or part) of his hand. None of his many sculptures and nothing of his musical compositions survive. Fortunately, much is known of many of these works because contemporaries who did see (or hear) them felt compelled to describe them in considerable detail. Also, his notebooks contain hundreds of preparatory sketches for later major works. Moreover, Leonardo's lost masterpieces so impressed many excellent artists—who had the opportunity to view them before they were destroyed, misplaced, or altered—that they reproduced faithful copies of Leonardo's originals.

Besides his paintings, thousands of Leonardo's drawings remain extant. Many of these were preparatory sketches for his later paintings, and thus provide valuable insights into his creative process. His numerous notes and drawings concerning his vast interest in science contain similar insights into how his mind worked, even if the many actual inventions and devices he made have not survived.

Though his notebooks don't reveal many—if any—close female relationships, one shouldn't assume Leonardo had no knowledge or appreciation of the female. In fact, if one contemplates Leonardo's paintings and drawings, an entirely different impression emerges. Has there ever been a male artist who more deftly depicted the enigma of a woman's smile, the love of a mother for her child, or the self-confidence of a beautiful woman posing for a famous painter? How is it possible that one man could have

coaxed out of mere paint the most subtle secrets of the feminine and yet not bother to allude to any of those revelations in ink, much less mention that he even *knew* any women? Quite to the contrary, a number of misogynist remarks mar his writings.

Leonardo was a vegetarian in a culture that thought nothing of killing animals for food. His explanation for his unwillingness to participate in carnivory was that he did not want to contribute to any animal's discomfort or death. He extended the courtesy of staying alive to all living creatures, and demonstrated a feeling of connectedness to all life, which was in short supply during a time that glorified hunting.

Another paradox: No other artist in history expended as much time and energy working out the geometrical details of the science of perspective. Page after page of his various codices contain intricate drawings that recursively return to the problems perspective posed to the artist. He gives precise instructions to painters on how they should depict the penumbra of shadows and how to position objects relative to each other in a composition so that the laws of perspective are rigorously followed. How, then, do we explain the unsettling discovery—when carefully examining Leonardo's paintings—that he cleverly violates the laws of perspective in all of them? These anomalies will be detailed in a later chapter. Leonardo is both an extraordinary left-brained academician obsessed with portraying perspective correctly and an impish right-brained trickster who takes delight in fooling the viewer with perspectivist sleights of hand.

An observer glancing back and forth between Leonardo's art and his notes would begin to suspect that the hand directing his pen did not seem to know what the hand holding his brush was doing, and vice versa. After poring over his voluminous notes and then studying his paintings, a neuroscientist most likely would conclude that only the paltriest of fiber bundles connected the two hemispheres of his brain. Yet, this neurological assessment regarding the status of Leonardo's corpus callosum—the broad band of fibers that connects the brain's two halves—would fly in the face of what we know about his left-handedness, which in turn is a fairly accurate predictor of hemispheric dominance. Leonardo was the rare writer who routinely engaged in reverse writing, or mirror writing. Someone wishing to read Leonardo's manuscripts must first hold the

pages before a mirror. Instead of writing from left to right, which is the standard among all European languages, he chose to write from right to left—what the rest of us would consider backward writing. And he used his left hand to write.

Thoroughly confusing the issue was the fact that sometimes he would switch in mid-sentence, writing some words in one direction followed by other words heading in the opposite direction. Another intriguing neurological datum: Careful examination of two samples of his handwriting show the one written backward moving from right to left across the page is indistinguishable from the handwriting that is not reversed.

Leonardo's quirks of penmanship strongly suggest that his two hemispheres were intimately connected in an extraordinary way. The traditional dominance pattern of one hemisphere lording it over the other does not seem to have been operational in Leonardo's brain. Based on what we can extrapolate from the brains of people who share Leonardo's ability to mirror-write, the evidence points to the presence of a large corpus callosum that kept each hemisphere well informed as to what the other was doing.

Another suggestive piece of evidence that Leonardo's corpus callosum was fairly bursting with an overabundance of connecting neurons was his seamless annealing of art and science. Numerous neurological studies have, in general, located the modules primarily concerned with art, music, imagery, metaphor, emotion, harmony, beauty, and the aesthetic sense of proportion in the right hemisphere of a right-handed person. Housed in the left hemisphere of a right-handed person are the skills required to carry out the logical, linear, sequential analysis necessary for grammar, syntax, reason, and mathematics. A neuroscientist, examining a subject who had harmonized the very different functions of art and science, would expect that an individual so endowed would possess an exceptionally robust corpus callosum. How, then, do we square these latter facts of hemispheric integration with the earlier observations of the seemingly apparent disconnect between the content of Leonardo's written words and the iconic imagery of his art? These neurological puzzles are just a few that I will try to decipher in my attempt to crack Leonardo's brain code.

CHAPTER 2

Medicis/Popes

When besieged by ambitious tyrants I find a means of offense and defense in order to preserve the chief gift of nature, which is liberty. . . . Death rather than loss of liberty. The goldfinch brings spurge [a poisonous plant] to its young when they are imprisoned in a cage. It is better to die than to lose one's freedom.

—Leonardo da Vinci

Leonardo created a kind of space that had never been seen in Europe before, one that not merely was a location for the figures but drew characters and spectators together, as time does, plunging into immensity.

—André Malraux

The real voyage of discovery consists not in seeking new landscapes, but in having new eyes.

—Marcel Proust

Brains organize themselves according to two factors: nature and nurture. Of all the organs of the human body, the brain is the most plastic. Events occurring in the womb, during birth, and in the first few years of life play an enormous role in shaping the brain and the occupant of the body attached. For example, toxic influences—such as a pregnant woman smoking—can have a deleterious effect on how the brain develops. Birth trauma, such as a prolonged period of oxygen deprivation that may last for only minutes, can alter subsequent brain function for a lifetime.

9

We have the maximum number of neurons in our brain at the age of eight months. It is as if Natural Selection provides each of us with an overabundant supply of neurons and then propels us into the world with the admonition, "Now, go and learn something." Over the next ten years a dramatic pruning occurs, and we lose approximately 40 percent of the neuronal pathways that were present when we peaked at eight months. The determining factor that influences which neurons survive and which neurons wither is what we learn. The current mantra in neurocognitive research is: *Neurons that wire together, fire together; neurons that fail to link, fail to sync.* What a child is exposed to in those formative years configures the strength and shape of many of the neural networks devoted to various neurological functions. Because of the importance of the first few years of his life, I will dwell at some length on those of Leonardo's.

Of his sixty-nine years, Leonardo's formative ones remain the most opaque. Yet, enough information gleaned from both the Vinci and Florentine tax rolls exists to warrant a series of speculations. As Tolstoy once remarked, "From the child of five years to myself is but a step. But from a newborn baby to a child of five is an awesome distance." Enumerating the many and significant obstacles Leonardo had to overcome makes his triumphs even more wondrous. Also, understanding his childhood tribulations may help to explain the man and his psychology more fully. What is certain is that the tumult of Leonardo's early childhood played an important part in how he came to view the world as an adult.

Leonardo was born of an illicit liaison between a rich city boy, Ser Piero da Vinci, and a poor peasant girl from Vinci, one of the picturesque, small Tuscan hill towns several days' walk from the center of Florence. That the town bears Piero's family name and that he had the privilege of using the prefix *Ser* orients us to Leonardo's father's social stratum.

History does not record the last name of the young woman, known only to us as Caterina, and this omission also helps us locate her in the town's social hierarchy. Leonardo's father was an ambitious notary who preferred to spend his time in bustling Florence. In the mid-fifteenth century, this city-state was the very epicenter of the power, wealth, creativity, and sophistication that has come to characterize the Italian Renaissance. One can safely assume that Piero was not overjoyed when

he learned that his dalliance with one of the local girls had resulted in her belly swelling. The notary business was a sober one. Practitioners composed and witnessed wills, deeds, and contracts. The vast gulf between their social stations presents historians with a plausible explanation for why Piero did not marry Caterina upon learning that she was pregnant with his child.

Perhaps Leonardo provided an insight into his parents' relationship when he departed from the usual impersonal authorial tone he used in his notebooks and let slip an uncharacteristic observation concerning the role of love in baby making. He muses:

The man who has intercourse aggressively and uneasily will produce children who are irritable and untrustworthy; but if the intercourse is done with great love and desire on both sides, then the child will be of great intellect, and witty, lively and lovable.

Might this comment be self-referential? In other places in his notebooks, Leonardo often wrote that he was a happy and contented man.

During this time, Leonardo seems to have been raised solely by his mother in the country. His father was not, however, totally disengaged. He, or someone in the Vinci family, arranged to have Caterina marry another man. Leonardo accompanied his mother when she went to live with her new husband.

When Leonardo was somewhere around the age of five, his father married a sixteen-year-old close to his own social class, and the young boy came to live in his father's household, which included Ser Piero and his new bride. Leonardo's young stepmother, herself still a girl, was trying unsuccessfully to give Ser Piero a legitimate male heir. In fifteenth-century Italy, a son was the single most important item a wife was expected to produce. The constant presence of her healthy stepson would most likely have served as a reproachful reminder of her continuing barrenness. Soon afterward Leonardo moved once again, this time to the family farm at Vinci. There, Leonardo spent his time in the company of his grandfather, Antonio, and his uncle, Piero's brother, Francesco. Piero's wife did finally become pregnant, but she died along with her baby, during labor. Piero

immediately married again and eventually fathered ten more children, with three different wives.

Leonardo's love of all living things and the beauty surrounding him was undoubtedly nurtured by this kindly uncle. Leonardo's references in his notebooks to Francesco are among the few times that he displays true tenderness.

A tantalizing clue about Leonardo's early life appears in his notebooks. One of the very few women he mentions, when he is in his forties, is a certain Caterina. Although it could have been the name of his housekeeper, there are compelling reasons to suspect that Leonardo invited his aged mother to come to live with him in Milan. An entry in his own hand states that he paid for Caterina's funeral after she died. This and other hints in his notebooks suggest that Leonardo remained in contact with his mother throughout his life.

Despite the warm relationship Leonardo developed with Francesco, the first and most important setback in his young life was likely his separation from his mother. Absent the most extreme circumstances, contemporary psychologists and family law experts universally agree that very young children should not be taken from their mothers. The disappointment and anxiety they experience as a result of this tends to cripple them psychically. As adults, they can become emotionally distant, distrustful of close commitments, and can remain averse to letting others get too close for fear of being hurt or disappointed again.

Leonardo's aloofness and remoteness, despite his apparent *bonhomie*, is a feature of his psychological makeup to which his biographers repeatedly allude. One does not have to look much further than the details of his childhood for a plausible explanation as to why this giant of intellect lived such an emotionally arid life.

Leonardo's illegitimacy would severely limit his options. The Church decreed that any child born of unwed parents was to be barred from enrollment in the cathedral schools associated with the major churches. Outside of the prohibitively expensive alternative of private tutors, admission to one of these schools was the only means to learning the secret code that opened the doors of opportunity.

The word *renaissance* means "rebirth." The rediscovery of ancient Greek and Roman wisdom reawakened in the intelligentsia an insatiable desire to study the writings of the ancients. Because there were few if any accurate translations into Italian of the works of Aristotle and Plato, knowledge of Latin and Greek was essential to participate in the *frisson* of the age. The secret code the boys learned in the cathedral schools was nothing less than how to read and write classical Greek and Latin, especially the latter. After all, this was Italy, the same soil from which the glory that was Rome arose. Opportunities to study the law, medicine, and banking, to control the levers of civil administration, or to climb the ecclesiastical hierarchy—all depended on knowledge of Latin. A dead language allowed the living to concentrate power in the hands of the few. Their prejudices were evident in their attitudes toward Leonardo.

Leonardo's response to these men who ignored his discoveries was harsh:

> *They will say that because of my lack of book learning, I cannot properly express what I desire to treat of. Do they not know that my subjects require for their exposition experience rather than the words of others? And since experience has been the mistress, and to her in all points make my appeal.*

These noblemen wanted to distinguish themselves from the lower classes, but because of the rise of trade in Florence, this distinction was fast disappearing. *Sumptuary laws* decreed what various classes could wear, even down to the color, fabric, and type of fur lining. Knowledge of Latin remained the best and most effective means of keeping the riffraff and nouveau riche in their place..

By the fourteenth century, all of the major countries of Europe had refined vernaculars. Inhabitants of Spain, Britain, France, Portugal, German lands, and the Italian peninsula had spent the previous three centuries ironing out the grammar, spelling, and fluency of their respective languages. These expressive new vernaculars needed only a means to cheaply and easily distribute their written text among the people. Johannes Gutenberg's introduction of movable type into Europe, which

took place around 1450, supplied the critical invention that would make duplication and translation of key works affordable.

If we could tune into a parallel universe, it would be fascinating to follow Leonardo's career had he not been born illegitimate and had been schooled in Latin. Would a university education have led to a lectern from which his pronouncements would have been greeted with respect? What would have been the overall effect on science if he had had an army of enthusiastic students to whom he could have assigned a task so that he would not have had to do everything by himself, alone and in secret? Might the world have learned of his prophetic visions much earlier, and might human progress, both in the arts and sciences, have accelerated the coming of the Enlightenment?

How many more finished paintings would the world have had from the hand of this master if he would have been able to command the respect, monies, resources, and recognition of one who claims noble blood, a university position, and powerful friends in high places? Would he have been given a large studio where eager apprentices would have paid hefty sums to work with a recognized master? What other ingenious discoveries would this overworked, penurious genius have been able to accomplish if he had been freed from the onerous task of arranging super-cilious entertainments for an ostentatious patron? If he had unhindered access to the wisdom of Eratosthenes, Euclid, Archimedes, and Aristotle, how many wheels would he not have had to reinvent himself?

However, a strong counterargument can also be put forth that it was precisely his *lack* of indoctrination into the reigning dogma taught in these institutions that liberated him from mental restraints. Unimpeded by the accretion of misconceptions that had fogged the lens of the edu-cated, Leonardo was able to ask key questions and seek fresh answers. Although he could not quote learned books, he promised, "I will quote something far greater and more worthy: experience, the mistress of their masters." He disdained "trumpets and reciters of the works of others," and tried to live by his own dictum: "Better a small certainty, than a big lie." He referred to himself as *omo sanza lettere*—an "unlettered man"— because he had not received the kind of liberal arts schooling that led to the university. Somewhere in his late thirties and early forties, Leonardo

made a concerted effort to teach himself Latin. Long lists of vocabulary words appear in his notebooks. Anyone who has tried to learn a foreign language in adulthood knows how difficult the task can be.

Leonardo surely must have been disappointed that Ser Piero was not willing to make the extra effort to eliminate what he must have known would persist as a lifelong obstacle to Leonardo's career. Had Ser Piero desired it, there were many subterfuges a well-connected father could use to transform his illegitimate child into a legitimate one. Renaissance history is replete with instances whereby a father bought his child's respectability by petitioning the right person, doing a favor for someone in a position to help, or exchanging gold for the right papers. For reasons known only to Ser Piero, he did none of these.

The Renaissance produced so many remarkable artists that it occurred to one man that future generations might be interested in the extraordinary lives of the artists that gave shape to this Golden Age. Giorgio Vasari, an artist of minor repute, influenced the course of art history by writing the first book on the subject. Unfortunately, Vasari wrote his *The Lives of the Most Excellent Painters, Sculptors, and Architects* (1550) after many of the principals were dead, so he had to rely on secondhand sources rather than personal knowledge. He surmounted this obstacle by gathering stories that were still being told about this constellation of individuals.

Vasari recounts a story about Leonardo's artistic potential when he was still a teenager. A peasant approached his father, Piero, and requested that he hire an artist to decorate a shield. Piero gave Leonardo the task. Leonardo took the project to heart and worked diligently, creating a very realistic-looking monster to adorn the front of the shield. He placed the finished work in a shed in a strategic location so that when the door was opened, the shield could be seen only in a "soft light," near the entrance. So realistic was Leonardo's creation that when Piero opened the door and dimly caught a glimpse of the monster seemingly lying in wait for him, he instinctively recoiled in fear. After he had regained his composure, Piero carefully examined the shield's exquisite workmanship. Surreptitiously, he substituted another shield he had bought at the market to present to the man who had ordered it so that he might sell Leonardo's fantastic creation at a much higher price in Florence.

Convinced his son should pursue a career in an artisanal guild, Piero sought out Andrea del Verrocchio, an artisan who headed one of the busiest workshops in Florence. Papers were signed, and Verrocchio agreed to take Leonardo under his wing at the age of fourteen and teach him the intricacies of his trade. Leonardo would prove to be a diligent student, learning from Verrocchio the wide-ranging skills necessary to cast bronze statuary, mix varnish for finished paintings, raise bells for belfries, and many other practical maneuvers.

Artistically, Leonardo came into his own under the tutelage of Verrocchio. In his first known serious endeavor, Leonardo painted one of the angels in the lower right-hand corner of a larger work principally done by Verrocchio, *The Baptism of Christ* (1472–75). Leonardo's angel was so obviously superior to anything else in the composition that Verrocchio decided to abandon painting and devote himself to other arts. Soon after, Leonardo painted his first commissioned work *The Annunciation of the Virgin* (1472), followed by the portrait of *Ginevra de' Benci* (c. 1476). He also finished *The Benois Madonna* (1479–81).

During the time of Leonardo's apprenticeship, Florence was the epicenter of the rising culture that has come to characterize the Renaissance. Ruled by an enlightened family dynasty, the de Medicis, with Lorenzo (The Magnificent) as its head, Florence was the Italian peninsula's most prominent city-state. The invention of double-entry bookkeeping expedited the city's banking and commerce. Florence also had a reputation for fostering all the arts and was home to many literary and intellectual giants.

Dante Alighieri, author of *The Divine Comedy* (c. 1320), and Giovanni Boccaccio, author of *Decameron* (1467), were both Florentines, as was the mapmaker Paolo dal Pozzo Toscanelli. In 1474, eighteen years before Columbus's famous voyage, Toscanelli sent the Genoese mariner a global map that explained how he could reach the Far East by traveling west. Master architect Filippo Brunelleschi had accomplished what most considered impossible: In 1436, he placed a dome atop Florence's massive cathedral. Another Florentine, Leon Batista Alberti, had refined Brunelleschi's earlier discovery of perspective in art and published a treatise on the subject in 1435, an act that would teach legions of artists how to realistically represent three dimensions on a two-dimensional canvas.

Besides being born illegitimate, Leonardo possessed another trait that also hindered his advancement. He likely practiced homosexuality at a time when it was dangerous to do so. The Signora of Florence (the city-state's highest legislative body) had decreed that homosexuality was a crime punishable by death, a law fostered by the Church. The law, however, was observed more in its breach than in its application. Giovanni Lomazzo, one of the first contemporaries who identified Leonardo as gay, notes that "homosexuality" was widespread in Florence. In fact, the Germans used the word *Florenzer* (Florentine) to describe a sodomite. Homosexuality was routinely denounced from the pulpit, although not all preachers went as far as San Bernardino da Siena, who exhorted the faithful to spit on the floor of Santa Croce and shout, "To the fire! Burn all sodomites!" "Things got worse in 1484," Charles Nicholl writes, "when a papal bull effectively stigmatized homosexuals as diabolical: Their 'heretical perversions' were on a par with having 'carnal knowledge with demons,' as witches were said to do."

Citizens of Florence considered someone who too openly flaunted his proclivities as a stain on the reputation of their virile city. Yet, historians have argued that Verrocchio, Michelangelo, Donatello, the poet Poliziano, and banker Filippo Strozzi were also practicing homosexuals. Because of the draconian laws, most gays were discreet. Some, however, especially the young, openly flaunted their sexual orientation. We know from Anonimo Gaddiano, another contemporary of Leonardo's, how he looked: "He wore a rose coloured tunic, short to the knee, although long garments were then in fashion. He had, reaching down to the middle of his breats, a fine beard, curled and well kept." From the available evidence it appears that the youthful Leonardo fell into this flamboyant set.

In 1476, when Leonardo was twenty-four, someone anonymously accused a group of five youths, Leonardo among them, as having committed the crime of sodomy. The authorities did not pursue the charges against Leonardo, but neither was the young artist's name entirely cleared.

Another trait that set Leonardo apart was that he had a clear empathy for animals and a philosophical aversion to eating them; some have argued that he was a practicing vegetarian. This dietary anomaly would have been exceedingly rare in a time of heavy meat consumption. He

noted that other animals suffered pain just as he did, and he did not want to do anything to contribute to their discomfort. Such was Leonardo's antipathy to the maltreatment of animals that he even extended it to what he wore. One of Leonardo's closest associates, the eccentric Tommaso Masini, described his friend in wonderment: "He would not kill a flea for any reason whatever; he preferred to dress in linen so as not to wear something dead."

Vasari recounts the story of how Leonardo could not stand to see wild animals in captivity. "He took an especial delight in animals of all sorts, which he treated with wonderful love and patience. For instance, when he was passing the places where they sold birds, he would often take them out of their cages with his hand, and having paid whatever price was asked by the vendor, he would let them fly away into the air, giving them back their lost liberty."

Politically, the Italian peninsula in the fifteenth century was highly unstable. An almost constant fission-fusion among the principal city-states produced hasty alliances, deadly skirmishes, treasonous acts, and seditious conspiracies. Individuals, groups, and entire city-states vied in constant competition for dominance and/or protection. The prospect of economic or military defeat at the hands of one's enemies was a constant threat. This factor alone could account for much of Leonardo's interest in the machines designed to tear, rend, and grind the flesh from the bones of enemy soldiers. But another aspect to consider was his brush with the law. Leonardo fiercely cherished his personal freedom, and it became his paramount goal to defend against anyone who would try to take that away from him. He believed that this should be the highest priority for any free man.

CHAPTER 3

Milan/Vatican

If the painter wants to see beauties with which he will fall in love, he is a lord who can generate them, and if he wants to see monstrous things which may terrify or be buffoonish—and be laughable or truly arouse compassion, he is their lord and God.

—Leonardo da Vinci

But of all other stupendous inventions, what sublimity of mind must have been his who conceived how to communicate his most secret thoughts to any other person, though very far distant either in time or place? And with no greater difficulty than the various arrangement of two dozen little signs upon paper? Let this be the seal of all the admirable inventions of man.

—Galileo Galilei

Of all the great hybrid unions that breed furious release of energy and change, there is none to surpass the meeting of literate and oral cultures. The giving to man of an eye for an ear by phonetic literacy is, socially and politically, probably the most radical explosion that can occur in any social structure.

—Marshall McLuhan

In 1481, Pope Sixtus VI summoned many of Florence's most outstanding artists to Rome. He let it be known that it was his intention to lavish commissions on the chosen artists for the purpose of glorifying Rome. Lorenzo de Medici assisted in compiling the list of artists the

Pope should invite. On the list of those selected were Botticelli, Ghirlandaio, Perugino, and many other Florentine artists. In what must have been a stinging rebuke, Leonardo was not included. Disappointed by his failure to obtain an ongoing stream of meaty commissions that he believed were his due, Leonardo increasingly longed for a fresh start in a city other than Florence.

Paolo Giovio, who had known Leonardo personally, wrote, "He was by nature very courteous, cultivated and generous, and his face was extraordinarily beautiful." Anonimo Gaddiano described him similarly: "He was very attractive, well-proportioned, graceful and handsome, with beautiful hair, arranged in ringlets, falling down to the middle of his chest." Further suggesting he was a dandy in both his habits and his dress, Leonardo recommended, "Take fresh rosewater and moisten your hands with it, then take flower of lavender and rub it between your hands, and it will be good." Leonardo was also athletic, an excellent equestrian, and exceptionally strong; one story recounted how he was able to bend a horseshoe with one hand.

Another trait that contemporaries marveled about was his superb singing voice. Somewhere along the way, Leonardo had learned musical notation, and there is strong evidence that he composed music. The ancients did not use chords in the sense of simultaneous production of sounds, but composed melodies of a single line. Later, the polyphonists of the eleventh century added counterpoint, which represented a second musical line. What Leonardo was excited about was the prospect of introducing a third dimension into music—chords.

He played many musical instruments so that he could accompany himself when he sang. What is surely one of the great losses for posterity is that not a single piece of his music has surfaced thus far. His love of music and his proficiency in it can be inferred from his strong interest in the design and crafting of musical instruments. One particular lute fashioned in the form of a horse's head and crafted from silver played a role in the next important chapter in Leonardo's life.

In 1482, Ludovico Sforza, the Duke of Milan, solicited other rulers for a court sculptor capable of casting a large equestrian statue. Sforza's claim to ruling Milan was tenuous, and he wanted to immortalize his father to

remind the citizens of the city-state of the importance of his family in its history. Upon hearing of the commission, Leonardo leaped at the chance. He wrote the Duke a lengthy letter of introduction, extolling his own many talents and virtues. Most telling was his emphasis on his skills as an architect, military engineer, and musician. The last thing he mentioned, almost added as an afterthought, was that he was also a painter.

The Duke offered the position to Leonardo. In 1482, the thirty-year-old artist left the city in which he had come of age and embarked on an entirely new venture. He could not have known then that he was destined to spend the next eighteen years of his life in Milan, under the rule of a man who was his complete opposite.

Fifteenth-century Milan was renowned as the Italian peninsula's armorer. The prosperous city-state occupied a position similar to that of Detroit in mid-twentieth-century America. Metal workshops turned out finely wrought instruments of battle. On the finer streets and piazzas, the many newly rich strolled in the comfort of knowing they were living in a prosperous and well-fortified city-state.

The Sforza family, from which the Duke was descended, did not have the cultural, intellectual, or aesthetic heft of the Medicis. The Duke was known as "Il Moro" for his dark coloring, and his many enemies considered him a usurper. He had a known appetite for war, sex, food, intrigue, and elaborate parties. He continually plotted foreign wars, and used marriage as a political tool to cement alliances.

An outbreak of the bubonic plague struck Milan several times between 1484 and 1485, killing over fifty thousand citizens. It was amid this tumult that Leonardo began his initiation as the Duke's court artist.

In this phase of the Renaissance, art emerged as the coin of prestige. Each city-state prized its artists. Rulers adorned their piazzas and loggias with sculptures and the inner rooms of their palaces with expensive tapestries and paintings. The prevailing attitude was clear: If, after spending treasure on an army of mercenaries and constructing imposing fortifications, there remained enough money and talent to beautify the city, then this extravagance would impress rivals. A healthy competition arose between the heads of these fiefdoms; unwittingly, they greatly benefited future lovers of art.

Unfortunately for Leonardo, the Duke of Sforza never completely grasped his court artist's extraordinary talents. Although Sforza gave Leonardo an apartment close to the court, he kept him on a tight financial rein. His erratic payments resulted in Leonardo having to beseech the Duke on numerous occasions to pay him the money he was owed.

Among those he added to his retinue was a beautiful ten-year-old boy named Giacomo, the son of a certain Giovanni Pietro Caprotti of Oreno. In 1490, he negotiated with the boy's father to let the boy come and live with him. In return, Leonardo told him that he would train the youngster as an artist. There is no indication that the boy had any natural talent, and he developed into a mediocre painter.

Leonardo renamed him Salai, which means "little devil"; the relationship with the boy proved to be a very frustrating one for Leonardo. Salai stole, lied, and created mischief on a regular basis. The most emotional entries in Leonardo's notebooks refer to the difficulties he experienced with Salai. Nevertheless, Salai remained with Leonardo for all but the last years of his life, and then perished in a duel resulting from a petty dispute.

Another youth whom Leonardo engaged as an apprentice was fourteen-year-old Francesco Melzi. Melzi, in contrast with Salai, came from a noble family, and had actually applied for the position because he truly desired to become an accomplished artist. He would become Leonardo's closest confidant and the heir to whom Leonardo would entrust most of his paintings and valuable notebooks. On the occasion of his mentor's death, Melzi wrote a touching and heartfelt encomium to Leonardo, claiming that he was like a kind father to him.

As Leonardo's household grew, so too did his problems working for the erratic duke. His patron might require him to paint one of his mistresses, or, alternatively, supervise the festivities necessary for a wedding or some other celebration. Leonardo was expected to design costumes and sets, provide decorations, and plan entertainments for the many lavish parties the Duke threw. On several occasions these superficial duties led Leonardo to complain to the Duke: "It vexes me greatly that you should have found me in need, and . . . that my having to earn my living has forced me to interrupt the work and to attend to lesser matters instead of following up the work which your Lordship entrusted to me."

Despite the demands of the court on his time and the hours he devoted to his scientific studies, Leonardo's sojourn in Milan witnessed the full flowering of his artistic genius. Leonardo initiated his career as the Duke's court painter by portraying Cecilia Gallerani, the Duke's sixteen-year-old mistress, in a manner most unusual (*Lady with an Ermine*, c. 1490–91). He followed this with a stunning grouping of the Holy Family in his first version of *Virgin of the Rocks* (c. 1483–86). These works were but a prelude to arguably the most complex masterpiece ever created by an artist. The Duke commissioned Leonardo to paint a mural high on the wall of a monastery at the request of its clerics. The wall chosen was in the refectory hall where monks regularly gathered to eat their supper. Depicted by hundreds of past artists, Leonardo's version of Jesus's Passover dinner with his disciples was unlike anything the world had ever seen. It has kept a veritable army of art historians busy for centuries, analyzing its many subtleties and innovations.

The Last Supper began to deteriorate immediately, because Leonardo had used an experimental method to apply the paint to the refectory wall. The mixture proved a poor choice, and the sharp details of the work soon began to fade and flake. Word of Leonardo's masterpiece spread throughout Europe, and many contemporary artists made a pilgrimage to see it. Fortunately for posterity, they copied it. From these reproductions, art historians have been able to piece together a fairly accurate rendering of Leonardo's original creation.

During the period that he completed these exceptional paintings, Leonardo also worked on diverse projects in architecture and public hygiene and performed extensive scientific investigations. There are suggestions from his notebooks that one of his lifelong ambitions was to become the first human to fly, although he never accomplished it. None of his writings was ever published. His output of paintings was limited, and most were either unfinished or suffered the ravages of time. But the bitterest disappointment during his sixteen years in Milan was the fate of his most ambitious project, the statue memorializing Sforza's father.

From the moment he arrived, Leonardo was consumed by his plans for the design and technical details of casting the largest equestrian

bronze ever attempted. Leonardo studied equine anatomy and made the most detailed drawings ever created of this subject. When he finally completed a clay model of the horse made to scale, he unveiled it in the piazza. People came from far and wide to gaze on the magnificent work of art.

The *equestrian monument* would have been enough to occupy the full energies of an ordinary man, but during his time in Milan, Leonardo also made occasional visits to surrounding towns. As a result of these visits, he made the acquaintance of several intellectual leaders. Through his association with the mathematician Luca Pacioli, Leonardo became intrigued with the clarity of mathematics, and contributed exquisite drawings for Pacioli's book of geometrical figures. Leonardo also became fascinated with all matters related to engineering. His notebooks are filled with some of the finest cog and gear machines ever to be illustrated by the human hand.

Engineering, architecture, and mathematics were not his only interests during his Milan years. He also studied geology, hydrology, botany, and comparative anatomy, to name a few. He made observations concerning the flight of birds in greater detail than had any previous investigator. He made studies of optics and the effects of light and shadow. And he became the most curious anatomist in an age that had not yet discovered the preserving benefits of formaldehyde. In a cramped, closed room, he had to work quickly to dissect the cadavers before they began to rot.

On top of these endeavors, each of which was enough to consume one lifetime, he wrote a treatise on painting, a book of proverbs, one on fables, another one of riddles, and another of word games. He composed a short pamphlet of prophesies. He also wrote travelogues about places he had never visited.

Despite his extraordinary achievements, his destiny was intimately entwined with a double-dealing ruler, which proved disastrous to Leonardo's career. The Duke, having engaged in belligerent machinations toward Florence, Naples, and the Papal States, found himself in a precarious situation. He schemed to invite the French king Louis XII to come to his assistance. During the monarch's visit, the king could not help but notice the riches apparent in the city. When he returned to Paris, he conveniently

remembered that the French had an ancestral claim on Milan and the surrounding countryside of Lombardy. The Duke's scheme backfired on him, and in 1499, the French returned to Milan, this time with hostile intent. They conquered the city, deposed the Duke, and imprisoned him in a dungeon in France where he died years later.

As the overwhelming French force approached Milan, the Duke's army melted away. The townspeople fled. When the French mercenaries arrived, they destroyed Leonardo's clay model. Leonardo realized that he could no longer stay in the city in which he had invested so much of his time and energy. After leaving Milan, he traveled to Mantua and then Venice. At the time Venice was engaged in a mortal struggle with its archenemy, the Ottoman Empire. The Sultan had previously conquered Constantinople in 1453, and his armies were on the move, advancing up the Western Adriatic coast directly opposite the Italian peninsula. When Leonardo visited Venice, they were concerned about the Turkish threat.

Such was Leonardo's reputation as a military strategist that the Venetians let him present an idea to keep the Turks at bay to the Venetian Senate. He devised an audacious scheme: Build dams to protect the land routes to the city. Leonardo told the city fathers that the water behind the dams could be released when an invading army attempted to attack Venice from the land, thus drowning them. While exceedingly ingenious in its scope, the plan was too impractical for the Venetians to put into use.

After leaving Venice, Leonardo stayed for a time at the Melzi estate south of Milan while he contemplated his next move. It must have been a dark period for him. He was without a patron, home, or income, and he was still responsible for the retinue of people that depended on him for their livelihood. Reluctantly, he decided to return to Florence. The year was 1500.

The city of his youth was hardly recognizable. The Medicis were no longer in power, and a weak, contentious public had replaced their strong leadership. During the years Leonardo had been absent, a dogmatic fundamentalism, led by the fiery cleric and orator, Girolamo Savonarola, had swept Florence. He inveighed against the sin of accumulating wealth and demanded a return to a simpler lifestyle that required strict adherence to

the dictates of the Church. Savonarola destroyed many works of art, considering them to be sinful and a detraction to worship. He instituted what amounted to a reign of terror that lasted until the people rose up against him, and he was publicly hanged in the piazza in 1498.

When Leonardo arrived, the city was still suffering from the aftereffects of this episode of madness, and a pall of anxiety and depression still hung over the populace. Nevertheless, Milan's court painter's reputation as a consummate artist had preceded him. The citizens of Florence had taken a lively interest in his artistic achievements as news of his Milanese works had seeped back to the city that claimed him as a homegrown son. But upon his return Leonardo discovered that he had to contend with another personality whose talent closely matched his—Michelangelo Buonarroti.

Michelangelo was twenty-five and Leonardo was forty-eight in 1500. The young sculptor had thrilled the citizens of Florence with his statue of *David*, completed when he was only twenty-one. Leonardo also had to compete with the even younger boy wonder, Raphael, the artist upon whom the authorities were lavishing rich commissions.

Michelangelo intensely disliked Leonardo because Leonardo maintained that the art of painting was far superior to sculpture, and wrote disparagingly about what he considered to be a lesser art: "The sculptor's face is so smeared with marble dust, he looks like a baker. The painter, by contrast, works at ease; he is well dressed; he moves a light brush dipped in delicate colors and adorns himself with the clothes he fancies." Such comments did not endear Leonardo to the highly sensitive Michelangelo.

Fortunately, Leonardo soon obtained a commission to paint the Holy Family, and began work on a revolutionary grouping of Mary's mother Anne, Mary, and the baby Jesus. As was often the case, he never finished it. The fault, as in similar situations, was not entirely his. One of the most notorious and disreputable characters to live in a time that was filled with notorious and disreputable characters offered Leonardo a high-paying, prestigious job as his military adviser and chief engineer.

Cesare Borgia was the son of Pope Alexander VI. Alexander had two infamous children: the ill-reputed Lucrezia Borgia and Cesare, a man

noted for his exceptional cruelty. Alexander had appointed Cesare a cardinal when the teenager was seventeen, but his father soon accepted that his son was not cut out to be a man of the cloth. He released his son from his vows and instead appointed him the titular ruler of Romagna, a region along the Adriatic coast with ill-defined borders that encompassed the land south of Venice and around Ravenna. Significantly, the Pope had not bothered to inform the existing rulers of the city-states of Romagna that they were now under the hegemony of a Borgia. Thus, his decree set in motion a series of wars between the local populations, who resisted the invasion of a well-armed, well-financed Borgia usurper.

It is another of the many paradoxes of Leonardo's life that a man who called warfare *una pazzia bestialissima* (a most bestial folly) and detested violence would end up on the payroll of such an unscrupulous and violent person. It is a measure of how badly Leonardo needed the money and wanted to leave Florence that he took the position with Cesare Borgia.

It was during his employ with Borgia that Leonardo focused his interest on cartography. Beginning with the exquisite jewel of a map that he drew of the town and surrounding countryside of Imola, he went on to create even more detailed maps of northern Italy, from higher and higher vantage points. No one has been able to adequately explain how Leonardo was able to envision the aerial maps of Italy from such staggering heights.

An unforeseen result of Leonardo's association with Cesare was a friendship with another of the Renaissance's key thinkers. In 1502, Leonardo met and formed a lasting relationship with Niccolò Machiavelli, who had joined Cesare as a young administrator and liaison. The two men met at the court of Cesare Borgia in the town of Imola. Historians presume that Cesare Borgia was the model for Machiavelli when he wrote his classic, *The Prince.*

While in the employ of Cesare, Leonardo and Machiavelli were approached by authorities of Florence who asked for their help in defeating their commercial rival, the city-state of Pisa. Leonardo devised a most outlandish engineering scheme: divert the Arno River away from Pisa and deprive the city-state of its lifeblood. An attractive side benefit of this was to dredge a series of canals that would make the Arno a navigable river that could accommodate seafaring vessels for Florence.

Machiavelli convinced the city's elders to fund this expensive project, but as so often happened with Leonardo's plans, it was dogged by bad luck, underfunding, and the poor workmanship of those to whom he had delegated authority. The scheme failed despite the considerable time and resources that the rulers of Florence had devoted to it. Leonardo and Machiavelli made little mention of the project in their subsequent writings.

Leonardo left the employ of Cesare Borgia after he learned that Cesare had personally strangled a subordinate that Leonardo had befriended. He returned once again to Florence. Michelangelo had also left, and was now working for the Signora of Florence. Florence had its two most famous artistic sons Leonardo and Michelangelo in one place. The governing body decided that they should paint two different battle scenes in which Florentine forces were victorious. Leonardo drew the commission to paint the *Battle of Anghiari*. All of the citizens took a keen interest in this competition, because it was widely known that the two artists disliked each other. The barely civil rivalry between Leonardo and Michelangelo soon became known as the "battle of the battles."

When Leonardo displayed his cartoon (a drawing to be used as a model for the final work), there was widespread amazement; as word spread, people arrived from afar to see it. Like so many of his other projects, fate was to interfere with its completion. Both the French king Louis XII and his son Francis I had instructed their aide, Charles d'Amboise, to order the Signora to release Leonardo from his obligations in Florence and send him to Milan to the court of the French immediately. At first, the Florentines were reluctant to allow Leonardo to leave, but the victorious French were in possession of a larger army, and that fact persuaded the Italians to submit. (Michelangelo never completed his commission, either, as he was called to Rome by Pope Julius II to paint the ceiling in the Sistine Chapel.) And so with another project unfinished, Leonardo packed his bags and headed back to Milan. One of the projects Leonardo took with him on his trek north was the portrait he was working on of a Florentine woman known only as *La Gioconda* (1504). She would later become the most famous painting in the history of art, known in English as the *Mona Lisa* [Fig. 1].

Unlike Leonardo's previous stay in Milan, his duties were light this time. He revisited a project that he had begun over twenty years earlier and painted a second version of *Virgin of the Rocks* (1506). His residence in Milan was short because an alliance of Venetians and Spaniards—with the help of papal armies—successfully drove the French out of Milan. Once again, Leonardo was forced to flee. And, once again, his situation was dire. He did not have a patron. He had little money. He had left a trail of unfinished works.

News that Pope Julius II had suddenly died and the College of Cardinals had elected a Medici from Florence to be the next pope gave Leonardo hope that at last he could find work in Rome. Leo X, the new pope, let it be known that he intended to leave an artistic legacy in the city. Leonardo headed for Rome with high expectations that he could secure a few of the commissions that his fellow Florentine was promising to lavish.

When he arrived, he found Michelangelo had finished his painting of the Sistine Chapel, and Raphael had painted his famous mural, *The School of Athens*. The architect Donato Bramante was occupied with the erection of St. Peter's Basilica. Leonardo failed to land a lucrative commission. Another factor was that Leonardo was engrossed in human dissection at this time, and his work did not go unnoticed. Leonardo wrote in his notebooks, "An ill-wisher hindered me in anatomy, denouncing it before the Pope and also at the hospital." This and other reports of his time spent with rotting corpses so displeased the Pope that it increasingly appeared Leonardo's hopes for success in Rome would come to naught.

Yet once again, fate intervened. The young French king Francis I had been so impressed with Leonardo when he'd spent time with him in Milan that he invited the aging master to come live with him in France and be his court artist.

At Chambord, in the bucolic Loire River valley, Leonardo finally found peace. His duties were light, and he was given a chateau at Amboise. Now in his sixties, his health had begun to fail; according to Antonio de Beatis, the secretary to the cardinal, "Leonardo's physical condition is that

in 1517, his right hand was 'paralyzed.'" Beatis goes on to say that this paralysis prevented him from painting.*

The French king traveled regularly to visit Leonardo. When asked why he didn't summon Leonardo to his court, the younger man replied that it was easier for him to travel to visit Leonardo than it was for the artist to make the trip to Paris. Leonardo spent the last few years of his life consumed as always with matters related to his boundless curiosity. He died in France in 1519 at the age of sixty-seven, and was buried at the Chapel of Saint-Hubert in Amboise.

* There is some dispute concerning which hand was paralyzed. Leonardo was left-handed, and he drew the elegant Turin red chalk self-portrait after this incident.

CHAPTER 4

Mind/Brain

Iron rusts from disuse; stagnant water loses its purity, and in cold weather becomes frozen; even so does inaction sap the vigour of the mind.

—LEONARDO DA VINCI

The theme of duality in human nature, of inner conflict, of man divided against himself has been at the core of great literature, art, and philosophy for thousands of years. Is the split-brain just another metaphor, or is there something deeper, something literal for us here?
—DAVID GALIN, SPLIT-BRAIN RESEARCHER

Time and Space are Real Beings, a Male & a Female. Time is a Man, Space is a Woman.

—WILLIAM BLAKE

To UNDERSTAND THE UNIQUENESS OF LEONARDO'S BRAIN, WE MUST FIRST consider our own. The human brain remains among the last few stubborn redoubts to yield its secrets to the experimental method. During the period that scientists expanded the horizons of astronomy, balanced the valences of chemistry, and determined the forces of physics, the crowning glory of *Homo sapiens* and its most enigmatic emanation, human consciousness, resisted the scientific model's persistent searching.

The brain accounts for only 2 percent of the body's volume, yet consumes 20 percent of the body's energy. A pearly gray, gelatinous, three-pound universe, this exceptional organ can map parsecs and plot the

whereabouts of distant galaxies measured in quintillions of light-years. The brain accomplishes this magic trick without ever having to leave its ensorcelled ovoid cranial shell. From minuscule-wattage electrical currents crisscrossing and ricocheting within its walls, the brain can reconstruct a detailed diorama of how it imagines the Earth appeared four billion years ago. It can generate poetry so achingly beautiful that readers weep, hatred so intense that otherwise rational people revel in the torture of others, and love so oceanic that entwined lovers lose the boundaries of their physical beings.

Distinctly different from all other creatures, the human brain can use its powerful time awareness to range along a vector of past, present, and future that includes the "Big Bang" fourteen billion years ago. Despite the extraordinary intelligence of dogs, cats, seals, dolphins, elephants, and chimpanzees, there exists not a one among them that a human could train to keep an appointment to meet at a particular location two weeks hence. No other animal's brain can hold steady in its consciousness the extended time frames from both the past and the future that a human can.

Similarly remarkable is the bipedal primate's freedom to explore space. All other complex animals remain tightly tethered by an invisible instinctual leash that confines them to a defined territory, flyway, or migration route. The human brain, in contrast, seems to possess an internal neuro-spatial GPS guidance system that allows its owner to wander freely all over the planet. While there exist a handful of creatures possessed of wanderlust, none can match a human in his or her willingness to explore distant and/or hostile environments. Moreover, no other creature has both plumbed the pressure-crushing depths of the oceans and escaped from the Earth's atmosphere to voyage to the sublunary reaches of cold space.

Early scientists, attempting to understand the human brain, confronted the ultimate "black box" problem: The investigative apparatus necessary to study the object of interest was the object itself.

Modern neuroscience has its roots with ancients who began gleaning information about brain function by studying patients who had something going very wrong inside their cranium. But first, these early observers had to discard the erroneous belief that consciousness arose in the heart, not

the brain. Given the virile vigor of the beating heart constantly rattling its cage when compared to the goopy brain, which to an untrained eye did not appear to *do* anything, one can easily forgive the earliest clinicians for making this error. Hippocrates, the Greek, fourth century BC father of all physicians, set the record straight. Using no device other than his own acumen, he correctly identified the conductor orchestrating consciousness as standing before a podium located behind the forehead rather than the breastplate.

Unfortunately, the practice of autopsy was taboo in ancient times.* Not until the Renaissance did a few of the culture's more intrepid explorers let their curiosity overcome squeamishness and religious strictures. Postmortems afforded a physician the opportunity to compare the clinical symptoms he observed during life with the lesions apparent in various parts of the brain after death.

This method had the inherent disadvantage of the interested party having to patiently await the subject's demise before he could pry open the deceased's skull to discover the physical abnormality lurking there. The clinician then would have to begin the difficult task of correlating the identified distinctive material defect observed within the brain with the neurologic deficit that he had noted during the patient's life. Given the complexities of any single individual's brain when added to the extreme variations between one brain and another, combining circumstantial observation with deductive reasoning was excruciatingly slow and hard work.

Moreover, the brain decomposes rapidly after death, leaving a very short window during which any aspiring ancient pathologist could work. Even after fixative stains, formaldehyde, and microscopes upgraded the process from the primitive to the refined, hurdles persisted. Peering at postmortem tissue on a slide under a microscope or examining a formaldehyde-fixed slice of dead brain tissue was a poor substitute for observing the living organ in real time, actively crackling with electrochemical jolts of energy and somersaulting neurotransmitters.

* Although there is evidence of trepanning (the boring of holes in the skull) among early cultures and the Egyptians certainly practiced postmortem examinations and removal of the internal organs, there is no evidence that any pre-Greek cultures had ever investigated what might be the *function* of the organs they were removing. From the available evidence, it appears that these activities were associated with magico-religious considerations more than scientific curiosity.

Another erroneous conception about the brain impeded understanding of its operating system's underlying architecture. The seventeenth-century philosopher René Descartes had authoritatively declared, "I observe . . . the brain to be double, just as we have two hands, two eyes, and two ears." Descartes would not entertain the notion that the brain would be anything but elegantly designed so that each half was the exact mirror image of the other. A measure of how entrenched this idea had become can be found in the statement of the French physiologist Bichat, who wrote in 1800, "Harmony is to the function of organs as symmetry is to their configuration." To Bichat and generations of earlier anatomists, because each half of the brain *appeared* symmetrical upon examination, it must follow that each side must *function* in a complementary way.

Additionally Descartes concluded that the mind was something completely separate from the body. Its ethereal nature caused Descartes to place the mind in the world of immaterial spirit. He introduced to philosophy the mind/body split, and in so doing inadvertently distinguished the brain and its principal by-product—consciousness—as something completely "other" than the more prosaic interlocking body parts that went about their business grinding and meshing below the neck.

God's special organ within God's special creation was essentially off limits to the more mundane human investigators. Descartes' philosophical decapitation lingered until the mid-nineteenth century, when a breakthrough discovery exposed his fallacy. Paul Broca, a French physician, fractured the symmetry of this organ and in a single bold stroke initiated the beginning of modern neurology. By connecting the common clinical syndrome of speechlessness (aphasia) that often followed a cerebral accident with its frequent accompaniment, paralysis of the right side of the body, he correctly located speech primarily in only one hemisphere of the brain; the majority of humans being right-handed, Broca identified the unique functions of the left hemisphere.* (Due to the arrangement of crisscrossed fibers in the brain, the left hemisphere controls the right side of the body and the right hemisphere controls the left side.)

* The French country physician Marc Dax had made this observation in the eighteenth century, but was unable to properly connect the defect of aphasia and paralysis of one side of the body with the localization of speech and preferential handedness to one dominant hemisphere.

Soon afterward, Carl Wernicke further refined Broca's observation by distinguishing another location in the left hemisphere that was specifically concerned with making sense of what we hear as opposed to Broca's area further forward, whose primary purpose was generating intelligible speech. Broca's and Wernicke's discovery of dedicated areas of the brain performing specific language skills introduced a novel way to conceive of brain functions.

With the advent of the twentieth century, new investigative tools gave neuroscientists the ability to study the brains of normal people in real time. The first was the measurement of brain waves. Because neurons, the workhorse cells of the nervous system, operate by using electrochemical impulses, they generate weak electromagnetic fields that extend into the surrounding space. The cortex, just under the bony plates of the skull, contains the most concentrated mass of neurons in the brain, and the neurons' combined activity can be measured by attaching sensors to a subject's scalp. The readout occurring in real time is called an electroencephalogram, or EEG. Following rapidly on the heels of this breakthrough came other developments that provided neuroscientists with increasingly sophisticated tools to investigate elusive brain functions.

In the 1960s, Roger Sperry discovered an experimental model that could be used to study brain activity. He surgically divided the corpus callosum of cats, anticipating that such radical surgery would create a dramatic, observable neurologic deficit. The corpus callosum, connecting the two cortical hemispheres, is the largest single structure in the cat's brain. To his surprise, his cats' behavior after the surgery appeared normal. How could that be? Sperry wondered. How could relatively normal behavior follow the disconnection of the great cable connecting one hemisphere to the other? And what, Sperry wondered, was the implication for human brain function?

Initially, he hypothesized that perhaps cats were too distant from humans on evolution's extensively branching bush. So he performed the same surgery on monkeys. The postsurgical monkeys pretty much resembled the disconnected cats in their observable behavior. Now Sperry was more intrigued than ever. He remained convinced that *something* must have happened to brain function as a result of his drastic cleaving.

Around the same time, two neurosurgeons in Los Angeles, Joseph Bogen and Philip Vogel, were mulling over the feasibility of performing on humans a similar procedure to the one that Sperry had performed on cats and monkeys. They speculated that commissurotomy (the technical name of the surgical procedure that severs the corpus callosum) could be an effective surgical method of treating intractable epilepsy.

An epileptic fit can be compared to an electrical storm occurring inside the head. Typically, it begins as a squall in one specific focus in the brain that manifests an abnormality in the local conduction of electrical current. At the outset of the fit, the electrical signal, in a process poorly understood, becomes greatly amplified in this focal area and, rapidly gathering force, spreads to neighboring normal regions, exciting them also to begin to fire erratic electrical impulses. Soon the brain is flashing like a pinball machine gone haywire, resulting in one of the most frightening paroxysms there is in the pathological catalog of conditions that can afflict a human.

Depending on where in the brain the abnormal locus resides, the body part directly under its control is the first to begin what the ancients called the Devil's Dance. As one possessed, the epileptic rapidly loses consciousness amid wild flailing of one of his or her arms or legs. As the brain storm moves across the nervous system's surface, eventually all four limbs join in the involuntary jerky motions. An inhuman sound issues from the vocal tract. The affected person's eyes roll back in their sockets until the pupils are not visible. While the eye muscles jerk the eyeball in rapid movements called *nystagmus*, the eyelids flutter violently.

At the time that Bogen and Vogel were investigating possible surgical treatments available to sufferers of this condition, a variety of efficacious drugs entered the market that could ameliorate or inhibit most epileptic seizures. Unfortunately, there still remained a small subset of patients for whom the medications were ineffective. It was to this group of intractable epileptics that Bogen and Vogel contemplated offering their radical approach. Commissurotomy, in theory, had an attractive premise. Bogen reasoned that if the electrical discharge initiating the paroxysm could not leap across from one cerebral hemisphere to the other by way of the corpus callosum, because it was surgically disrupted, then the fit would

remain confined to only one hemisphere, leaving the other one aware and alert enough to call for help. Further, by confining the seizure to only one hemisphere, its outward manifestations would be less severe or protracted.

Of course, no one could claim with the slightest degree of confidence what would be the consequences of such a radical approach on the patient's behavior, language, coordination, balance, personality, rationality, sexuality, or consciousness. Cats, monkeys, and humans are all mammals, but a deep divide separates the last mammal in this list from the other two. The risks were high.

Nevertheless, a small group of patients signed their informed consents to go under the knife, even though they were forewarned about the untested and highly dangerous surgical procedure. Their lives were so chaotic that they were willing to have their brains permanently and drastically altered on the chance that they might gain some semblance of control over the singular factor causing the disruption.

Bogen and Vogel performed the first successful commissurotomy in 1963. The patient survived, and, remarkably, there was little in his observable behavior and answers to posed questions that seemed different from his preoperative state. Friends and family confirmed that he walked, talked, and went about his business seemingly unaffected by the fact that his right hand quite literally no longer knew what his left hand was up to, and vice versa.

Thus emboldened, Bogen and Vogel repeated their performance. For reasons unknown, the surgery not only ameliorated the severity of the patients' epileptic attacks, as had been anticipated, but there was also an unexplained decrease in their frequency. For a limited time, physicians recommended the split-brain operation as a reasonable approach to drug-resistant intractable epilepsy. Over a thousand patients had their brains split in this fashion. Commissurotomy fell out of favor in the 1970s because a new generation of drugs ultimately proved more successful in controlling epilepsy.

Sperry followed the initial success of Bogen and Vogel with great interest, recognizing that their accumulating pool of patients possessed a veritable treasure chest filled with information concerning how the human brain functioned. Along with Michael Gazzaniga, David Galin,

and many other researchers, they designed a series of exceedingly clever experiments that allowed them to examine each cortical hemisphere in relative isolation. Never before had an experimental model presented itself to neuroscientists that could assess which functions of the brain resided predominantly in which hemisphere.

Soon, various centers around the world began to accumulate their own group of split-brain patients.*

The results of all this activity produced a body of knowledge that was truly revolutionary despite the serious objections some neuroscientists raised. A number of skeptics correctly pointed out that there were flaws in the experimental model. Epileptics have abnormal brains. Extrapolating the results obtained from the split-brain group to normal populations was like comparing apples and oranges. Additionally, they pointed out that the surgery itself radically reconfigured the brain, and that it was scientifically imprecise to superimpose the research findings of these altered brains on the brains of those in the population that had not undergone a splitting of the cortical lobes.

Even when considering these objections, however, the sheer volume of information coming from split-brain studies provided a fascinating window into the workings of the human brain. Newer methods of brain imaging of normal subjects have substantially corroborated the more important claims made by the earlier split-brain researchers. There is much still to be learned, but one fact remains beyond doubt: Natural Selection designed each cortical hemisphere in the human brain to process dramatically different functions.

The brain is an immensely complicated organ. Words such as *never*, *always*, and *for sure* have little place in a discussion concerning it. So the reader will forgive me when, for the sake of clarity, I characterize some of the functions that are still ambiguous as black and white.

Progressing in parallel to the understanding of brain function wrought by split-brain studies were the equally important advances made in the field of neurobiochemistry. Scientists first began to identify and then

* In 1981, Sperry was awarded the Nobel Prize in Medicine for his groundbreaking work.

to understand the function of a wide variety of molecular messengers called *neurotransmitters*. Some were blood-borne hormones acting over long distances; others were local agents never straying far from home. For example, hormones such as testosterone, insulin, estrogen, and thyroxin (from the thyroid) can profoundly affect emotions, mood, and mental functioning, even though they are secreted by organs distant from the brain. Local agents such as dopamine, epinephrine, and serotonin in tiny doses can initiate seismic shifts in a person's emotional tenor and intellectual clarity.

Neurotransmitters work by changing the state of neurons, the defining cells of the nervous system. Neurons differ from other cells in their two distinctive extensions leading away in opposite directions from the cell's body. The shorter of the two resembles an extensively branching tree at the end of which forms a tangle of twiglike projections called *dendrites*. These filaments are the receiving ends of a nerve cell. Extending away from the cell body opposite to the dendrites is a solitary longer trunk called an *axon*.

In humans, some axons achieve lengths of over three feet. For example, the axons of the nerves that enervate the toes must travel from their origin in the lower spinal cord down the length of the thigh and leg to reach their final destination. There is one other notable nerve in which axons achieve extraordinary length. Bundled in the *vagus nerve* originating in the brain, axons journey down through the neck, chest, and abdomen, finally terminating deep in the pelvis at the level of the anus. All along the way, other shorter vagal axons peel off on their path to various internal organs, such as the heart, lungs, stomach, or colon. Anatomists chose to name this nerve with the Latin word that means "wanderer." *Vagabond* and *vagrant* are other English words derived from the same Latin root.

Dendrites, like sensitive weather vanes, react to changes in local conditions, such as stimuli arriving from the axons of other nerve cells. Neurotransmitters impinging directly along their length can also activate them. Once a signal travels from the end of the dendrite to the cell's main body, a mighty assessment must then be made. Like the ones and zeros winking on and off in the motherboards of a computer, the cell decides

to either fire or not fire its singular axon depending upon the intensity of impulses tickling the ends of the nerve cell's dendrites.

Should the determination be in favor of activating its single axon, a chemical chain reaction begins at its root, resulting in an electrical current progressing along the axon's length. Differing from the nature of a current generated along a copper wire that moves at near the speed of light, an electrochemical nerve impulse moves along in a manner more resembling digestive peristalsis; think of a snake digesting a mouse. The distance traveled in one second in a typical motor axon is 100 *yards* per second compared to light speed, which is 186,000 *miles* per second.

For many years, neuroscientists believed that a nerve fired in gradations. According to this early thinking, a powerful stimulus would produce a strong discharge, and a feeble stimulus would produce a weak discharge. Subsequently, we have learned that a neuron either fires or it doesn't. It is an *all or none* phenomenon.

Despite the close proximity of nerve endings, neither axons nor dendrites actually touch. In between them is a small gap called a *synapse*. It is here that neurotransmitters principally act. Some neurotransmitters behave like barricades to inhibit the transmission of impulses across a synapse, while others facilitate or amplify its passage, increasing the likelihood that the nerve will fire. Synapses, although empty spaces in the materiality of nervous tissue, nevertheless play a critical role in nerve function. One of the most puzzling aspects of the hunt for neurotransmitters has been the realization that the majority of active chemicals bear a molecular structure indistinguishable from substances found in plants.

Another significant development to occur, and the one that really opened the field, was the discovery that brain function could be observed in an alert subject by tagging one of the brain's various fuels with a radioactive isotope. After injecting it into the subject's arm, the brain could be examined by observing on a scanning device which areas in the brain "lit up" when the subject was asked to perform a task. Brain scans have provided an invaluable window into the black box. The number and type of brain scans has proliferated at an astounding rate, with each one monitoring a slightly different aspect of brain activity in real time.

The newest most exciting advance in studying the brain has emerged from the field of genomic research. Since the DNA code was broken a little over half a century ago, the pace of research has logarithmically accelerated. Recently, research scientists have begun to identify the specific genes that control aspects of human behavior. The discovery that the gene FOXP2 is responsible for language not only provides scientists with a dramatic new tool for understanding this key human attribute, but it also opens a window into the past. Knowing when the gene appeared, and in what species, gives researchers new insights into the age-old question as to when human speech began. The field is in its infancy, but mapping the genes that determine different kinds of mental functioning has opened an entirely new field of neuroresearch.

The development of the computer and then the Internet had a profound impact on human culture. An entirely new set of metaphors and conceptual models concerning how information is transmitted, interpreted, processed, and stored came into being. In one sense, both the brain and computers are information-processing devices, and the intense resources devoted to the progress of computer networks provided cognitive neuroscientists with new models and metaphors with which to think about consciousness. Neurons and wires are not very different from each other; neither are transistors and synapses. The intense effort to develop artificial intelligence has increased our understanding of neural networks because at its core, AI is but an attempt to improve artificially what the brain already does effortlessly.

All of these models provide us with insight into the working of our subject Leonardo's brain.

CHAPTER 5

Leonardo/Renaissance Art

The dragonfly flies with four wings, and when the anterior are raised, the posterior are dropped. However, each pair of wings must be capable individually of supporting the entire weight of the animal.

—LEONARDO DA VINCI

This book is not concerned with Leonardo as an inventor, but his studies of flight have a bearing on his art because they prove the extraordinary quickness of his eye. There is no doubt that the nerves of his eye and brain, like those of certain famous athletes, were really supernormal, and in consequence he was able to draw and describe movements of a bird which were not seen again until the invention of the slow-motion cinema . . .

—KENNETH CLARK

Ted Williams, the legendary baseball player renowned for his extraordinary ability to hit a ball, used to claim that he could see the seams on a pitched baseball.

—BÜLENT ATALAY

LEONARDO'S WORKS WERE SO BREATHTAKINGLY BEAUTIFUL AND SHOW-stoppingly original that during his life, many artists, art lovers, and the just plain curious journeyed considerable distances to gaze in wonder at his paintings and sculpture. A few were lucky enough to have Leonardo give them a glimpse of the drawings in his notebooks. His influence

43

on Renaissance artists was profound, and his innovations subsequently appeared in many of his contemporaries' works.

Leonardo-mania continued long after his death. Artists and art lovers from all over Europe traveled to Italy and France to study his masterpieces. From diaries, letters, and the very visible record that these "pilgrims" left behind, both in the unabashed reproductions of Leonardo's paintings or in their own art, art historians have been able to trace Leonardo's impact on their works. To name but a few, Raphael, Peter Paul Rubens, and Albrecht Dürer enthusiastically adopted many of Leonardo's novel techniques.

The term *avant-garde,* a French military expression, refers to an army's most forward advancing unit. Exposed to the greatest risks, it leads the charge. Art historians have co-opted this idea to describe artists who break away from their era's conventions and initiate a new style of art. Had such a term existed in the Renaissance, Leonardo would have certainly been considered an innovative painter by his fellow artists. Nevertheless, few art historians catalog in their entirety how many of his innovations foreshadowed the signature styles of modern art that so discombobulated the art world of the late nineteenth and entire twentieth century.

When looking for precedents for the revolutions wrought by Édouard Manet, Claude Monet, Paul Cézanne, Eadweard Muybridge, Pablo Picasso, Georges Braque, Marcel Duchamp, Giorgio de Chirico, Salvador Dalí, René Magritte, Max Ernst, Jackson Pollock, Robert Rauschenberg, Henry Moore, and many others, art historians rarely extend their purview beyond several earlier generations of painters. Moreover, in the above artists' written notes, interviews, and biographies (with the exception of Max Ernst), none mention that the breakthroughs for which he became famous were influenced by any Renaissance painters.

Yet, as the following parallels between Leonardo's works and modern art will demonstrate, no other artist in history incorporated so many concepts into his images that would remain dormant for hundreds of years only to reappear in the context of what we have come to characterize as Modernism. Like his scientific discoveries, Leonardo's art exhibited an uncanny prescience that as yet lacks any compelling explanation. Before describing the aspects of Leonardo's art that foretold the advent of

modern art, it's important to consider the innovations that immediately affected artists in his own time.

At the age of twenty-one, Leonardo paused on a hill overlooking a valley near his hometown of Vinci. Moved by the sheer beauty of the scene, he used pen, ink, and some watercolors for shading to quickly sketch in that fleeting moment all that his restless eye surveyed (*Val d'Arno*) [Fig. 2].

In the thousands of years preceding Leonardo, beginning with the cave paintings of southern France and continuing on into the distinctive styles of art created in ancient Egypt, Mesopotamia, Harrapa (Indus Valley, India), Classical Greece and Rome, Mesoamerica, Medieval Europe, and the High Middle Ages, the background was never the sole subject of a work of art. Previously, human figures, their godlike avatars, or animals dominated the focus. Artists often treated the background as if it was, well . . . background.

In contrast, Eastern artists had made the elements of nature and their harmonious relationships the predominant subject of Asian art. In practically all of their major landscape scenes, an identifiable human element is present—small and insignificant, to be sure, but nearly always discernible in some part of the composition. The artist reminds the viewer of the insignificance of man compared to the majesty of nature. Generally, the Western artist adopted the exact opposite position: The focus was on the figures in the foreground—until Leonardo.

No identifiable human exists in Leonardo's 1473 drawing of Val d'Arno. Although there are some tiny man-made dwellings barely visible far in the distance, it does not appear that he intended to make a statement similar to the kind for which Eastern artists strove. Leonardo simply desired to make nature, not humankind, the subject of his composition. This hastily drawn but elegantly executed landscape is the beginning of the flood of landscape paintings destined to grace the walls of numerous hotel rooms, school hallways, museum walls, and collectors' dens in the succeeding centuries.

Half a century later, the German painter Albrecht Altdorfer painted in oils the first Western landscape completely devoid of any animal, human, or supernatural personage (*Danube Landscape near Regensburg,*

1522–25). Art historians generally honor Altdorfer with the pride of primacy as the first Western landscape artist. It is not known whether or not Leonardo's earlier work had any influence on Altdorfer. If art historians tabulate the enormous number of landscapes painted since Leonardo's pen-and-ink drawing, and the total absence in Western art of this genre before his sketch, it seems reasonable that they would accord a special honor to his work located at a critical hinge point in art history.

Leonardo's sketch is all the more impressive when one considers that the three monotheistic Western religions, Judaism, Christianity, and Islam, had a very contentious relationship with depictions of nature. They had supplanted earlier "pagan" religions, each of which worshipped nature and venerated sensuality, fertility, and sexuality. Abrahamic religions, in contrast, worshipped an incorporeal deity who occupied an ethereal realm existing above and outside of nature. These religions believed their deity was the *creator* of nature rather than viewing nature as a manifestation of deity, which was the core of all earlier systems of belief. The three Western religions, firmly rooted in the written word, denigrated nature because the so-called "pagan" beliefs competed with the newer, monotheistic doctrines. Early adherents banished flowers and plants from the interior of any synagogues, churches, or mosques.

It is not a coincidence that the second commandment, the second most important rule of righteous living, proscribes the making of images—and not just graven images, but images of anything:

> *Lest ye corrupt yourselves, and make you a graven image, the similitude of any figure, the likeness of male or female, the likeness of any beast that is on the earth, the likeness of any winged fowl that flieth in the air, the likeness of any thing that creepeth on the ground, the likeness of any fish that is in the waters beneath the earth. (Deuteronomy 4:16–18)*

Authorities representing the principal Western religions considered any likeness created by the human hand depicting any aspect of nature an "abomination," because it could possibly detract from the worship of an invisible deity. "Thou shalt make no images" is the gist of the Second Commandment,

and "Thou shalt not kill" is the sixth. Question: Why did the West's three major religions all rank art more dangerous than murder?

Following the fall of the Western Roman Empire in the fifth century AD, and for the next four hundred years—sometimes referred to as the Dark Ages—the approximate literacy rate of Western Europe fell to 1 percent. This, then, was the quandary: If the population remained essentially illiterate, by what means could the ecclesiastical class inculcate the tenets of the struggling Christian religion?

Pope Saint Gregory the Great (590–604) effectively annulled the Old Testament's Second Commandment, but insisted that the Church—the primary dispenser of commissions—play the leading role in censoring what exactly the artists chose as proper subjects for their art. In the midst of the heavy religiosity that still characterized much of the Renaissance, it took a mold-breaking sensibility for an artist to focus on the pleasing arrangement of rocks, hills, trees, and distant vistas. And, Leonardo drew it in flawless perspective.

The signature breakthrough in Renaissance art was the artists' discovery of perspective. It allowed them for the first time to place the objects in their increasingly complex compositions in an orderly hierarchy that closely approximated normal vision. The fourteenth-century master painter Giotto di Bondone had intuitively understood how modeling and superpositioning could create the illusion of depth, but some aspects eluded even this great painter. In his rendering of the Pentecostal dinner, Giotto could not solve the perspectivist problem of how those apostles sitting in the foreground were to eat their meal through their solid halos.

The next important figure to advance the development of perspective was Filippo Brunelleschi. His fame is forever established as the builder of the colossal dome of the cathedral of Santa Maria del Fiore in Florence. Among his other achievements was his invention of a method for drawing a scene with its objects in their proper perspective. Around 1415, he used an ingenious arrangement of mirrors—one had a peephole through which he could peer to create the first geometrically correct perspectivist drawing using a device.

Seventeen years before Leonardo's birth, another architect/engineer, the polymath Leon Battista Alberti, published a formal treatise on the subject in 1435. Alberti laid out for artists the steps they needed to master if they were to convey the sense of realism hitherto lacking in previous complex compositions.

Almost overnight, perspective became the very lodestone that set the direction for Western art. For nearly five hundred years, all Western artists agreed that *this* was the way to organize a painting. An artist could stray from the rules of perspective intentionally, but these were minor deviations from the main theme that ran through Western art from the onset of the Renaissance to the modern era.* Critics considered an artist unschooled if the art of perspective was amateurish, and it was one of the early skills mentors insisted that young art students learn.

Vasari relates the story of one of the Renaissance greats, Paolo Uccello, who spent hours poring over his studies concerning the intricacies of perspective. One night, his frustrated wife urged him to pull himself away from his drawing board and come to bed. Going reluctantly, as if leaving a lover of superior allure, he was reputed to have muttered as he trundled off, "Ah, perspective, what a lovely thing it is."

Chiaroscuro became a painterly technique that accentuated lighted surfaces while simultaneously casting shadows darker than they would normally appear. Artists such as Michelangelo, Caravaggio, and the Dutch painter Johannes Vermeer used chiaroscuro with great effect in their works. The combination of perspective and chiaroscuro greatly enhanced the realism of Renaissance paintings.

Leonardo made many contributions to the art of perspective, but the one for which he is the most famous was his refinement of chiaroscuro, known as *sfumato*. The Italian term translates as "turning into smoke." Leonardo observed that due to atmospheric haze, the borders of far-distant objects appear less distinct than those that are closer to the foreground. Distant objects' colors were less crisp and their shadows less

* Occasionally an artist like the eighteenth-century Englishman William Hogarth purposely violated the rules of perspective to create compelling optical illusions. One of his titles, *Satire on False Perspective,* belied his tacit recognition that the absurdities he introduced into his picture plane reaffirmed his recognition of the importance of perspective to the Western artist.

sharp. He greatly increased the effect of perspective by painting distant scenes as if viewed through a layer of gauze, making them less colorful than those in the foreground. Although he was not the first artist to make this observation regarding the nuances of perspective, Leonardo's mastery of *sfumato* so surpassed any other artist that his name is inextricably associated with the technique.

While working at the French court, Leonardo's familiarity with perspective led him to invent *anamorphism*, a form of painting that distorts perspective so that the anamorphic (distorted) object, when viewed in the conventional manner from the front of the painting, appears either grossly distorted or as it would appear in a funhouse mirror. In most cases, an anamorphic image embedded in a painting is unrecognizable. When viewed from an extreme angle off to the side, however, the anamorphic object springs out of what is a markedly distorted main image to appear realistically drawn.

Only someone keenly aware of the laws of perspective and optics, and who possessed an intuitive grasp of algebra, could create such a picture. Anamorphic technique was very difficult to execute. As Leonardo's example of anamorphism appeared in his notebooks, it is not presently known whether his technique was disseminated out into the artistic community after the pages of his notebooks circulated, or whether the artists employing this technique invented it independently. What is known is that Leonardo's simple line drawing constituted the first anamorphic image in Western art.

Given Leonardo's perfectionist bent and curious mind, it should come as no surprise that he expended untold hours and a considerable number of pages studying the optical science behind perspective. He filled his notebooks with exacting sketches of buildings and other objects drawn within the overlay of a perspectivist grid. Here, then, is a mystery: In his written notes, he exhorts artists to adhere to the rules of perspective and in many instances explains in detail just how they are to accomplish this goal. Yet, this master of the technique routinely violated the rules he so painstakingly explained. As early evidence for the adage "Rules are meant to be broken," Leonardo's tampering with perspective was so artful that instead of detracting from his compositions, it enhanced them.

Leonardo crafted numerous sleight-of-hand perspectivist idiosyncrasies in his *The Last Supper* (1495–97) [Fig. 3]. The site selected by the monks for the enormous fresco was in the refectory, high on the wall behind the table where the monks took their meals. The painting had to be viewed from below, yet Leonardo strove to achieve the effect that the viewer was looking upon a scene that was essentially at eye level. In art critic Leo Steinberg's book, *Leonardo's Incessant Last Supper*, he enumerated multiple examples in which Leonardo contorted perspective to enliven his most complex masterpiece. None were clumsy mistakes, as Steinberg points out, but rather thoroughly planned tinkering that Leonardo used to make his composition work within the constraints of the rectory's room.

For example, the table has thirteen individuals sitting at it, yet it seems to only have eleven place settings. Johann Wolfgang von Goethe wrote an authoritative essay on *The Last Supper* in which, taking note of the foreshortened table, he commented wryly that if any of the apostles who were standing in the painting decided to sit down, they would find themselves in the lap of another apostle. The figure of Jesus is one and a half times larger than his dinner companions, though this distortion of perspective is only evident after close scrutiny. The room in which the action takes place appears at first glance rectangular. Looked at another way, it becomes an expanding trapezoid.

Leonardo intuited that a person's face, despite appearing symmetrical, is actually divided into two slightly different halves. Because of the crossover in sensory and motor nerves from each side of the face within the brain, the left hemisphere controls the muscles of the right side of the face and the right hemisphere controls the muscles of the left side. The majority of people are left-brained/right-handed, which means that the right half of their face is under better conscious control than their left. In contrast, the left half of the face connects to the emotional right brain, and is more revealing of a person's feelings. Right-handers have more difficulty trying to suppress emotional responses on the left side of their face.

In a recent psychology experiment, a group of unsuspecting college students were ushered into a photographer's studio one at a time and informed that they were to pose for a picture to be given to members

of their family. The majority of these right-handed students positioned themselves unaware that they were turning the left side of their face toward the camera's lens. All of them smiled.

Brought back a second time, the researchers informed them that, now, they were to pose for a job application photo. In this case, they adopted a more professional demeanor, and the majority of right-handers emphasized the right side of their face. The results of this experiment, along with several others of similar design, strongly suggest that unconsciously, most people know that the right side of their face is best to present to the outside world. They are also subliminally aware that their left side is a more natural reflection of who they really are.

Leonardo understood these subtleties of expression. *Mona Lisa* is best appreciated by observing the left side of her face. Heightening the ambiguity of her smile, Leonardo chose to highlight the right side of her face and place the left in shadow.

Leonardo initiated several other innovations that now seem so commonplace we have difficulty imagining just how revolutionary they were to their time. Earlier portrait painters included only the sitter's upper chest and head. In the mid-fifteenth century, a few Flemish artists began to widen the focus to include the subject's hands. The historical evidence is unclear as to whether or not Leonardo saw examples of what his northern colleagues were doing, or if he arrived at the notion of including hands in his portraits independently. Nevertheless, Leonardo took full advantage of this enlarged scope, recognizing more fully what had escaped the attention of the earlier Flemish painters: the importance of gesture.

Leonardo's accentuation of a subject's hands was an elegant substitute for the expressiveness of speech. Oral human communication is a complex combination of speech and body language. The ear and the eye work in concert to ferret out the true meaning of the speaker's message. Speech is received by the ear, and the left brain busily attends to the linear arrangement of incoming words transmitted by the inner ear. The listener gathers revealing information by assessing the speaker's facial expressions, his or her clothes, grooming, body language, and hand gestures, along with those involuntary reflexes that cause, on occasion, pupil dilation,

perspiration, or blushing. In some cases, gesture is superior to speech. Ask anyone to describe a spiral staircase. As their words falter, their hands will invariably trace a corkscrew motion that more accurately conveys the concept better than either the spoken or written word can. Psychology researchers estimate that listeners decipher as much as *80 percent* of a message from nonverbal clues.

Portraits cannot speak. Leonardo sought a way to express with a brush the essence of his subjects' personae. Including hands in his portraits was an important part of Leonardo's dictum that the artist must not only reproduce a faithful copy of his subject, but must also try to depict the subject's state of mind.

In a portrait he completed soon after arriving in Milan (*Lady with an Ermine*, c. 1489), that of Sforza's sixteen-year-old mistress, the beautiful Cecilia Gallerani, he intentionally elongated the fingers of her hand [Fig. 4]. Combined with her narrow face, her fingers accentuate her willowy form. He also painted her holding an ermine, the name of which is connected symbolically to the House of Sforza. Additionally, the small mammal had a reputation for fastidious cleanliness, a metaphor that extolled Cecilia Gallerani's wholesome nature. And the Greek word for ermine is *gallan*, another clever play on words and images that Leonardo used to insinuate her family name into the picture. By positioning his subjects' hands just so and sometimes giving them something symbolic to hold, Leonardo augmented their facial features and increased the viewer's access to the subject's inner state of mind.

In the middle of the nineteenth century, a Swiss draftsman, Rodolphe Töpffer, extensively examined the nuances of caricature.* Art historian E. H. Gombrich grants Töpffer pride of place as the father of this form of art. Caricature was but another new form of visual communication, an alternative means to convey emotions and viewpoints. Cartoonists make us laugh, satirists make us think, and the political cartoonists' daily offerings are often more penetrating than the editorials appearing alongside

* *Caricature* is named after the Italian artist Agostino Carracci, who, around 1600, created images of faces that were distorted. At the time, only a few artists were aware of Leonardo's work. Although we cannot know for certain, it is not unreasonable to speculate that Carracci, who lived and worked in nearby Bologna, would have known of Leonardo's work.

them. Töpffer's tribute aside, Leonardo can rightfully lay claim to being one of history's greatest caricaturist. He filled his notebooks with drawings of faces he distorted, emphasizing prominent features while minimizing others—the essence of caricature. His drawings in this genre zigzagged the fine line separating the grotesque from the comical. No previous artist had exaggerated human faces to the extent that Leonardo had.

Landscape painting, *sfumato,* anamorphism, caricature, the inclusion of hands in portraits, and sophisticated observations concerning facial expressions are among the innovations that Leonardo slipped into the Renaissance's swelling art stream. Leonardo profoundly affected the art of his time, and his influence extended far and wide among the generations of artists that followed him. But, another aspect of Leonardo's art, not as thoroughly chronicled, was his uncanny ability to invent the principles that undergird modern art. How did a Renaissance artist anticipate so many of the explosive and revolutionary art movements that have come to define "modern art"?

CHAPTER 6

Renaissance Art/Modern Art

If the body of every feeding thing continually dies and is continually reborn, how can that art be "most noble" which can engrave or paint only a single moment?

—LEONARDO DA VINCI

He was like a man who awoke too early in the darkness while everyone else was still asleep.

—DMITRY MEREZHKOVSKY

There is in great art a clairvoyance for which we have not yet found a name, and still less an explanation.

—JOHN RUSSELL, ART CRITIC

THE FIRST ARTIST IN THE MODERN WORLD TO RESURRECT LEONARDO'S innovations was Édouard Manet. Following a span of nearly half a millennium, during which artists obediently conformed to rigid guidelines concerning perspective, composition, and subject matter, Manet was in the vanguard of a new generation of artists who acquired their skills outside of the influential French Beaux-Arts Academy. In 1859, the twenty-seven-year-old artist stood before his works and destroyed nearly everything he had painted up to that point. He announced to his startled friends, "From now on I will be of our times and work with what I see." But the new works that he created met with a withering reception. With a few notable exceptions, critics delivered harsh verdicts, criticizing his paintings as clumsy and unpolished.

Acceptance for artists at this time in France depended upon winning a cherished spot to show their art in the prestigious annual Salon, and it was the grand old graybeards of the Academy who made up the jury of this much-anticipated public event. But change was in the air, and many younger artists decried the selection process, suspecting that it was heavily biased against them. Rebelling against repeated rejections, in 1863 they defiantly organized a parallel art show nearby, naming it the *Salon des Refusés* (Salon of the Rejected).

Manet exhibited several major works, but his centerpiece was *Le Déjeuner sur L'Herbe* (*Luncheon on the Grass*, 1863) [Fig. 5]. It was a shocking composition. He positioned his favorite model, Victorine Meurant, nonchalantly sitting *sans* clothes upon a picnic blanket while staring impudently at the viewer. Alongside her, two men in business suits discourse on some subject; but, adding to the unsettling aspect of the painting, they not only seem oblivious to the naked woman sitting next to them, but they are not even looking directly at each other. The critics savaged the painting. People came and laughed at its composition. Nevertheless, *Le Déjeuner sur L'Herbe* drew the largest crowds and garnered considerable ink in the newspapers.

The criticisms leveled at *Le Déjeuner* were that it was not picturesque, nor did it seem to have any symbolic reference to virtue, mythology, history, or religion. Increasing the tension, Victorine's clothes lay in a pile in front of her. The recent popularity of photography had made pornographic images ubiquitous. In France, the art-savvy public acknowledged that the nude belonged to a genre of high art, but a naked woman represented pornography. Among Manet's other painterly sins was his disregard of perspective. The figure of the woman bathing in the background would have to be about nine feet tall if she was corrected for perspective. Further, Manet played fast and loose with the direction of the light source and the position of shadows.

Critics attributed these flaws to Manet's lack of a formal École des Beaux-Arts' education, or simply wrote them off to a sad dearth of talent. Manet, however, was a master draftsman and was well acquainted with the intricacies of perspective; he disobeyed those rules purposely to increase the painting's interest. Manet's alteration of perspective compares

to Leonardo's. Both artists clearly understood that this optical technique could be manipulated to produce a dramatic effect in the painting. In this way, both men are markers at each end of perspective's hold on the imagination of Western painters.

While art history books have repeatedly documented the brouhaha over *Le Déjeuner*, less well known is that Manet had positioned an equally outrageous work on the adjoining wall: *Mademoiselle V . . . in the Costume of an Espada* (1862). As the viewer walked from one wall to the next, the juxtaposition of the same model, naked in one painting and cross-dressed in the most macho outfit imaginable in the other, increased their visual shock. But, Manet further discombobulated his viewers by cutting the ground out from under his matadoress. (As we shall see later, Manet's use of sexual ambiguity was also a key feature of Leonardo's paintings.) Given the background information, she is obviously positioned in a bullring, but Manet obscures where exactly she is standing. She appears suspended in midair!

In many of his other paintings, Manet again placed his solitary figures with minimal or contradictory perspectivist clues (*The Fifer, Woman with a Parrot,* and *Dead Toreador*). Similar to Manet's female matador, the viewer is unsure where exactly these figures in the foreground are in relationship to their background. Leonardo's last painting, *St. John the Baptist* (discussed in the following chapter), is completely devoid of any background that could assist viewers in knowing where the saint is standing. In between Leonardo and Manet, there were no artists who painted figures without background clues.*

In the first half of the nineteenth century, great strides were made in chemistry that led to the manufacture of oil paints that could be stored in aluminum tubes. Colors became brighter and more stable, and a greater number of hues were available commercially. These advances relieved artists from the tedious task of having to mix and compound their own paints from scratch. In the early 1870s, the portability of paints and the invention of the folding easel led French artist Claude Monet to abandon his

* Many of Rembrandt's portraits seem similarly devoid of background clues, but close inspection reveals something in the background that helps to locate the subject of the painting.

studio and venture out into the countryside to begin to paint his subjects and landscapes *en plein air*. This change in locus constituted a revolution. Rather than plan, study, and labor over preparatory drawings and paint compositions in the confines of often poorly lit studios, Monet moved outdoors to paint the objects and scenes he saw with greater immediacy in their natural settings.

Monet strove to capture on canvas the evanescent moment of his first impression, and critics dubbed his technique *Impressionism*. There were no artists in the preceding several centuries that had ever experimented with a similar technique. But should not Leonardo's 1473 sketch of the Tuscan countryside *en plein air* qualify as the first Impressionist work in Western art history? A full four hundred years earlier, Leonardo had anticipated this great movement of art of the late nineteenth century.

Another giant among *fin de siècle* artists was Paul Cézanne. He began a series of still lifes in the late 1880s that differed from those painted previously by Western artists. Viewers and critics stood before them baffled as to how to correctly "read" them. The problem: They tried to view Cézanne's work within the hidebound framework that had been the accepted norm for hundreds of years. Cézanne painted each object in his compositions as if it was viewed from a different angle. Essentially, Cézanne's still lifes afforded the viewer the opportunity to see multiple views *simultaneously*. Cézanne's eccentric reading of perspective set the stage for a much more radical revolution.

In 1904, the twenty-two-year-old Spanish artist, Pablo Picasso, moved to Paris and teamed up with another young artist, Georges Braque. Together they rocked the art world to its foundation by introducing a new way to see art that radically broke with everything that had come before. Picasso outrageously declared, "We must kill modern art."

The critic Louis Vauxcelles acidly criticized Picasso's and Braque's new style by claiming that their paintings resembled a jumble of "little cubes." The name Cubism stuck. Despite its initial hostile reception by many art critics and art lovers, Cubism took the art world by storm. Critics alternately fumed or waxed hyperbolically that, even taking into account Cézanne's earlier intimations, nothing like it could be found in the work of any previous artist.

Pablo Picasso was once asked in a train compartment by a fellow passenger why he did not paint people "the way they really are." Picasso asked what the man meant by the expression. The man pulled out a snapshot and said, "That's my wife."

Picasso responded, "Isn't she rather small and flat."

Perhaps confident that they would not find a lone Renaissance artist who had anticipated the Cubist movement, art critics did not search far enough into the past. Leonardo, like Cézanne, Picasso, and Braque, felt constrained by the monocular view demanded by perspective. He sought a way to show multiple points of view of the same object, simultaneously. He needed a better way to envision the relationships of parts to the whole, and to each other. It was Leonardo's anatomical dissections that provided the impetus for such an optical trick. Leonardo was the first artist to make comprehensive illustrations of the interior of the human body. Although technical in nature, they are masterpieces of art by any standard, and many art historians have not hesitated to call them just that.

He solved the problem of how to demonstrate the many different sides of an anatomical feature simultaneously and the relationship of parts to contiguous structures by inventing the *exploded view*. Leonardo drew the same object on the same page but rendered it from different angles of vision, thus allowing a viewer to envision simultaneously multiple aspects of the same object. There is an uncanny similarity between Leonardo's anatomical drawings and Picasso's and Braque's Cubist paintings. At the heart of all of these works is the principle of conveying information about an object's *suchness* (to borrow a term from Zen).

Leonardo's art tilted more to his dissections' scientific needs than the art of the Cubists, who were more interested in artistic deformations of familiar objects. Leonardo, in his anatomical drawings, Cézanne in his still lifes, and Picasso and Braque in their Cubist paintings, all wrestled with a new way to portray visual information outside the cage of cyclopean perspective. All of their solutions were stunning and revolutionary; they also all revolved around the same principle. In

the vast expanse of years that intervened between Leonardo and the turn of the twentieth century, *no* other artists had tackled this problem.*

Another similarity between the innovations of Cézanne and Leonardo concerns Cézanne's desire to capture the essence of one mountain in Provence: Mont Sainte-Victoire. He understood that he could not convey the mountain's *suchness* by painting it only from a single point of view. During the 1890s until the time he died in 1906, Cézanne painted a series of views of the mountain from different locations. The total effect of these combined paintings was to convey a holistic view of the mountain. No Western artist had ever conceived of this method of showing the differing aspects of the same object as seen from different angles—except one.

Five hundred years earlier, Leonardo had invented a method to do just that. In his anatomical drawings he depicted sequential renderings close together of the shoulder but visualized from different angles [Fig. 6].

From the Bavarian countryside, Russian-born artist Wassily Kandinsky initiated an innovation that would dominate twentieth-century art. Like many great discoveries in both art and science, his breakthrough was serendipitous, but it occurred in a mind prepared to look at the world in a fresh way. Alone in his studio one day in 1910, Kandinsky became increasingly dissatisfied with his efforts to force the painting he was working on to conform to the vision that existed in his mind. Frustrated, he decided to take a break and go for a walk. Just before leaving, for no particular reason, he absentmindedly turned the painting on its side.

Returning later, Kandinsky, deep in thought about some other subject, paused in the doorway and, looking up, caught a glimpse of his work in progress. For a moment, he stood there, puzzled, unable to recognize it. Then he remembered that he had turned the work 90 degrees. Upon reflection, Kandinsky realized he was more engaged by *not* being able to make sense of what he was looking at. He alternatively experimented with examining his work right side up and turning it on its side. Kandinsky finally concluded that the painting was more interesting when he could not affix a name to a familiar image. So began abstract painting.

* Between 1826 and 1833, the Japanese artist Hokusai predated Cézanne by painting thirty-six views of Mount Fuji in his famous Ukiyo-e series.

Leonardo, too, was interested in the nature of abstract designs. In his *Treatise on Painting* (not published until 1651), he spoke of a method "of quickening the spirit of invention." He advised artists:

> *You should look at certain walls stained with damp, or at stones of uneven colour. If you have to invent some backgrounds you will be able to see in these the likeness of divine landscapes, adorned with mountains, ruins, rocks, woods, great plains, hills and valleys in great variety; and expressions of faces and clothes and an infinity of things which you will be able to reduce to their complete and proper forms. In such walls the same thing happens as in the sound of bells, in whose stroke you may find every named word which you can imagine.*

A new kind of abstract painter emerged after World War II in the United States. Jackson Pollock, the leading proponent of the school of "action painters," had set for himself the daunting task of representing on canvas the essence of the *process* of painting.

The verb "to paint" describes an artist holding a paint-soaked brush, making repetitive strokes on a surface. How could someone represent what is essentially a motion on what would eventually become a static canvas? Pollock's solution was pure genius: He discarded his brushes and placed his canvas on the floor. He exaggerated the delicate movement of the typical artists' wrists and fingers by flinging, dripping, and throwing the paint. The resulting pattern of colors amid tangled skeins of paint, although appearing chaotic, paradoxically possessed a strange unity and beauty.

Critics have hailed the abstract painters as true revolutionaries who blazed a trail in an area where no Western artist had gone before. But has their assessment left someone out? Near the end of Leonardo's life, he began to experiment with art lacking a recognizable image. In a melancholy mood of his failing fortunes, health, and the many reverses he had suffered, his mind turned to imagining how the world would end. He began an apocalyptic series of pen-and-ink drawings that were his rendition of the great flood that would wash away the evils to which mankind, in Leonardo's view, was so inextricably entwined.

In these fantastic drawings, Leonardo blurred the distinctions between objects and patterns. The walls of falling water that Leonardo envisioned engulfing the world in this series, when aligned alongside Jackson Pollock's *Autumn Rhythm (Number 30)* (1950), reveal an astonishing similarity. Further, Leonardo's recommendation to other artists to throw a paint-soaked sponge at a wall presages Pollock's paint-flinging method by centuries.

Leonardo also preceded by half a millennium a novel art movement that arose from a genteel argument concerning the manner in which a horse runs. In 1872, Leland Stanford, railroad magnate, founder of Stanford University, and racehorse aficionado, engaged in a lively dispute with several other owners of thoroughbreds. The question: Does a galloping horse have one of its four legs in contact with the ground at all times, or is there a moment when the horse is completely airborne? Bets were placed, and to settle the wager, the equestrians called upon Eadweard Muybridge, a noted photographer. He positioned a series of cameras along the side of a racetrack and then rigged them with strategically placed trip wires. Muybridge produced a series of still photographs revealing that the positions of the galloping horse's legs were unexpectedly different from how generations of artists had imagined them.

Artists typically rendered a galloping horse with its two forelegs extended forward and both rear legs extended backward, with none of them touching the ground.* Muybridge's experiment proved without a doubt that a horse in motion has all four of its feet off the ground, if only for an instant. Stanford's original challenge led eventually to the invention of the motion picture. Muybridge's work attracted the attention of Thomas Edison and William Dickson, and, in 1888, the two inventors produced the first motion picture camera. In the same time span a French physician and photographer, Étienne-Jules Marey, and his countrymen, the Lumière brothers (Auguste and Louis), also contributed to the development of film independently of Muybridge. Using the technique of time-lapse photography, all of these pioneers studied the motion of bodies in time and space.

* Leonardo incorrectly drew a horse with two legs forward and two legs back.

Master of the future, Leonardo anticipated all of their ideas and innovations. The artist was in his fifties when he began making preparatory sketches for his work, *Leda and the Swan*. He experimented with a series of poses wherein, when placed side by side, Leda rises from a kneeling position to a full upright one. If these drawings were to be placed one in front of the other in sequence, they would create a flipbook that would reveal Leda moving in time.*

Leonardo employed a similar technique in his anatomical drawings. As noted earlier, seeking a means to illustrate multiple views of an anatomical part, such as the shoulder and upper extremity, he drew it in multiple views presented on the same page, as if the viewer were moving around the object. If these drawings were arranged to run together at flicker fusion, the result would be similar to what one sees in a motion picture.**

Leonardo's studies concerning multiple positions in time joined to sequential views of space, found in both his *Leda* sketches and his anatomical illustrations, qualify him as the originator of the principle of cinematography. In his anatomical studies of the shoulder and his *Leda* studies, Leonardo explored the ideas that were central to the invention of the movie camera, half a millennium prior to the point when inventors working in different countries arrived at the same solution.

Leonardo left an unusually high number of his works unfinished. Art historians have offered many plausible reasons for why this peculiar habit so afflicted him. Among them is one that does not reappear until the advent of modern art: An unfinished canvas forces viewers to complete it using their own imagination. The very power of Leonardo's *Adoration of the Magi* (1481) [Fig. 7] and his *St. Jerome* (1480) [Fig. 8] can be partially attributed to their state of incompleteness. Not until Paul Cézanne, working in the 1880s, and Henri Matisse, working in the early 1900s, would other Western painters purposely leave empty reaches of a canvas bare with the intent of letting the viewer fill them in.

* Leonardo's original painting was ordered burned by a prudish French noblewoman who felt the work was too lascivious, but we know how it appeared, both from Leonardo's extensive preparatory drawings contained in his notebooks and the copies followers made of it.

** Flicker fusion is the speed that a series of stills must pass before a projector to create the impression of a motion picture film.

Carrying *sfumato* to an extreme, Leonardo began to blur the distinction between figure and ground by blending, ever so subtly, the borders of his figures with the surrounding ground. As his work progressed, it became increasingly unclear where one began and the other ended. Previous artists prepared their compositions by outlining the figures in black and then filling in the borders with color. This tended to give their paintings the appearance of a stage filled with cardboard cutouts superimposed upon a perspectivist background. Leonardo abandoned the outlining technique, and by subtly blurring the border between background and foreground, he gave his paintings a more realistic yet otherworldly quality that made them unique. Leonardo introduced a principle into his art that had been previously considered poor workmanship. The principle was painterly ambiguity, and he began using it at a time when artists were striving to achieve the exact opposite—leaving nothing to the imagination by meticulously painting every detail.

In his *Treatise on Painting*, Leonardo proposed that the boundary of a body is neither a part of the enclosed body nor a part of the surrounding atmosphere. Yet despite his observation, painters and viewers alike remained sure that the boundary did lie on this crisp margin. Five hundred years later, Henry Moore understood that the sharp boundary between the mass of an object and the negative space around it was an illusion, and he expressed this difficult idea with smooth-flowing statues, such as *Internal and External Forms* (1953–54), in which the space pours into the mass, and, conversely, the mass surrounds empty space so the distinction between inside mass and outside space is blurred. Moore required that the viewer at some level integrate the notion that space admixes with mass; both affect each other and seem to inform each other. The rare physicist who could understand Einstein would have to have reached the same conclusion. Leonardo grasped the principle five hundred years earlier.

Leonardo was an artist who loved paradox. He wrote books of riddles and presented paradoxical-themed poems at court. The boulders forming the ceiling of the cave in his *Virgin of the Rocks (Madonna of the Rocks)* [Fig. 9] resemble René Magritte's boulder in the sky. And the puzzling battle between two men on horses in the background of his *Adoration of the Magi* is an example of paradox that Magritte would heartily admire.

In 1915 the psychologist Edgar Rubin introduced the public to his familiar optical conundrum of a vase versus the outline of two faces in profile [Fig. 10]. Rubin used it to examine how the human visual apparatus distinguishes between figure and ground.

When Rubin asked subjects to concentrate on seeing the two faces, they could not see the vase. When they were instructed to visualize the vase, the faces mysteriously disappeared. It became impossible for all but a rare few to see both images at once. Rubin's work concerning visual perception had implications for artists and their public.

Rubin was the first scientist to make a thorough study of the nature of dual readings of the same image. For four hundred years, the subjects of compositions might have suggested ambiguous themes or symbolism, but painterly ambiguity of the kind Rubin had identified played no role in art for centuries following the Renaissance. The principle of ambiguity—and, in particular, the ambiguity associated with dual readings, in contrast— became one of the defining constructs of Modernism.

The Spanish painter, Salvador Dalí, converted Rubin's scientifically expressed principle into a work of fine art. In his *Slave Market with the Disappearing Bust of Voltaire* (1940), a woman in the foreground looks upon a scene in the slave market where people interact in front of an arched doorway. The two clerics dressed in black-and-white cassocks form the face (eyes, cheekbones, chin, and neck) of the French philosopher Voltaire as he was portrayed in a bust sculpted by Jean-Antoine Houdon in 1781. The archway forms the top of Voltaire's head. Dalí created a highly sophisticated version of Rubin's vase and two faces. One can either see the face of Voltaire or the two clerics walking through the archway. One cannot, however, see both at the same time.

In seeking precedents for this kind of *trompe l'oeil* (the expression means "fool the eye"), we would find almost none before the modern age except for one artist who played with this optical illusion. As Leo Steinberg pointed out in *Leonardo's Incessant Last Supper*, Leonardo painted the moldings on the wall in a manner that re-creates Rubin's visual puzzle. Similar to the familiar Necker cube [Fig. 11], they can be seen in two distinctly different ways. But the two versions, both optically correct, cannot be visualized simultaneously.

CHAPTER 7

Duchamp/Leonardo

O writer, with what words will you describe the entire configuration of objects with the perfection that the drawing gives? If you are unable to draw, you will describe everything confusedly and convey little knowledge of the true form of objects; and you will deceive yourself in imagining that you can satisfy your hearer when you speak of the configuration of any corporeal object bounded by surfaces.
—LEONARDO DA VINCI

As soon as we start putting our thoughts into words and sentences everything gets distorted, language is just no damn good—I use it because I have to, but I don't put any trust in it. We never understand each other.
—MARCEL DUCHAMP

Really, we can speak only through our paintings.
—VINCENT VAN GOGH

OF THE MANY MODERN ARTISTS WHOSE WORK WAS ADUMBRATED BY Leonardo, Marcel Duchamp resembled his predecessor the most in temperament and character. Like Leonardo, Duchamp's outsized reputation stood in contrast to the small number of pieces in his completed oeuvre. He frequently left works unfinished, was continually experimenting with new means to express himself, initiated many radical ideas that completely challenged the artistic conventions of his day, and even wrote

copious notes concerning his ideas about science that he secreted away from the eyes of the public.

Although both were capable of technical mastery, both expended considerable time and effort on other endeavors. For Duchamp, it was his abiding interest in chess; for Leonardo, it was his interest in scientific pursuits. Both started major works and left them unfinished for years. And both loved practical jokes and riddles. Leonardo drew the first caricatures, and Duchamp was a founding member of the 1915 Society of Cartoonists. Duchamp, like Leonardo, emerged as one of the most influential artists of his age, and the works of both have withstood the judgment of time.

Born into an artistic family in 1887, Duchamp passed through a series of phases during which he experimented with styles initiated by others. Once he had extracted what he considered necessary from each one, he moved on and rarely repeated himself.

In the second decade of the twentieth century, Duchamp reached a bold conclusion concerning the state of art: The retina of the eye held art hostage. While the audacity of the Impressionists, pointillists, primitivists, and other artistic -ists continued to dazzle most of his contemporaries—who were convinced that they were rebelling against the moribund conventions of the Beaux-Arts Academy—Duchamp intuited something very different. With a few exceptions, he noted that these avant-garde artists, similar to the academics they sought to supplant, appealed primarily to the eye. Their work demanded minimal introspection. Decrying "pretty pictures" and "retinal art," Duchamp strove to move the interpretation of art from the gossamer layer at the rear of the eyeball to a haunt deeper within the interstices of the brain's neuronal ganglia. Duchamp fought for nothing less than a great rethinking concerning what exactly constitutes art. He challenged viewers to question everything that they had previously taken for granted by creating works that both the critics and the public increasingly struggled to understand.

Duchamp achieved instant recognition when his iconic *Nude Descending a Staircase, No. 2* (1912) exhibited at the 1913 Armory Show in New York. It created a *succès de scandale*. This inscrutable painting attracted considerable attention, as it was the first time Americans were getting a glimpse of the new art emerging from Europe.

In 1912, Marcel Duchamp put the finishing touches on the second of two versions of his *Nude Descending a Staircase, No. 2.*

In one of his more clever titles, Duchamp even managed to spurn the futurists' embargo against the nude as subject matter, even if (in true Duchampian fashion) art critics cannot be sure it is a representation of a woman due to the painting's high degree of abstraction, and because Duchamp never clarified the issue. In *Nude,* Duchamp allows the viewer to see where the woman was, where she is, and where she is going to be. In a single gestalt, the past, present, and future of her motion are on display.

Was there an artist in the preceding centuries who also managed to accomplish the feat of inserting more than one duration of time in a single major painting? There is this one exceptional drawing finished five hundred years earlier by Leonardo, "The Vitruvian Man" [Fig. 12]. Here, we see the figure as a double exposure. Is not the Vitruvian Man a prelude to Duchamp's *Nude?* Are not these two images a chance to see more than one duration of time simultaneously?

It may be worthwhile to examine another work by Leonardo in this context—considered the most complex composition in all of art history, *The Last Supper.* Five hundred years before Duchamp and the futurists, Leonardo provided a preview of their coming innovations. Similar to so many of Leonardo's artistic firsts, this one is subtle and not easily discerned.

Prior to Leonardo, artists depicted the Last Supper merely as a meal during which Jesus and his twelve apostles broke bread. Compositionally, artists desired to project an air of piety. Leonardo departed from this convention and captured the emotionally charged moment immediately following Jesus's stunning announcement in John (13:21–26):

> *After he had said this, Jesus was troubled in spirit and testified, "I tell you the truth, one of you is going to betray me." His disciples stared at one another, at a loss to know which of them he meant. One of them, the disciple whom Jesus loved, was reclining next to him. Simon Peter motioned to this disciple and said, "Ask him which one he means." Leaning back against Jesus, he asked him, "Lord, who is it?" Jesus*

answered, "It is the one to whom I will give this piece of bread when I have dipped it in the dish." Then, dipping the piece of bread, he gave it to Judas Iscariot, son of Simon.

As one would expect, Jesus's accusation threw the diners into chaotic confusion. Leonardo assigned Jesus's companions facial expressions, body language, and hand gestures that intimated their inner thoughts at that moment, and also used this state of shock to accentuate the prominent character trait of each apostle. Philip, the third figure to the left of Jesus, whom the Gospels characterize as the naive apostle, bolts to his feet anxiously. His expression, overall demeanor, and the position of his hands are such that the viewer can almost hear him imploring Jesus, "Will it be me, master?" In contrast, Leonardo depicts Peter, who is known for his temper and protectiveness toward Jesus, clutching a knife in a threatening way. His facial expression closely follows the written narrative, in which he demands that John the Younger ask Jesus the identity of the traitor among them. Judas, his face darkened with guilt, clutches a purse containing, no doubt, the thirty pieces of silver that was his reward for betraying his master. The enormous range of feeling he paints into the disciples' experience in that one singular moment covers the spectrum of emotional response.

The interpretation of Leonardo's *The Last Supper* has occupied an army of copyists and art critics and many who are unfamiliar to the field of art criticism. For centuries, the dominant interpretation was the one put forth by the literary giant, Johann Wolfgang von Goethe. A great admirer of Leonardo, in 1817 the famous German playwright and poet wrote an extensive essay outlining his interpretation of *The Last Supper*. He and a great many of the secular Romantics of the Enlightenment wanted to move Leonardo's masterpiece out from under the rubric of religion and characterize it as a psychological study concerning betrayal—a subject with which just about every viewer has had an unpleasant experience. Goethe and his followers championed the view that the only valid interpretation possible was that Leonardo froze the dramatic moment that followed immediately after Jesus's accusation, *unus vestrum . . .* , "one of you . . ."

In 1904, a Polish art critic, Jan Boloz Antoniewicz, delivered an impassioned lecture disputing Goethe's interpretation. Antoniewicz observed that Goethe had viewed *The Last Supper* only once, and had reached his conclusions concerning the meaning of the painting by repeatedly referring to a faithful engraving of *The Last Supper* copied by Raphael Morghen in 1794, before the original had significantly deteriorated. While Morghen's copy seemed identical to the original, Antoniewicz observed that there were several crucial changes. Morghen omitted the two items that were near Jesus's hands—a wineglass and a bread roll. In the original, Jesus's right hand adopts a gesture of reaching as it nears the wineglass. Adding to the ambiguity, Jesus's right hand, while apparently reaching for the wineglass, is also in close proximity to the dish containing oil that Judas's hand is also nearing. Jesus's left hand adopts a palm-up and open position in a gesture of acceptance of the bread roll nearby. Remember, Leonardo was the first artist to make the position of his subject's hands symbolize something in each of his paintings. This, then, is the incongruity. Leonardo did not arrange Jesus's hands as one would expect of a person who has just accused another man sitting at the same table of committing the ultimate disloyal act, which would lead to the accuser's painful death.

Antoniewicz's interpretation reopened the debate concerning what exactly is going on in *The Last Supper*. Prompted by this outspoken and public challenge to the august Goethe's interpretation, other voices were emboldened to recall that earlier painters who had seen the work prior to its sorry twentieth-century state had also interpreted it as Jesus announcing the Eucharist. Peter Paul Rubens roughly copied the schema of Leonardo, but in his version he cleared the table of all plates, silverware, and condiments, except for a chalice and a loaf of bread. Other painters, too, faithfully copied *The Last Supper* to emphasize the presence on the tabletop of bread and wine. They re-created the similar facial expressions and body positions of the apostles that appeared in the original, but instead of anxiety and fear over a shocking accusation, these painters render the apostles in a state of awe, reacting to what was to become a far more portentous moment in the history of Christianity.

Since these new interpretations have resurfaced in the modern era, Leonardo scholars have debated which of the two interpretations are valid. In his book *Leonardo's Incessant Last Supper*, Leo Steinberg wrote:

> *I am trying to track in the painting [The Last Supper] a mode of thought pervasive and all-embracing—an intellectual style that continually weds incompatibles, visualizes duration in one seeming flash, opposites in marvelous unison. Again and again, whether in choice of subject or formal arrangement, whether addressed to a part or the whole, Leonardo converts either/or to both.*

Presently a diplomatic truce has coalesced around a consensus that Leonardo accomplished the impossible: He managed to represent in one classic, perspectivist painting two distinctly sequential moments.

In *Nude No. 2*, Duchamp shows his model in all three durations of time—past, present, and future. If Leonardo revealed both the past (accusation and identification) and present (communion) in his composition, where, a viewer might ask, is his representation of the future? In his final mind-bender regarding time, Leonardo cleverly inserted in the painting intimations of events that had not happened yet. Extrapolating from the New Testament and legendary accounts concerning how the Romans martyred some of the apostles, he inserted these forewarnings into the painting. The knife held in the outstretched hand of Peter that menacingly appears as a disembodied threat points directly at Bartholomew. The New Testament reports that Bartholomew was flayed alive. Further, the knife foretells of Peter swinging a sword the following night in the Garden of Gethsemane, in a futile attempt to prevent Jesus's arrest. Jesus's feet under the table are held in an unnatural posture. Viewed in an alternative way, they assume the position they will be in when he is nailed to the cross. Leonardo managed in this single masterpiece to reveal multiple durations of time simultaneously. His depiction of the past (accusation, identification), present (sacrament), and future (foreordained actions) would not appear again in art until the modern era.

Duchamp shocked the art world in 1919 by painting a mustache and goatee on a reproduction of Leonardo's *Mona Lisa*. Adding to his outrageous gesture, he further desecrated what many in the art world felt represented the pinnacle of highbrow art by entitling his hirsute *La Gioconda* with what, at first glance, seemed like a meaningless acronym: *L.H.O.O.Q.* Pronounced out loud in French, however, the title's letters sound out a slang French expression that roughly translates to *She has a hot ass.**

Duchamp aimed his visual and auditory double entendre at everyone who loves fine art. He wanted to puncture the notion that art was only for the cognoscenti. Average viewers, he believed, did not need a layer of interpreters interceding to tell them what they should see. In another of his memorable quotes, Duchamp said:

> *Art is a habit-forming drug. That's all it is for the artist, for the collector, for anybody connected with it. Art has absolutely no existence as veracity, as truth. People speak of it with great, religious reverence, but I don't see why it is to be so much revered. I'm afraid I'm an agnostic when it comes to art. I don't believe in it with all the mystical trimmings. As a drug it's probably very useful for many people, very sedative, but as a religion it's not even as good as God.*

In an age replete with revolutionaries, Duchamp was *sui generis*. His work was influential in setting the stage for the Dada and Surrealist movements that followed within a few years.

But was there an artist in the Renaissance who performed an act comparable to Duchamp's *Mona Lisa* graffiti? Again conjuring time travel, what if we could beam Leonardo into the twenty-first century and give him a tour of our museums and let him follow the trends in art from after his death leading right up to the modernism revolution. Then, bringing him to stand before *L.H.O.O.Q.*, what would be his reaction? Would he

* Neuroscientist Lillian Schwartz observed that the bony structure of Mona Lisa's face corresponds uncannily to Leonardo's features. When the famous red chalk drawing of an old sage that most art historians agree is Leonardo's self-portrait is superimposed on the image of the Mona Lisa, the fit is striking. If Schwartz's hypothesis is correct, Duchamp's gesture is all the more prescient and outrageous (Carmen C. Bambach, ed. *Leonardo da Vinci, Master Draftsman*. New Haven and London: Yale University Press, 2003).

not have recognized Duchamp's impish gesture as that of a kindred soul? Given Leonardo's disdain for the pretensions of the academics, parvenus, the Church, and nobility, would he not have applauded Duchamp's act of vandalism? Tailored for his time, Leonardo, too, carried out a less obvious but nevertheless vigorous seditious warfare against artistic conventions.

A crucial difference is that artists in Leonardo's time were completely dependent for commissions on rich patrons, ruling authorities, and the Church. The concept of "art for art's sake" did not exist. Also, artists lived in a far more dangerous and censorious time, when dissent was often brutally quashed. Those in power who felt threatened by different points of view not uncommonly assassinated enemies, exiled opponents, burned "heretics" at the stake, or, in the case of the Pope, wielded the heavy cudgel of excommunication for any perceived menace to their authority. Leonardo's gestures could not dare be as flamboyant as Duchamp's. Nevertheless, in many respects, Leonardo's well-cloaked defiance exceeds that of his impertinent twentieth-century counterpart.

Leonardo, like Duchamp, attempted to move away from mere retinal art, although he never called it that. He advised artists that merely reproducing the external appearance of their subjects was not sufficient, no matter how technically excellent were their efforts. Leonardo insisted that besides a realistic landscape into which they placed their subjects, they must also find a way to convey the subject's inner mental landscape. Failure to accomplish this mandate relegated their art to Duchamp's dismissive epithet, "pretty pictures." Leonardo expected that a painting should encourage a viewer to ponder something deeper than just the surface "prettiness" of artfully arranged objects realistically rendered. Duchamp and Leonardo echoed each other, and likely would have heartily enjoyed each other's company.

CHAPTER 8

Leonardo the Trickster

We have seen that central among the traits that define a creative person are two somewhat opposed tendencies: a great deal of curiosity and openness on one hand and almost obsessive perseverance on the other. Both of these have to be present for a person to have fresh ideas and prevail.

—Mihaly Csikszentmihalyi

The desire to know is natural to good men.

—Leonardo da Vinci

[Leonardo] had a very heretical state of mind. He could not be content with any kind of religion at all, considering himself in all things much more a philosopher than a Christian.

—Giorgio Vasari

Duchamp's antiestablishment stance is but an echo of the many disputes that arose between Leonardo and clerics. The Church had a considerable investment in maintaining a pious decorum when commissioning religious art. Artists and the public were of the same mind. When racy paintings and sculptures of nudes reappeared in the Renaissance, they made it past the religious police under the flimsy excuse that they were permissible because they evoked the newly rediscovered art of the "Classical Age." When depicting the Holy Family or the saints, however, the Church expected artists to strictly adhere to the sanctified conventions.

In the early 1480s, Milanese friars of the Confraternity of the Immaculate Conception commissioned Leonardo and his two partners, the de Predis brothers, to paint the Holy Family, with the emphasis on Mary. The brothers were to paint the two panels on the sides, but the center panel was to be the work of Leonardo. The friars demanded that he sign a contract specifying how the paintings were to be composed, what color clothing the principals were to wear, how many cherubim and prophets there were to be in accompaniment, and other irritating intrusions on the artist's creativity. They also inserted a clause demanding that he finish the painting by a fixed date. Leonardo signed, but he obviously had no intention of being told how to compose a painting. Missing the deadline, he finally delivered to his impatient but eager patrons his first version of *Virgin of the Rocks* in 1483.

Historical records confirm that they were so upset, they refused to pay him until he altered this masterpiece to comply more fully with the contract. To express their displeasure, they piled on additional contingencies not included in the original document. As the dispute dragged on, a disillusioned Leonardo turned to the many other responsibilities he had as the artist and engineer to the court of Milan's Duke of Sforza. The de Predis brothers, however, persisted in demanding their share of the commission, and a long and contentious lawsuit followed that was not resolved until some twenty years later.

There has been debate on the reasons for the dispute but we do know of Leonardo's idiosyncratic rendering of the holy assemblage and his jettisoning of clichéd sacred shibboleths. In what would become his signature style of composing multiple subjects in a painting, Leonardo grouped the Virgin, the infant Jesus, the infant St. John, and the angel Uriel in a pyramidal construction—nothing very heretical. However, Leonardo omitted the requisite halos floating above the heads of his figures, blurring the distinction between the sacred and profane. Thus, Leonardo moved the four revered personages, each of whom is associated with heaven, closer to the secular.

If one wants to read heresy in Leonardo's *Virgin*, there is more. The Gospel of Matthew tells the story of Joseph and Mary's flight into Egypt to escape the wrath of Herod, the king of Judea. Tricked by the Magi, who were present at Jesus's birth, Herod was told that an infant was born

within his kingdom that would one day usurp his power. Intent on ensuring that this could not happen, Herod ordered the killing of all the firstborn sons of the Jews. The angel Uriel forewarned Mary and Joseph, and, under his protection, they fled into the Egyptian desert. The thinly veiled attempt by Matthew to relate the birth of Jesus to the birth of Moses (whose mother also had to protect her son from an identical threat) and the connection of both narratives to the desert raises the possibility that Matthew's story was completely fabricated. None of the other three Gospel writers mention this tale.

Further, The New Testament does not contain any passage about a meeting between John the Baptist and Jesus when they were infants. Instead, an unverifiable and extremely implausible legend has the two babies meeting during Mary's flight into the desert. Only a strained and fanciful interpretation of any biblical passage could place the two in proximity at this young an age.

Leonardo also painted the male archangel Uriel in a strange way. According to the Bible, Uriel was the Angel of Death. He is the archangel responsible for killing all the firstborn sons of the Egyptians in the Exodus story. Presiding over God's potent thunderbolts, Uriel generally comes across as a terrifying figure. Leonardo rendered this supposedly frightening character androgynously. A fierce *he* appears more like a gentle *she*. Additionally, Uriel points his/her dainty finger portentously at the infant John the Baptist rather than at the baby Jesus.

Compounding the strangeness of Leonardo's composition was its setting. Mary appears to be in a cave, but impossibly suspended boulders that defy the principles of gravity form its ceiling. Leonardo's otherworldly landscape does not resemble anything heavenly, and is more the way artists typically imagined Hell. What's more, Leonardo's seascape in the background does not jibe with what one conjures up when imagining an Egyptian desert landscape. All told, Leonardo's rendering of the Holy Family in this version of *Virgin of the Rocks* would have had the same effect on his audience as did Duchamp's much later placement of a mustache and goatee on the Mona Lisa.

Twenty years later, with the help of the de Predis brothers, Leonardo delivered a second version of the same painting. This time, halos were in

evidence, and the archangel Uriel, who appeared more masculine, was no longer pointing at the wrong baby. Leonardo did render the Virgin as older than the fresh maiden he had painted in his first version. Due to insufficient records, art historians have been unable to unravel the peculiar set of circumstances surrounding the mystery of why it took Leonardo twenty some years to redo the painting.

Leonardo also unconventional renders Mary and the baby Jesus in *The Benois Madonna* (c. 1478) [Fig. 13]. The New Testament does not provide readers with any clues as to whether Mary was right- or left-handed. Yet, in many of the paintings, artists depict Mary holding her baby with her right hand. Casual observation of real mothers reveals that the majority of women, being right-handed, cradle their babies on the left side of their body, the better to free up their dominant hand.

Even left-handed mothers prefer holding their baby in their left hands as the soothing rhythm of their heartbeat quiets the baby. In a significant number of these early Madonna and child paintings, the manner in which male artists depicted Mary holding her baby borders on the incompetent. In more renderings than one would expect, a modern woman would be admonished for child endangerment if she held her baby similar to the way Mary does. In Leonardo's *Benois Madonna*, Mary's hands hold a robust baby Jesus in what appear to be a natural manner. Some have gone so far as to argue that Mary's smile and the sheer healthy size of the baby Jesus also go against typical renderings of the time.

Others have seen an artfully disguised jab in his widely-hailed *The Last Supper*. Vasari tells us how Raphael stood before it speechlessly, marveling at the expressiveness of the heads and the grace and movement of the figures. Kenneth Clark called it the most dramatic and most highly organized composition of its kind.

But another ambiguous riddle in the painting has recently ignited a flash fire. Leonardo always emphasized the art of seeing, which meant to him abandoning preconceived notions about the subject matter. In his famous rendering of *The Last Supper*, Leonardo positioned immediately to Jesus's right a figure who appears to be a woman instead of one of the twelve male apostles. And not just any woman, but the woman whom the

New Testament smears as a prostitute, despite (or because of) beliefs that she was Jesus's wife or lover.

Viewers consistently read the figure to the right of Jesus to be the youthful apostle John. A few art historians had raised the question in hushed voices in the genteel world of academia, but author Dan Brown brought the controversy to a large public audience in his 2003 bestseller, *The Da Vinci Code*. The result was unexpected and volcanic. It seemed everyone had an opinion, and it elicited a vigorous defense from offended traditionalists who insisted that the figure is not Mary Magdalene but St. John the Younger.

The accounts of the three synoptic Gospel writers (Mark, Luke, and Matthew) and John's version, which is the most complete, provided considerable detail when they described the scene of the Last Supper. At the meal itself, the apostle John the Younger's place was next to Jesus, on whose chest he leaned (John 13:23, 25). The Last Supper was a favorite theme that had been rendered by numerous previous artists. In many of these other paintings, the artist remained faithful to the New Testament, posing the figure of the apostle John as either asleep with his head resting on the table or, alternatively, leaning on Jesus, as described in the text. Most obvious is that the figure resembles less in form and face a young man, and more a young woman.

Let us consider the alternative possibility—that the figure to the right of Jesus actually *is* Mary Magdalene. Is not her body language, her folded hands, and her facial expression that of a woman resigned to the coming arrest, trial, torture, and crucifixion of the man she loves?

Outraged traditionalists dismiss the theory out of hand, claiming that the whole argument is the result of fevered emanations from feminist-leaning, anti-Christians' overactive imaginations. But does this alternative interpretation have merit? *The Last Supper* is arguably the most complex composition in the entire history of art. Leonardo left not a single detail to chance. Taking all of the above arguments and counterarguments into consideration, a strong case can be made in the court of competitive plausibility that Leonardo, in a grand Duchampian gesture, fooled generations of viewers and art critics.

Duchamp's guerrilla act of pasting a mustache and goatee on the features of the most famous visage in Western art alludes to a man

impersonating a woman, a not particularly subtle reference to Leonardo's sexual orientation. *L.H.O.O.Q.* was not only disrespectful, but it was also vulgar both in its title and iconic sexual innuendo. Not only would Leonardo not have been insulted by Duchamp's subversive act, he probably would have approved.

Leonardo concluded his artistic career by painting his most enigmatic work, a portrait of St. John the Baptist, the patron saint of Florence [Fig. 14].

According to the New Testament, John was an anchorite who spent most of his years living a self-imposed life of deprivation in the Judean desert. Avoiding the temptations of the external world, anchorites fasted, meditated, prayed, and renounced worldly pleasures. Sects promoting such a lifestyle were common around the time of Jesus. The Essenes, for example, were a breakaway group of militant Jews committed to living a spare, desert existence free of the pleasures of the senses while they waited impatiently for the arrival of the Messiah to right their perceived wrongs.

The Synoptic Gospels describe John the Baptist as an undernourished, pious, abstemious holy man who cared little about his external appearance. Taking their cues from the text, artists preceding Leonardo imagined John the Baptist as a gaunt ascetic.

So what are we to make of Leonardo's final painting of this well-defined historical figure? Instead of painting an environment that aids in his identity, Leonardo eliminated all perspectivist clues and external hints of context. The viewer simply confronts the half-naked saint wearing a smile, his right forearm upright with forefinger extended in a gesture pointing heavenward.

In contrast to Leonardo's earlier figure of another ascetic, *St. Jerome* in the wilderness, John does not express the stereotypical, anguished face of a religious seeker. Instead, Leonardo presents a youthful, pretty boy with a head of carefully coiffed, cascading curls falling to his shoulders. A sly smile graces his smooth, beardless features. No masculine muscle definition sculpts this figure's biceps, triceps, or deltoids. Leonardo's version of the saint presents a well-fed, pneumatic young man.

Leonardo was preternaturally aware of the power of symbolism and rarely did he place a plant, tree, flower, or animal in one of his compositions

that did not refer to literature, religion, or mythology. These symbols always enhanced the central subject of the painting or deepened its meaning. As evidenced in the detail Leonardo devoted to his *The Last Supper*, he obviously studied the New Testament very thoroughly. Therefore, his departure from its details describing the saintly anchorite's surroundings is noteworthy. St. John the Baptist lived in a harsh desert environment that presently borders Israel and Jordan. There are few trees and little vegetation. Leopards are not indigenous to this desiccated environment today, and they were not present in the first century. So why would Leonardo drape John's midriff in a leopard skin, especially when the Bible states that John wore a meager covering composed of camel skins and leather? So subtle are the leopard's spots on John's garment that only very close examination of the painting will reveal their presence.

The figure in mythology intimately associated with leopards and leopard skins is Dionysus, god of sensuality, wine, ecstasy, and unbridled sexuality. Ample corroborating evidence in Greek plays associate leopards with Dionysus. Looking at the painting with fresh eyes suggests that the sensuous smile, oiled curls, boyish figure, and overall sumptuous nature of this painting, at the very least, beget another interpretation.

Among the many exploits the Greeks attributed to Dionysus was one that involved the theme of resurrection. Prior to the masculine ethos of Christianity's suppression of pagan beliefs, the central myth revolved around a mother resurrecting her son. In the Dionysus myth, the son resurrected his mother. With permission from Zeus, Dionysus traveled to the netherworld to petition the god Hades to release his dead mother, the mortal Semele. Surprisingly successful, Dionysus departed with her and ascended to Mount Olympus, whereupon Zeus graciously seated her next to him on his right. Among the lush imaginative adventures of the gods and goddesses of the Greek pantheon, no other rescue of this nature *ever* occurred.

There is more. The myths associated with Dionysus share many other similarities with Christianity. Dionysus is the only born-again god. The "Twice-Born," one of his many appellations, led a scruffy group of followers that sophisticated people regarded as riffraff. Jesus and his early followers were similarly characterized by the intelligentsia of their age.

Around 1480, Leonardo had completed an earlier version of St. John the Baptist, which was eventually altered. It was an enigmatic painting of a relaxed, androgynous figure sitting under the ample shade of a bulbous tree, reaching more into terra than into heaven. The muscular, effeminate male in the painting was considerably younger than the usually gaunt ascetic who announced the coming of Christ. Cassiano dal Pozzo, who saw the painting at Fontainebleau in 1625, remarked, "It is a most delicate work but does not please because it does not arouse feelings of devotion."

Since the poet Petrarch in the fourteenth century unearthed the lost legacy of the Classical world, many works of Greek playwrights, including Sophocles, Euripides, and Aeschylus, became available to a public eager to rediscover these treasures. One play in particular was the compelling story of King Pentheus's encounter with the god Dionysus. It's important to remember that Leonardo completed his painting shortly after he was arrested, arraigned, and imprisoned while awaiting trial for the charges of sodomy.

Nowhere in his long career does Leonardo seem to have had a truly supportive or appreciative major ecclesiastical figure. In the first edition of *The Lives of the Most Excellent Painters, Sculptors, and Architects,* Vasari wrote, "Leonardo had a very heretical state of mind. He could not be content with any kind of religion at all, considering himself in all things much more a philosopher than a Christian."

When the second edition was released, Vasari amended his characterization of Leonardo, making him a pious Christian. It is unlikely that Leonardo had any regard for the Church. In one of many riddles targeting the Church, he wrote, "I see Christ once more being sold and crucified and his saints martyred." He protested the sale of indulgences and criticized the exaggerated pomp of churches, obligatory confession, and the cult of the saints. He mocked those redundant prelates who claimed to be "pleasing God" by lounging year-round in sumptuous residences. From all that we know of Leonardo's character, the first edition's version would most likely be the more accurate one. In many of his notes, Leonardo displayed a cynical, skeptical attitude toward the Church's teachings.

I am aware that my interpretations of the four Leonardo religious paintings I have discussed are extreme and provocative. Many readers will take issue with me on any one of them. But if one stands back and examines Leonardo's irreverence in all of them combined, a distinct pattern emerges. He painted haloless holy figures, sexually ambiguous angels calling attention to the wrong boy, smiling Madonnas, the infant Jesus swaddled in baby fat, and a clearly feminine figure sitting next to Jesus at the Passover dinner. Most provocatively, he created a *St. John the Baptist* who wears an animal skin associated with Dionysus, appears too well fed to be an anchorite, and is portrayed in the same posture as one of Leonardo's pornographic drawings, making an enigmatic gesture. Taken together, these appear to be too significant to be mere coincidences.

Throw into this brew the fact that Leonardo loved playing practical jokes, creating illusions, and fooling people. Once, he invited a group of people into a room in which he had hidden in the corner a carefully cleaned mass of deflated sheep intestines. To the group's curiosity, then discomfort, and finally horror, Leonardo arranged to have a bellows inflate the guts, which then began to balloon out into the room. As the space diminished, the guests were forced to crowd into the corner.

Even at a low point during his failed time in Rome, Leonardo managed to play a practical joke by fashioning a mythical beast. He dipped scales in quicksilver and pasted them onto a live reptile, which he had also augmented with large, exaggerated eyes. When he opened the box in which he kept the reptile, anyone coming in contact with the "monster" would justly recoil in terror, generating laughter from Leonardo.

For someone who reveled in being a trickster and posing riddles, what better way to get even with an institution that had repeatedly misunderstood and dismissed his genius than to hide in his paintings alternative interpretations that would have to wait for centuries until they could be read by a more secular society.

When the formidable pianist and composer Muzio Clementi first studied Beethoven's quirky late string quartets, he was taken aback by how far Beethoven had pushed the boundaries of what was considered music in the early nineteenth century. Troubled by their complexity, he expressed

his concern that audiences would find them so strange and unfamiliar to their ears that they would reject them. Clementi even went so far as to impertinently ask Beethoven if he even really considered them to be music. "Oh," replied Beethoven casually, "they are not for you, but for a later age."

Leonardo not only represented a shooting star in his own age, but he also presaged the pyrotechnics that would ensue far into the future. Like Beethoven, he not only created spectacular art for his own time, but also for viewers who would not be born for another five centuries, and who would have new sensibilities not present in Leonardo's age.

Duchamp in the twentieth century channeled the rebellious licentiousness of a master who lived five hundred years earlier. Leonardo's *St. John the Baptist* on one end and Duchamp's *L.H.O.O.Q.* on the other form another set of bookends. Each contained a shocking poke at authorities in a paradoxically hidden (and not so hidden!) way; both challenged tradition in unconventional ways, declaring that the artist must do more than just realistically re-create surface details. They were kindred spirits, working centuries apart.

CHAPTER 9

Creativity

There is a paucity of interhemispheric communication during the first phase of the creative process. This provides an opportunity for the right hemisphere to explore its own territory of excellence with a minimum of interference from the left.

—Bogen and Bogen

Often we have to get away from speech in order to think clearly.
—Robert Shaver Woodworth

Leonardo was arguably history's most creative individual. But what does it mean to be "creative"? Where does it originate? How does it manifest? In Greek mythology, Apollo was the sun god, the shining representative of light, reason, and logic. He epitomized the god of intellectual pursuits. His shrines had pithy proverbs over their entrances, like "Know thyself" and "Nothing in excess." But, he was also humorless and imperious. His exploits with the fairer sex were generally a failure. The nymph Daphne was so repulsed by his pursuit of her that she turned herself into a laurel tree rather than fall to Apollo. He had homosexual relations with a young boy, Hyacinth. Among his exalted positions, he was the patron god of the famed Oracle of Delphi. But he only served in this function for nine months, and then left to live among the Hyperboreans in the extreme north.

Replacing him for the final three months of the year was his brother, Dionysus, god of the moon, night, ecstasy, intoxicated states, sensuality, fertility, and altered states of consciousness. He was the god of the

lucky hunch, the divine epiphany, and intuitive knowledge. His retinue consisted of a riotous bunch of satyrs and nymphs and other symbols of fertility. He was a cannibal god much to be feared, and he was the god of creativity. The flash of insight was his domain, but it bordered narrowly on the verge of madness.

Whereas Apollo presided over courage and incisive cold logic, Dionysus held sway over fear and lust. As Friedrich Nietzsche brilliantly argued in his *Birth of Tragedy*, these two opposing principles formed the basis of Greek culture. This dichotomy between the spirits of Apollo and Dionysus suggests that the Greeks allegorically understood the different functions between the right and left brain.

The neurologist Charles Sherrington, using a marvelous metaphor, referred to the brain as an "enchanted loom." We spin our dreams, thoughts, concerns, and hopes on it. Of all the weavers in all the annals of history, none has produced a more complex tapestry for the rest of us to appreciate than Leonardo. This leads to the question: Was Leonardo's extraordinary level of creativity merely a matter of degree, or was there something else involved?

All vertebrates have brains, yet in only this one species has creativity reached a level vastly different from all other vertebrates. The splitting of the human brain into two functionally different hemispheres was the critical adaptation that ensured humans would propel themselves away from all other creatures in nature. Émile Durkheim, one of the founders of twentieth-century sociology, referred to man as *Homo duplex* in recognition of the two natures arising from the two different sides of the cranium.

What part of the brain generates creativity? The capacity of *Homo sapiens* to solve problems in an innovative way requires two hemispheres working in concert. But a considerable body of research exists suggesting that of the two, the minor one—the right brain—is more critical for true creativity. This should come as no surprise, because the left hemisphere, intricately wired to interpret and generate language, depends heavily on obeying the rules of speech.

Speech requires properly arranging the linear sequence of syllables to form words, and grammar demands adherence to a set of rules children

learn before they even know what a rule is. To add to the complexity, every language has many grammatical idiosyncrasies that follow no logical pattern. Also, in a child's acquisition of numeracy skills, he or she learns that this essential knowledge requires that its laws be obeyed. Numbers proceed in a crisp linear fashion in a proscribed order. There can be no rearranging.

The most sublime function of the left hemisphere—critical thinking—has at its core a set of syllogistic formulations that undergird logic. In order to reach the correct answer, the rules must be followed without deviation. So dependent is the left brain on rules that Joseph Bogen, the neurosurgeon who operated on many of the first split-brain patients, called it the *propositional brain*: It processes information according to an underlying set of propositions. In contrast, he called the right hemisphere the *appositional brain*, because it does just the opposite: It processes information through nonlinear, non-rule-based means, incorporating differing converging determinants into a coherent thought. Bogen's classification of the brain into two different types, *proposition* versus *apposition*, has been generally accepted by neuroscientists, and it appears often in neurocognitive literature.

The right brain's contribution to creativity, however, is not absolute, because the left brain is constantly seeking explanations for inexplicable events. Unfortunately, although many are extremely creative, without the input of the right hemisphere, they are almost universally wrong. It seems that there is no phenomenon for which the left brain has not confabulated an explanation. This attribute seems specific for the left language lobe.

One does not need to examine many more examples from split-brain research to accept the idea that the left brain "makes stuff up." The incredibly fanciful mythology that humans from divergent cultures have invented to explain natural phenomena bespeaks the creative ability of the left hemisphere to invent a story about why things happen. Confabulation, unfortunately, is not the kind of creativity that moves cultures forward.

The first step in the creative process is for an event, an unidentified object, an unusual pattern, or a strange juxtaposition to alert the right

brain. In a mysterious process not well understood, it prods the left brain to pose a question. Asking the right question goes to the heart of creativity. Questions are a *Homo sapiens* forte. Despite the amazing variation in animal communication, there is only one species that can *ask a question* and—most impressively—*dispute the answer*. But Mother Nature would not have provided us with language simply to ask a question. She had to equip us with a critical appendage that could investigate those questions. That appendage was the opposable thumb. Thumbs have a lot to do with curiosity, which in turn leads to creativity.

Judging from the observable behavior of other animals, there are only a few that can be said to be truly curious. The primary reason for most animals' lack of curiosity has to do with their inability to do anything about a question they were intelligent enough to formulate in the first place. For example, dolphins are very intelligent animals. Pound for pound, their brains are much larger than ours, and they exhibit behavior that is quite compatible with curiosity.

But there is a major difference.

Let us imagine that we are swimming with a school of dolphins in the open ocean. A fishing tackle box falls off the transom of a boat above them and begins its descent to the bottom. As it falls the dolphins circle it, curious about the nature of this most unusual item in their midst. In sophisticated dolphinese they whistle and click speculations to each other on the contents in the box. When the box finally settles on the bottom, they circle it and gently probe it with their bottle-nosed snouts. Alas, they will never be able to answer their original question concerning what is in the box, because they lack the means to *open* the box. Their flippers do not have the dexterity to accomplish the task. Neither do paws, claws, or talons. Natural selection tends to be economical. It does not burden a creature with instincts and abilities that exceed the limits of its normal operating system. Bestowing language on a creature that does not possess the means to answer the questions it has posed would be uneconomical. The opposable thumb provides *Homo sapiens* with the critical appendage.

To begin the search for where in the brain creativity arises, it would be beneficial to examine the pathological condition of *alexithymia*.

The term literally means the absence of emotional words, but it is also accompanied by the absence of creativity. Patients suffering from alexithymia have dull dreams and speak in a flat monotone, without affective adjectives or adverbs that refer to emotions. They rarely use metaphors or resort to proverbs, and nary a sarcastic phrase passes their lips. They do not hum when they are doing something pleasurable, they rarely daydream, and they do not exhibit playfulness. In a group setting, after someone has told a joke, the alexithymic will likely frown and say, "I don't get it."

Joseph Bogen, the neurosurgeon, first called attention to the distinct syndrome when he observed that many of the epileptic patients on whom he had performed a commissurotomy manifested the syndrome of non-creativity. Somehow, disconnecting the two hemispheres deprived the left speech hemisphere of the input of the emotional right brain's speech patterns, content, and inflection. The left brain of Bogen's split-brain patients could not access the emotional tenor of the right brain, so they spoke in a flat manner and rarely used emotionally charged words to enliven their speech. The left brain lost access to what the right brain generates, which is essentially the source of creativity.

Examination of the brains of other alexithymic patients using CT scans and MRIs revealed that they had suffered a stroke or developed a tumor in their right brain. The evidence accumulated from studying alexithymic patients points convincingly to the right hemisphere as the locus for creativity.

In his comprehensive book, *The Act of Creation*, author Arthur Koestler poses the paradox of the holon. A *holon* exists as a self-contained entity, yet simultaneously it is a component of something else that makes up a greater whole. Cell mitochondria are organelles that are complete in themselves, yet they are also components of the larger cell. Our solar system is an entity that can be contemplated in isolation. Yet at the same time we know that it is but a component of our much larger Milky Way galaxy, which itself is but one tiny galaxy among an uncountable array of galaxies in the universe. In considering any aspect of reality, we shift our focus back and forth between the individual component and the greater gestalt. It is the figure/ground distinction every artist confronts. Koestler's

concept of the holon provides a useful template that can be superimposed on the two halves of the human brain to better describe their differing functions.

The left brain, the seat of the ego and superego, defines itself as separate from the world. When it speaks, it uses the pronoun "I." It contemplates the world from its comfortable executive function chair perched within the brain's left frontal lobe, just behind the forehead. "I" sees itself and everything inside the encasement of the body's skin as isolated from everything outside, which it classifies as "Not-I." It focuses on the particular and is represented in the figure/ground in art. It sees itself as separate.

The right brain, in contrast, engages in holistic thinking, aware of its web of connections to everything else. The right brain's mental states do not occur in single file as they do in the left brain, but rather the minor lobe merges a complex web of spirituality, intuitions, mysticism, and pattern recognition to generate complex feelings. From out of this soup emanates the first wisps of creativity.

Koestler personified his concept of the holon by using an example from mythology. Janus was the Roman god of the threshold. He was portrayed as having two identical faces, each one facing in opposite directions. When the two sides of the brain are truly integrated, Janusian thinking occurs. It is of a kind whereby a person will examine two opposing viewpoints or observe something from two entirely different directions. F. Scott Fitzgerald encapsulated Janusian thinking when he opined, "The test of a first-rate intelligence is the ability to hold two opposing ideas in mind at the same time and still retain the ability to function."

Creativity proceeds in four stages: perspiration, incubation, inspiration, and verification. The first stage requires that an individual master a particular domain of knowledge. Whether in the laboratory, before an easel, or simply at one's desk, the problem has been examined thoroughly. Creative flashes come to those who have contemplated the problem for a long time. Everyone is familiar with this first phase, the one that demands the most perspiration. The frequently quoted maxim of Louis Pasteur referring to the process of scientific investigation was "In the fields of observation, chance favors the prepared mind." During the long period of

preparation leading up to a creative insight, the left brain is busy codifying and classifying the ins and outs of a particular field. On rare occasions, creativity can seem effortless. Mozart claimed that he often envisioned the entire score of a composition all at once, within his mind, and all that he had to do was to translate the score's notes one at a time on paper. For the majority of people, a creative insight comes only after much noodling of the problem, looking at it from many different angles, seeking a solution.

It is during the phase of perspiration, and sometimes when the active phase of seeking a solution is over, that the most mysterious aspect of creativity commences—that of incubation. Somehow, even though the left brain is no longer concentrating on the problem, at some deep, subterranean level, the right brain continues to labor. Many times in art and science, the search for the answer to a particularly vexing problem eludes the laser-concentrating ability of the left hemisphere. Despite the sustained application of all the forces of one's logic, the problem remains. And then, in a moment of relaxation or when the artist or scientist is doing or thinking about something entirely unrelated, the answer suddenly pops into consciousness.

The French mathematician Henri Poincaré described how the answer to a complex mathematical problem eluded him despite his most concentrated efforts. Then he put the problem aside and went on holiday. Several days later, when he was boarding a bus, as he placed his foot on the step, the solution occurred to him as if from out of the blue.

There is a common saying in science that the bed, the bath, and the bus are the three most inspirational locations to have major insights. Ideas emerge into consciousness as if from out of nowhere. Illumination occurs in the most mundane places, and when we are going about the most ordinary tasks. Typically, a solution to a problem will burst upon us when we are not thinking about it. If this is the case, how, and where, does the brain pull off its rabbit-out-of-a-hat trick?

Think of the right and left hemispheres as Siamese twins joined at the corpus callosum. Although each hemisphere has its own preferences and approaches, each contributes to make a whole person only when the corpus callosum integrates the two. But in the process of generating a major

creative insight, a disconnect *must* occur between the two halves. Arthur Koestler called this "hemispheric bisociation."

The two hemispheres work in concert nearly all of the time, and the dominant hemisphere has the capability to inhibit the nondominant hemisphere. Natural Selection gave the left hemisphere hegemony over the right. Under certain circumstances, however, the minor hemisphere must escape the control of the major one to produce its most outstanding contribution—creativity. For creativity to manifest itself, the right brain must free itself from the deadening hand of the inhibitory left brain and do its work, unimpeded and in private Like radicals plotting a revolution, they must work in secret out of the range of the left hemisphere's conservatives.

After working out many of the kinks in the darkness of the right hemisphere's subterranean processes, the idea, play, painting, theory, formula, or poetic metaphor surfaces exuberantly, as if from beneath a manhole cover that was overlaying the unconscious, and demands the attention of the left brain. Startled, the other side responds in wonderment.

Numerous artists and scientists throughout history have experienced this strange phenomenon. If creativity begins in the right brain, it must at some point make the journey across the great divide between the two hemispheres. To translate an insight into words or action, the left hemisphere must be involved—but not always. In the kinesthetic arts, such as dance or basketball, the right brain may invent a creative maneuver never used by anyone before. In general, however, the left lobe must translate the insight into words, or verify the insight using paint or equations. This step requires that the insight be formally introduced to the left lobe.

After arising in isolation in the right hemisphere, the creative insight must find a way to be ferried across to the left side of the brain. This is done by way of the corpus callosum, that broad band of neurons that connects the right and left cerebral hemispheres. Is it merely a conduit, or does it serve a higher, more integrative function?

The corpus callosum is the most poorly understood structure in the human brain, and it also happens to be the largest. Arching over the midline, the corpus callosum is an enormous band of well over 200 million neurons. Neuroscientists have two theories as to the function of this broad

band of connecting fibers: The first posits that the corpus callosum serves only as a conduit that allows the right hand to know what the left hand is doing, and vice versa. The opposing theory proposes that the corpus callosum integrates information from each side, functioning as a third brain, producing something qualitatively different from what the right and left brain generate individually.

Because creativity depends to a large extent on the message of the right brain making it over to the left brain, ungarbled, the maturation schedule of the corpus callosum is pertinent. *Myelin* is a gigantic molecule that binds fat globules within a lattice of protein. Once formed, it serves to sheath individual neurons, the information-transmitting cells of the nervous system. *Myelination* is the process by which a human brain's nerves receive their myelin coatings, the function of which is similar to the insulation used on copper wires. Disparate areas of the brain and the peripheral nervous system myelinate at different ages during growth.

Both nerves and wires conduct electrical currents that generate electromagnetic fields, extending into the surrounding space. As with man-made devices such as radio and television transmitters, "interference" (or static) in nerves is a potential problem. To protect signals from corruption by neighboring electromagnetic fields, each individual nerve is encased in insulating material.

In the electrical industry, this substance is the familiar plastic or rubber that sheaths the wires of appliances. In the brain and peripheral nervous system, the insulating substance is myelin. The fetal brain contains very little myelin. Evidence of a newborn's lack of it is apparent in the Moro reflex. Hands clapped loudly near a newborn will startle it. The sharp sound sets off a chain reaction, so that the infant responds as if every nerve in its body had been activated. The newborn adopts a signature open-armed grasping manner, as if the child were reaching out to embrace its mother for protection.

As an infant's brain grows, it steadily lays down myelin around its nerves. In general, myelination proceeds from the bottom up, back to front, and right to left, and takes some twenty-odd years to complete. Myelination of the corpus callosum begins at the age of three months but

is not complete until early adulthood. This is the reason why neuroscientists suspect that creativity does not really peak until late adolescence or early adulthood. There are exceptions to this rule, as Mozart and other child prodigies have demonstrated.

This brings us back to the wiring diagram in Leonardo's brain. How did Leonardo's left-handedness and ambidextrousness affect the balance of his left brain and his right brain, or, should we say, his balanced brain?

CHAPTER 10

Fear, Lust, and Beauty

Lust is the cause of generation. . . . Beauty in life perishes, not in art.
—Leonardo da Vinci

[Leonardo's art is an] interfusion of the extremes of beauty and terror.
—Walter Pater

When John Keats penned his immortal line of poetry in "Ode on a Grecian Urn"—"Beauty is truth, truth beauty—that is all Ye know on earth, and all ye need to know"—he could not have more succinctly described the twin goals to which Leonardo dedicated his life. The Florentine polymath spent enormous time, study, and effort attempting to discern the truth behind natural phenomena. He then employed his artistry to depict those truths in a way that continues to captivate and enthrall five hundred years later. In his mature years, he sought to uncover the principles that lie beneath it all.

In seeking the function of the human eye and dissecting it with unerring accuracy, in noting how atmospheric conditions affect the view of distant objects, or drawing a mechanical device with great accuracy and detail, Leonardo illuminated his search for truth using his art. But his greatest fame rests with his unique ability to translate truth into beauty, to capture the delicate emotions in a child's face, a woman's smile, an anguished combatant with an unsurpassed skill.

What are the origins of our need to appreciate beauty and satisfy our insatiable curiosity concerning truth? Many poets, art critics, philosophers, and commentators from other academic fields have weighed in on

this subject and tried to define these two abstract words. *Homo Aestheticus: Where Art Comes From and Why* is a book written by Ellen Dissanayake that attempts to identify the sources of beauty. Although deeply informative, quoting many art critics, psychoanalysts, and evolutionists, the book does not delve deep enough to answer the question: *Why are we blessed with the aesthetic sense?*

I want to approach the problem from an evolutionary point of view. Why did we humans evolve an aesthetic sense so sensitive that we can make a judgment about good and bad art? Why is discovering the truth at the heart of matters such an obsession with us?

Humans are qualitatively different from all other animals. Among the many features that we are quick to list to advance our claim of superiority are textured morality, complex language, and sophisticated toolmaking. Recently, however, biologists have increasingly identified other species that manifest similar behavior. Much of our "uniqueness" has been reclassified to be more a matter of degree than one of distinction.

Armed with mounting evidence, researchers in the relatively new field of sociobiology posit that human characteristics, originally thought to be God-given, can be explained in terms of Natural Selection—random mutations that ensure humans will be able to compete with other species for resources. There remain some features, however, that as best as we can ascertain, seem relatively unique to humans. Foremost is our creativity.

At the heart of all creativity lies our fear of danger. Natural Selection installed this basic instinct in every animate creature to enable the creature to stay alive. Among all animals, it is the premier early-warning system. The key to sensing trouble is any alteration in the environment. The sudden appearance of novelty alerts an animal that something is awry, and its first imperative is to make sure that the "something" is not hankering to eat it.

Upon the sudden appearance of novelty in the environment, a carefully orchestrated cascade of neurotransmitters begins its waterfall of changes that will alter an animal's state of consciousness. The arousal center in the brain shifts from the wide-focus diffuse lens and immediately lasers at the source of the novelty, effectively shutting down extraneous

input. It must devote all its concentration to the narrow cone of vision that is now scrutinizing this one aspect that has captured its attention.

The flood of danger hormones released by the pituitary activates the release of adrenaline from the adrenal glands. (The technical name for adrenaline is epinephrine.) This puts the animal in a state of maximal hyperalertness, preparing it to fend off a potential threat. Not coincidentally, this is also the state that artists and scientists both report that they are in when they are experiencing a major insight. A heightened alertness, a burst of energy, and an increased clarity of thought are common to both fear and creativity. In addition to adrenaline, the danger hormones from the pituitary urge the adrenal glands to increase their production of corticosteroids, further preparing the body for whatever comes its way. Steroids bulk up the muscle, improve the immune system, and help blood to clot faster.

In almost all other animals, because threats originate equally from the right and left sides, the midline brain structures that include the amygdala and hypothalamus can be counted on to generate an equal response to danger. Not so in the human animal. The right side of the hippocampus is activated in dire circumstances, and the left side is relatively unsupportive. The right side of the hypothalamus plays a greater role in priming the pump of the pituitary than does the left. The right brain has a larger concentration of norepinephrine, the danger hormone, than the left.

Not all novel situations result in danger. To prevent the nervous system from constantly being thrown into a state of heightened receptivity, Natural Selection installed the counterreaction called "habituation." The first time a novel situation occurs, the internal response of the animal resembles a four-alarm fire. However, if no threat to life or limb materializes, then the next time it will evoke a lesser emotion of fear. Finally, when the organism is habituated to it because it is deemed not a threat, the fear response will shut down.

As an example, in the history of science, this condition of habituation can be understood from the insights of Thomas Kuhn in his classic book, *The Structure of Scientific Revolutions*. Kuhn's thought would suggest that scientists, before the breakthroughs of a revolutionary thinker on the order of Einstein or Newton, had become "habituated" to the kind of

thinking that had characterized their respective fields. Once the revolutionary ideas were brought forth and all that they had taken for granted had been overthrown, there was an initial period of shock and disbelief. Rejection of the new paradigm was the order of the day, because their habituation to what they had become accustomed to was so strong.

Novelty is the crux of creativity. For those who "get it," there is wonderment and great surprise, an emotion commonly witnessed in animals (and humans) when they are suddenly confronted with danger. The emotions associated with creativity are all closely related to the appreciation of danger. Excitement serves to get the nervous system ready for approaching danger, and it is the same heightened state of emotions experienced by someone who has a new idea. Before he painted *Les Demoiselles d'Avignon*, Picasso was visiting the Trocadero when he came upon the primitive masks from Africa. He began to shake with anxiety, the same emotion that humans experience when confronting fear.

Internally, the rush of adrenaline that accompanies the presence of danger is indistinguishable from that which floods the nervous system at the eureka moment. It is not uncommon for someone possessed of a really great idea to slam his or her fist against an open palm, strike a wall, or make an extreme physical gesture. The metaphors used to preface an insight are revealing. "I 'hit' upon a 'shocking' idea." "A great thought 'struck' me." "I was 'knocked' out by it." "I had a 'dynamite' idea." "I was bowled over." And, "I really slammed it right out of the park."

Creativity is a combination of courage and inventiveness. One without the other would be useless. The courage of Leonardo to use experience as his teacher rather than parrot what was written in ancient textbooks; the stance of a Giordano Bruno in promoting the Copernican theory that resulted in the Church burning him at the stake; and the hubris of the lowly twenty-six-year-old patent official submitting his paper on relativity without major references to a prestigious journal are all examples of courage.

Because of the lopsided shift to the left hemisphere of nearly all the language modules, the right side ended up with an equally lopsided share of the emotions. Fear plays a most prominent role. Because the right brain is essentially bereft of language, the description in words of

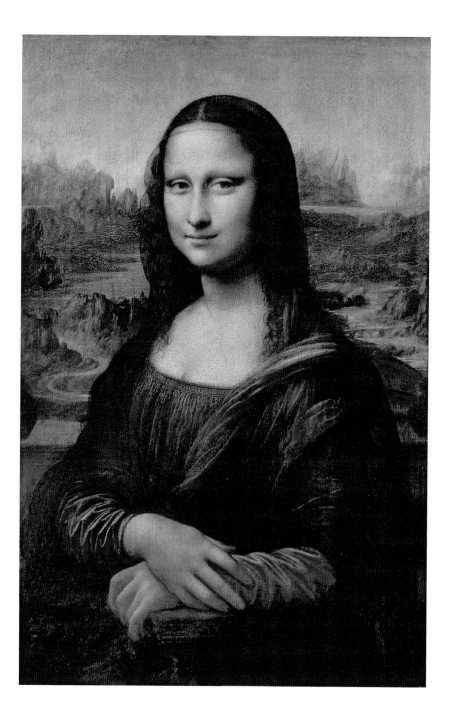

Previous page: Fig. 1: *Mona Lisa*, c.1503–6 (oil on panel),
Vinci, Leonardo da (1452–1519)
Louvre, Paris, France / Giraudon / The Bridgeman Art
Library

Fig. 2: *Arno Landscape, 5th August*, 1473 (pen and ink on paper)
Vinci, Leonardo da (1452–1519)
Galleria degli Uffizi, Florence, Italy / The Bridgeman Art Library

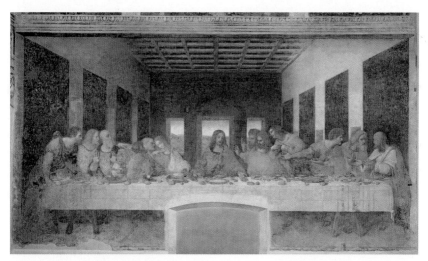

Fig. 3: *The Last Supper*, 1495–97 (fresco) (post restoration)
Vinci, Leonardo da (1452–1519)
Santa Maria della Grazie, Milan, Italy / The Bridgeman Art Library

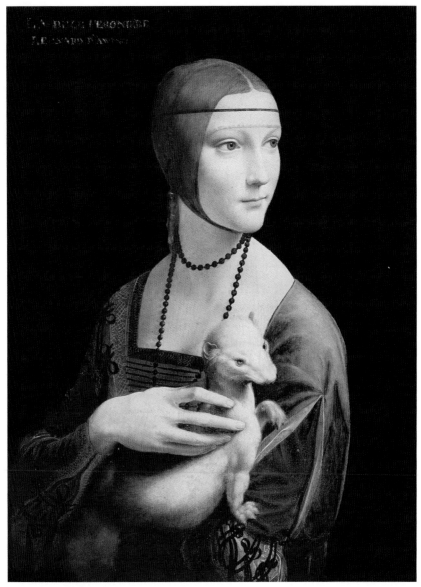

Fig. 4: *The Lady with the Ermine* (Cecilia Gallerani), 1496 (oil on walnut panel)
Vinci, Leonardo da (1452–1519)
© Czartoryski Museum, Cracow, Poland / The Bridgeman Art Library

Fig. 5: *Le Déjeuner sur L'Herbe (Luncheon on the Grass)* (oil on canvas)
Manet, Edouard (1832–83)
Musee d'Orsay, Paris, France / Giraudon / The Bridgeman Art Library

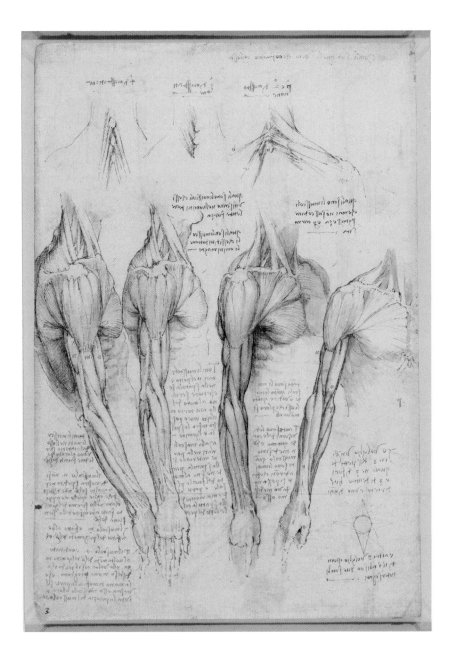

Fig. 7: *The Adoration of the Magi*, 1481–82 (oil on panel)
Vinci, Leonardo da (1452–1519)
Galleria degli Uffizi, Florence, Italy / The Bridgeman Art Library

Fig. 8: *St. Jerome*, c.1480–82 (oil & tempera on walnut)
Vinci, Leonardo da (1452–1519)
Vatican Museums and Galleries, Vatican City / De Agostini Picture Library /
G. Nimatallah / The Bridgeman Art Library

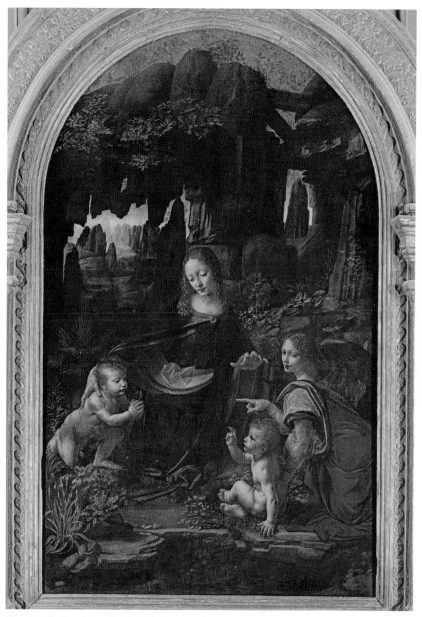

Fig. 9: *Virgin of the Rocks (Madonna of the Rocks)*, c.1478
(oil on panel transferred to canvas)
Vinci, Leonardo da (1452–1519)
Louvre, Paris, France / The Bridgeman Art Library

Fig. 10: Rubin Vase

Fig. 11: Necker Cube

Fig. 12: "The Vitruvian Man," c.1492 (pen & ink on paper)
Vinci, Leonardo da (1452–1519)
Galleria dell' Accademia, Venice, Italy / The Bridgeman Art Library

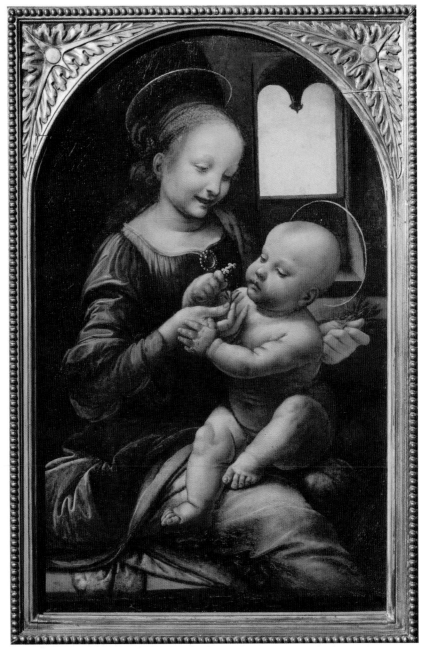

Fig. 13: *Madonna with a Flower,* or *The Benois Madonna*, 1478–81 (oil on canvas)
Vinci, Leonardo da (1452–1519)
Hermitage, St. Petersburg, Russia / The Bridgeman Art Library

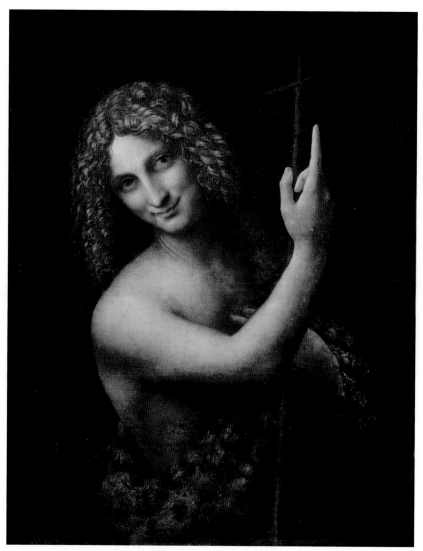

Fig. 14: *St. John the Baptist*, 1513–16 (oil on canvas)
Vinci, Leonardo da (1452–1519)
Louvre, Paris, France / The Bridgeman Art Library

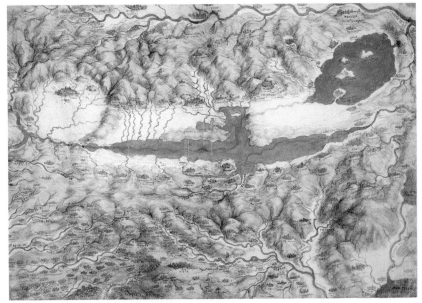

Fig. 15: A map of the Val di Chiana, c.1503–4
(pen & ink with w/c and gouache over chalk)
Vinci, Leonardo da (1452–1519)
The Royal Collection © 2014 Her Majesty Queen Elizabeth II / The Bridgeman
Art Library

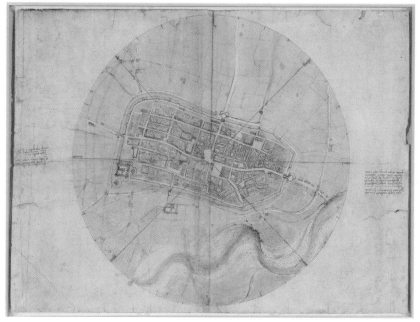

Fig. 16: A plan of Imola, 1502 (pen & ink, wash and chalk on paper)
Vinci, Leonardo da (1452–1519)
The Royal Collection © 2014 Her Majesty Queen Elizabeth II / The Bridgeman
Art Library

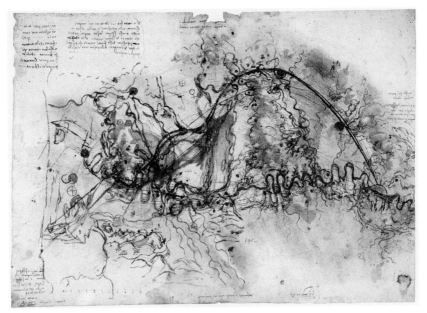

Fig. 17: A scheme for a canal to bypass the Arno, c.1503
(brush & ink over black chalk on paper)
Vinci, Leonardo da (1452–1519)
The Royal Collection © 2014 Her Majesty Queen Elizabeth II / The Bridgeman
Art Library

how the creative process proceeds is practically impossible. Ask artists or scientists how they arrived at their most novel and creative work, and you will no doubt receive either an inarticulate answer or the left brain's confabulation.

A few higher animals are capable of creative solutions to problems. But, as best as we can determine, none of their solutions include an aesthetic quality. That sense remains among the most resistant to the sociobiologist's evolutionary explanations. A Pleistocene hominid lost in the contemplation of a beautiful sunset would be less alert, making him an easier target for a predator on the prowl. It is not at all apparent why an expenditure of considerable time and calories of energy creating a work of art that is nonutilitarian, and whose sole purpose is to make something that is pleasing to the eye, would increase the fitness, either physical or reproductive, of the species.

There are suggestive examples of this trait existing among a few animals, but a fully developed sense of beauty seems to have blossomed in humans to a far more sophisticated degree than in any other animal. Which leads to the question: From an evolutionary point of view, why are the genes that enable this trait sitting in our genome? And under what evolutionary pressure did they arrive in the first place?

Despite the fact that different cultures may have wildly disparate conceptions concerning what is beautiful, an appreciation of beauty seems to be universally distributed among peoples everywhere. And its distribution in any given population of humans seems to follow a bell-shaped curve: Some at one end are seemingly devoid of a sense of beauty, and others at the opposite extreme are exquisitely sensitive. At its core, a sense of beauty does not seem to be rooted in culture, but rather appears to be a quality that we are born with and refine as we grow older. As the German philosopher Immanuel Kant would say, it is an *a priori* potential that is built into our nervous systems.

Examining the question of beauty is particularly relevant to a study of Leonardo. The Florentine master was extremely interested in ferreting out the elements of beauty to better represent them visually.

Many philosophers, aestheticians, artists, and art critics have had an enduring interest in understanding what they think beauty is and what it is not. In contrast, although scientists consider the natural world to be a fit subject for investigation, examining what exactly is the scientific basis for our human sense of beauty has aroused remarkably little interest. This is all the more puzzling when one considers how often scientists wax rhapsodic in their memoirs about how they were moved to ecstasy by an elegant solution to a problem, or the sense of wonder they experienced facing the mystery of their particular field. In general, curiosity about the roots of why we humans seem to have evolved a sense of beauty is considered by most scientists to be beyond their purview. And yet, I will contend that the search for beauty has played a crucial role in propelling our species away from all the others. I believe that a highly refined sense of beauty, when combined with the most primitive of instincts—fear—is the *driving force behind human creativity.*

When sexually reproducing creatures evolved, the primitive instinct warning them that something dangerous had entered their field of vision began to serve double duty, alerting them that a willing mate could be in the vicinity. The fear response became intimately associated with sexuality. In mammals and birds, the two phyla that display emotions, this bundling would become more visible. Sex and danger became integrated.

Because males produce so many sperm in comparison to the precious resource of females that only comes into estrus ("heat," or whatever else ethologists choose to call the female's "season"), the male must be the one to display courage. He must prove to the female that he is worthy of her attention above all others.

Peacocks strut their stuff, some frogs ribbit until they croak, a few moose sing their hearts out, but the preferred method for gaining dominance is to fight. Above all else, courage is the singular trait females are looking for. It tells the females that they are witnessing the display of a trait that guarantees superior genes.

Creativity is at its base a combination of fear and lust. Danger and sex are the fundamental processes that artists traditionally call upon to create

a work of art. Of course, he or she is not aware that these are the root causes. Creativity begins with perceiving a pattern, a feature, or an alternative use for a common object. After recognizing something novel, the artist breaks down the observation into its component parts. This is primarily a left-brained function, reductionist and analytic. An artist will reassemble the pieces into a new and compelling manner that others will recognize as art. But the work of art must contain "passion." It must be a work of "love." He or she must be in a nearly "orgasmic" state to produce it. Our word *enthusiasm* comes from Dionysian *enthousiasmos*, a wild state of holy inspiration. Orgasm is a right-hemispheric function. Love is rooted in the right brain. Ecstasy is an emotion experienced at the right of the corpus callosum.

The scientist does the same, but is interested in understanding how the parts relate to the whole. Whereas the scientist uses reductionism and synthesis in the service of advancing knowledge, the artist uses the same in the service of aesthetics. The artist employs images and metaphors to interpret the relationships of reality; the scientist imposes numbers and equations on nature to express the relationships of reality. The writer Vladimir Nabokov observed, "There is no science without fancy, and no art without facts." The revolutionary artist and the visionary scientist are both fundamentally engaged in investigating the essence of reality.

A sense of beauty would not have evolved unless it gave humans an edge in the fight against other animals for resources. But, the question must be asked: Of what conceivable benefit could it have been to be in awe of a gorgeous sunrise when the attention would have diminished one's alertness to danger?

Beauty is, unfortunately, one of those short, slippery, all-purpose words that resemble children's play bubbles. The word *beauty* is used so commonly in so many different contexts that trying to grab ahold of the word is like trying to wrap your arms around a rainbow. The experience of beauty, like love and truth, is subjective. Its qualia of nonobjectivity is the reason scientists have, for the most part, avoided getting stuck in this ambiguous word.

Further reflection on beauty's definition, however, allows its breakdown into several different categories. There are three distinct kinds of

beauty: sexual, natural, and artifactual. (An *artifact* here is something crafted by the human hand.) These three categories overlap each other.

Sexual beauty refers to the attraction between the sexes. Beautiful women are attractive to heterosexual men because that is the way men's brains are hardwired. Heterosexual women are attracted to handsome men because that is the way their brains are hardwired. Gays and lesbians are attracted to the same qualities as heterosexuals, but their sexual interest is primarily focused on members of the same sex. Because every human is a psychic hermaphrodite—that is, each of us has a masculine side and a feminine side—all humans experience some degree of pleasure when looking at a healthy, well-formed human of either sex.

Natural beauty is a combination of features of the environment that evokes feelings of pleasure, serenity, or awe, and these combinations are fairly universal in their ability to arouse these feelings among peoples who live in widely diverse locales. Shady glens, clear running streams, craggy mountain vistas, waves breaking upon a sandy beach, and bright blue skies containing fluffy white clouds all produce a similar feeling in the vast majority of humans.

The third category, *artifactual beauty*, is the oddest. While humans are among a multitude of other creatures that fashion tools for a particular use, we appear to be the only animal concerned that the tool we make is aesthetically pleasing. From artisanal toolmaking, humans progressed to becoming artists. The objects they created increasingly had less and less practical value, until the artist was motivated to make something beautiful that was *not* utilitarian: art for art's sake. But why would someone devote time and energy to create something that could not be used in any capacity other than to evoke a response in the viewers or the artists themselves? Why do we seek beauty for beauty's sake?

The adaptation we call "appreciating beauty" begins with sexual attraction. How humans sublimated one of the instinctual drives, originally intended to heighten procreation, into an urge that propelled Leonardo to paint *The Last Supper* is instructive. It will lead to an understanding of how the quest for beauty became an integral part of human creativity.

When we compare how humans mate to the manner by which other animals mate, the human conception of beauty begins to be seen as one very strange adaptation. In almost all sexually reproducing species extant on the planet, males are attracted to females by means of a signaling device she emits around the time her eggs (or ova) become ripe. In every other species other than humans, this is the prod that informs his instinctual nervous system that it is time for him to get sexually aroused.

This simple arrangement alerts the male that the female of the species is approaching a time when copulation (or its equivalent) will result in a maximal chance that conception will occur. This ensures that the next generation of the species will endure, and that the entire species will avoid extinction.

In elephants, ethologists call this signal "musth"; deer have their "rut," dogs experience "heat," and primates have "estrus." Despite the colorful names humans have assigned to these periodic celebrations, the purpose of all the signals is the same. In the majority of instances, the female wafts a pheromone into the surrounding environment. This enticing odor, sometimes measuring molecules in the minutest concentration, reaches the sensitive olfactory organ of the male, producing an altered state in his nervous system manifested by profound changes in his behavior. The male becomes fixated on one thing and one thing only—sex. Males of some species can detect the females' pheromonic siren scent/song from miles away.

In most species, males congregate around the females and a great sexual emporium begins. Sometimes males engage in fights for dominance to see who has the heart, strength, and courage to mate with the females. In other species, males perform elaborate courting displays. The female signaling is the method that has been used with enormous success for millions of years for millions of species. It is extremely efficient, because this instinct gets the job done by selecting the most superior genetic material of males and matching them with the precious and sparse ova of the female.

So why did we humans abandon this system? What benefit to our species was so great that Natural Selection chose to give us an entirely new way to do it? Of all the species present on the planet, the one we

know for sure that *does not* give an easily identifiable signal is the human female. And if humans abandoned the signaling system, what device has replaced it? What is it that attracts men to women and, to a lesser extent, women to men? Although pheromones continue to play a minor role in humans, they have receded into insignificance.

The signaling device that replaced leading pheromones or an involved swelling of vulvar signaling in humans was—beauty! A ravishingly beautiful woman could and does turn a man weak in the knees. What a fascinating and interesting development! Beauty as a means of sexual attraction seems to be nonexistent in other animals. Drawing on the observable behavior of other creatures, we do not see males interested in the overall shape of a female's body or the configuration of her facial features when he is in the mood to mount.

Jane Goodall and her team observed that Flo, an old, scrawny, and, to them, relatively ugly female chimp, was the preferred female of the troop. The males, young and old, would patiently line up awaiting their turn to copulate with Flo, passing up the opportunity to have sex with much younger females. Goodall's team concluded that Flo's superb mothering skills meant more to the chimpanzees than physical beauty. As far as we can ascertain, only in humans are the males of the species profoundly influenced by the female's outward appearance.

Two other physical indicators are so entwined with beauty that the three are nearly inseparable: health and youth. Both, when added to beauty, were prime indicators by which a male's limbic system could gauge whether the female was fertile and likely to bear healthy children.

A prospective mate's health also determined whether the infant she bore would survive the critical early years of childhood. Muscle tone, limber limbs, a shapely body, and a symmetrical face were good indications a man could use to unconsciously choose a woman who most likely would increase the odds of his genes surviving in the next generation. From an evolutionary point of view, this was a very radical development. Rather than giving a signal that her eggs had departed her ovaries, a female attracted a male by her "looks."

Human females—by virtue of their radical reproductive makeover— were also no longer driven by the urgent instinct to mate during ovulation,

as all other females were. This gave them the opportunity to reflect on their choice of mate. Despite the fact that females of any species also exercise choice, none exercise near the degree of choosiness as the human.

For sure, the human female, similar to her non-human counterparts, is still attracted to a male that exhibits outstanding physical traits. Only the human female consciously makes the connection between sex and pregnancy, leading her to understand that she needs a male companion who not only comes and goes in a heated rush, but one who will stay by her side to help her raise their young. Unlike health, strength, and handsomeness, few external signs exist to indicate the internal character of the male. The human female needs an instinct to see beyond the physical appearances of a man and ferret out his true nature (eventually labeled "woman's intuition"). This assessment, which she has come to understand over many generations, is of more value than choosing a male based on physical characteristics alone. While beauty continues to play an important role in female selection of men, it plays a far lesser role in sexual desire than it does for a man.

Despite the enormous variations in body type and facial features, the standard for sexual beauty is buried deep within the human genome. Once this feature became manifest, it began to leak over to other areas so that humans would use beauty for more than just sexual survival.

Nowhere in the thousands of pages that Leonardo wrote does he ever explicitly offer his personal concept of beauty. Yet, there can be no other subject that consumed Leonardo more. Art critics and subsequent painters had to invent a special art term, *Leonardoesque*, to convey his unique ability to capture the beauty of the human face and form. He created animals so lifelike they appear ready to step right off the page. And, in the run-up to the Renaissance, no ancient, medieval, or contemporary artist was ever able to re-create with such unerring accuracy the beauty of their natural surroundings. Leonardo's renderings of rocks, water, clouds, plants, and flowers were exceptionally beautiful. And yet no meaningful hypothesis of why we have an aesthetic sense appears in his voluminous writings.

Natural Selection installed the code in our genome that established beauty as *the* key criterion associated with sexual attraction, and this

extraordinary new aesthetic would be pressed into a new role in our environment. An unusual feature of humanhood made this transition imperative for the survival of the species. The beauty gene was pressed into service to cover another function, because humans wandered away from the template used by practically all other animals: We are explorers.

Endowed with a thirst for exploration, humans are willing to venture far away from what can be considered home. This untethering of humans from an invisible border fence that more or less hems in other creatures has enabled humans to populate the entire globe. There is no environmental niche that humans have not explored or inhabited. Human communities can be found thriving in steamy rain forests, arid deserts, arctic tundras, and air-thin mountain peaks. With the possible exception of rats, there are no other species of mammals that can make that statement.

What makes human wanderlust so extraordinary is how poorly equipped *Homo sapiens* originally were for a life of trekking. Being the only one of 270 species of primates that have permanently molted any vestige of a thick coat of fur that might keep them warm in the winter, humans were dependent on the availability of resources to fashion garments to serve as a substitute. Author Desmond Morris aptly named our species, and his book, *The Naked Ape*. He pointed out that if the pelts of all primates were arranged in a line, the one that would stand out from all the others was the one that had no fur. In extreme heat humans need to perspire to control their internal temperature; this requires them to have a constant source of freshwater and salt.

To supplement this extraordinary foray away from the norm of animal behavior, Natural Selection found it necessary to install in these intrepid travelers an instinct that would inform them when they were in an environment that could sustain them. This new instinct was based on aesthetics.

There was a considerable trade-off, however, when Mother Nature enlarged the function of the sexual attraction gene to include natural beauty. Lost in the reverie of observing a beautiful tableau, a prehistoric human would be less aware of the wild beast stealthily creeping up behind him or her. It is a measure of just how urgent it was for Mother Nature to install an instinct for appreciating natural beauty. To do so, she had to override the

instinct designed to keep an individual safe. The "Wow!" factor was for the wandering human more important than the "Look out!" factor.

Once archaic humans evolved into the exploratory primate willing to leave the comfort and safety of a familiar territory to strike out for parts unknown, they needed a sense that would subconsciously inform them when they were in an area propitious to their survival. Fast-running streams, meandering rivers, or waterfalls not only fill humans with a sense of beauty, but also provide necessary water. Craggy cliffs and rugged mountains provide rock shelters, ledges, and caves for refuge. Wide-open spaces, crystal-clear atmospheric conditions, and distant sight lines allowed our ancestors to spot potential prey and identify approaching predators or enemies.

When we more closely examine the aesthetic associated with nature, we encounter very different criteria for determining what is beautiful and what is not. Instead of using the most common ratios and regular proportions among various facial and body features to evaluate beauty, we judge the wild by how distant a feature resides from the crest of the bell-shaped curve. The highest mountains, deepest valleys, fullest waterfalls, wildest rivers, and steepest cliffs are the ones designated as national parks. Whereas the beautiful in human faces tends toward the familiar and symmetrical, in nature it is the unfamiliar and irregular.

At some unconscious level, randomness and asymmetry appeals to our aesthetic sensibilities. Who has not lain on their back in fresh, sweet-smelling grass while looking at the sky, festooned with shape-shifting clouds? It is the sheer unpredictability of their ever-changing patterns that makes them so beautiful. Strolling in a forest planned and planted by humans in which the trees are spaced in neat rows is not as aesthetically exciting as exploring the irregular twists and turns of a wilderness. Snow-flakes, the vein pattern in leaves, and the random arrangement of features in a meadow drive home the point: Natural phenomena never exactly repeat. Unlike the regularity and symmetry we seek in sexual attraction, our attraction to the wild is spiced by its stupendous variety.

The instinct to appreciate beauty, originally installed for sexual attraction, eventually served to alert us to beautiful natural surroundings. It then

made one final leap to a new set of chromosomes, and the new combination infused something spectacular into the life of humans.

From that evolutionary moment forward, the species that would evolve into *Homo sapiens* began to create, seek, find, assemble, and rearrange material objects and abstract symbols. Increasingly, these artifacts possessed the qualities of elegance and grace. The instinct to search for beauty is so powerful that in many cases, it is capable of overriding the instinct for sexual attraction or natural beauty. Many artists and scientists would rather forgo the pleasures of carnal delight in order to complete their quest to create something of beauty.

Visionaries are those in the field of art and science who recognize novel patterns. They see beauty before the rest of us do. Then we catch up with them and agree that the innovation they imagined is, indeed, something marvelous to behold. That is why scientists speak of elegant equations and why artists can rearrange components of reality in countless new patterns that allow the rest of us to see the world in a new way.

CHAPTER 11

Leonardo/Theories

Science is not a heartless pursuit of objective information. It is a creative human activity, its geniuses acting more as artists than as information processors. Changes in theory are not simply the derivative results of new discoveries, but are the work of creative imagination influenced by contemporary social and political forces.

—STEPHEN JAY GOULD

The Earth is not in the center of the circle of the sun, nor in the center of the universe, but is in fact in the center of its elements which accompany it and are united to it. And if one were to be upon the moon, then to the extent to which it together with the sun is above us, so far below it would our Earth appear with the element of water, performing the same office.

—LEONARDO DA VINCI

More than any other single invention, writing has transformed human consciousness.

—WALTER ONG

LET US NOW CHANGE THE FOCUS BACK TO LEONARDO. HIS NAME IS featured prominently in all comprehensive art history books. Rarely does it surface in science history books. When it does, there always seems to be an asterisk next to it, as if to say, yes, this exceptional human being did indeed make some prescient notes in his private journals, but because he did not influence the forward movement of that collaboration called

the "scientific endeavor," his place among great scientists must be a mere footnote.

Scientific luminaries of the stature of Albert Einstein and Stephen Jay Gould dismissed Leonardo's contributions. Yet, if one carefully examines the record, one cannot fail to stand in awe of his accomplishments in the field of science—or, more appropriately, in various *fields* of science. One of Leonardo's biographers, Edward MacCurdy, summed up his accomplishments thus:

> *Before Copernicus or Galileo, before Bacon, Newton or Harvey, he uttered fundamental truths the discovery of which is associated with their names. "The sun does not move." "Without experience there can be no certainty." "A weight seeks to fall in the centre of the Earth by the most direct way." "The blood which returns when the heart opens again is not the same as that which closes the valve."*

Identifying the individual upon whom they would bestow the title of the *first* scientist has kindled a gentlemanly debate, with Galileo Galilei garnering the lion's share of supporters. Until recently, Leonardo's name has rarely surfaced as a candidate for the honor. Leonardo, however, *was* history's *first* true scientist. He enthusiastically embraced the scientific method of observation, hypothesis, and experimental proof, adumbrating Galileo by a century. He was more exacting than Aristotle, more hands-on than Francis Bacon, and more relentlessly curious than Descartes. Newton seems to have channeled many of Leonardo's earlier concepts.

Leonardo can be credited with having initiated entirely new fields of scientific endeavor. He thoroughly investigated the fields of optics, botany, geology, anatomy, aeronautics, cartography, fluid dynamics, city planning, and mechanical engineering, to name but a handful. Using the scientific principles he either discovered or built upon the work of others, he invented myriad machines, military hardware, and measuring devices. Some sources credit Leonardo with having invented no less than three hundred of these marvels. So visionary were they that few ever actually became working models, because during the time in which he lived, the technology did not exist. In terms of the sheer volume of

significant inventions based on scientific principles, only Thomas Edison can compare.

Although Leonardo generously shared his knowledge concerning the finer points of painting and drawing with his students and disciples, he rarely divulged the information he had so painstakingly gathered concerning the workings of the natural world. The only cohesive "book" Leonardo ever assembled was his *Treatise on Painting*, and even this extended essay had to wait. His loyal disciple Francesco Melzi compiled an abridged version, and it was not published until 1651, well over a century after Leonardo's death.

His contemporaries, accustomed to reading about scientific matters in Latin or Greek, would have denigrated Leonardo's use of what they dismissed as "the vulgar" language. His notebooks did not contain a clear linear narrative that clarified his thought processes. Leonardo made his comments on various subjects haphazardly; they resembled a stream of consciousness more than they did a coherent argument.

Compounding the confusion, the keepers of Leonardo's papers after Melzi's death in 1572 often cut them up, or arbitrarily rearranged and shuffled them so as to obtain a higher price from the collectors who viewed them as extraordinary oddities without any understanding of the value these pages possessed. Extrapolating from what remains, experts speculate that two-thirds of his original notebooks have been lost. Correctly collating and sequencing his remaining pages and accurately dating them was something that had to wait until the end of the twentieth century.

Further complicating the task: Leonardo had the habit of writing or drawing on a sheet of paper and then years later adding something else to the same page. This has bedeviled those *Leonardisti* attempting to follow the trajectory of his restless thoughts. An army of dogged researchers, however, using handwriting analysis, computers, and constant cross-referencing, have nearly completed the herculean task of rearranging his notebooks into a linear sequence. One benefit of this research was the discovery that around 1490, when Leonardo was thirty-eight, his notebooks moved from describing inventions to a more intense search for underlying principles.

Comparable to an explorer on an unknown continent, Leonardo made many false starts, proposed many wrong hypotheses, and came to many erroneous conclusions regarding the workings of the natural world. He corrected some of these misperceptions through sustained research and experimentation. These redeeming findings have only recently come to light, making the present time propitious to reevaluate Leonardo's record as a scientist.

The nature of scientific exploration is its inherent sense of incompleteness. For Leonardo, there always remained a few unexamined phenomena that he believed were necessary to enfold into his theories before he could triumphantly explicate them. This obsession with perfection presented another obstacle to sharing his valuable scientific insights.

Further complicating matters: He recognized his genius and appreciated that his greatest marketable resource was his imagination and creativity. He lived in a society without patents, in which one's discoveries could be stolen and used for someone else's monetary and prestigious advantage. Leonardo's ability to promote himself as an engineer, architect, or designer depended on keeping much of his hard-won knowledge to himself.

Leonardo sincerely believed, as he stated in various places throughout his scattered notes, that he would eventually get around to organizing his observations regarding anatomy, optics, botany, and mechanical engineering, and publish them in a proper book. It was an incredibly daunting goal to set for himself. His notes were a hodgepodge, and he refused to delegate this project to anyone else. The demands of organizing his writing would have been considerable, diverting him from his art and his scientific investigations. Adding to the problem was his need to make a living and deal with all the vicissitudes of life. Unfortunately, the sixty-nine years allotted to him by fate were insufficient, and he was unable to accomplish his goal.

Secrecy is an anathema to science. In the years following Leonardo's death, science slowly evolved into a cooperative venture that recognized it could only flourish if its practitioners shared their findings with each other. Many science historians are critical of Leonardo for hoarding his knowledge when it could have made a huge impact on subsequent

scientific investigations. Lest we be too hard on this Renaissance poly-math, let us remember that the trend toward openness and the sharing of one's discoveries was something that developed in fits and starts, and was in very short supply during the era in which he lived.

Because of his failure to publish, Leonardo failed to excite the imagi-nation of later scientists, nor did he ignite the interest of subsequent his-torians. In addition, art critics and the public had firmly established his reputation as a consummate artist. The barrier separating first-class art from first-class science was so formidable, it seemed almost excessive to accord him his due in the field of science. Nevertheless, history has a way of righting wrongs, and I will make the case that Leonardo should receive the honorific of history's First Scientist.

Let us begin by enumerating the many examples of Leonardo's theories.

Scientists generally accord physics the honorific of the "King of Sci-ences" because of its centrality to all the others. Leonardo made a number of astounding discoveries in this axial field. Of Newton's Three Laws of Motion, Leonardo had elaborated both the first and the last. Newton framed his first law in 1687 thus:

An object at rest tends to stay at rest, and an object in motion tends to stay in motion with the same speed and in the same direction, unless acted upon by an unbalanced force.

Leonardo wrote in his notebook, "Nothing whatever can be moved by itself, but its motion is effected through another. There is no other force." Elsewhere he wrote, "All movement tends to maintenance, or rather that all moved bodies continue to move as long as the impression of the force of their motors (original impetus) remains in them." His explication was once known as the Principle of Leonardo until Newton restated it in mathematical terms.

Leonardo also had expressed the idea behind Newton's Third Law: For every action there is a reaction. In studying the effects of air and eagles, Leonardo wrote: "See how the wings, striking the air, sustain the heavy eagle in the thin air on high. As much force is exerted by the object

against the air as by the air against the object." Similarly, he grasped the principle of flight by determining that to understand how a bird's wings keep it aloft, one must also understand the action of winds that press upward under the bird's wings.

The number of important principles of physics that Leonardo either noted in words or graphically illustrated, long before the essential groundwork had been laid, was astonishing. He intuited Torricelli's law, propounded by Evangelista Torricelli in 1643, which enumerated the factors that affect the rate a liquid flows through an opening. Torricelli expressed the law in an elegant equation that factored in all the variables. Nearly two hundred years earlier, using his astute observations of flowing water, Leonardo arrived at a remarkably similar conclusion using words and images.

In his extensive study of the preconditions for flight, Leonardo grasped the great principle laid out in Bernoulli's law, expounded in 1738 by Dutch mathematician Daniel Bernoulli. The speed of air flowing above a plane's wing in contrast to the slower speed flowing below the wing creates a pressure differential that is the crux of Bernoulli's law. This simple aerodynamic is what supplies the "lift" necessary for flight, and allows massive airliners to take off and stay aloft. More than two centuries earlier, a lone investigator uncovered this great principle without the benefit of higher mathematics.

The peculiar sound of a train's whistle as it approaches and then recedes as it passes is a familiar phenomenon. The German mathematician Christian Doppler in 1840 explained in refined mathematical detail how the phenomenon is due to lengthening concentric ovals of sound waves due to the movement of the source of sound past the hearer. For his discovery, this hee-haw sound has been christened the "Doppler effect." Leonardo observed the oblong wave patterns created on moving water by a pebble tossed into a stream. Extrapolating from water waves to sound waves, Leonardo described and illustrated the auditory phenomenon Doppler described in equations three hundred years later.

Leonardo's intuitive grasp of exceedingly complex concepts in physics without the benefit of a deep knowledge of the underlying mathematics makes his discoveries all the more impressive.

When Descartes invented the field of analytical geometry in the mid-seventeenth century, demonstrating how algebraic relationships could be expressed visually on a graph, he was unaware that an unschooled genius working practically alone 150 years earlier had converted abstract mathematical relationships into visual representations with stunning results.

The French lawyer/politician and renowned mathematician Pierre de Fermat had the habit of not publishing his extraordinary mathematical findings. He wrote in a letter to a friend in 1657 that light must travel in the shortest path in the least amount of time. Fermat's principle, as it has come to be called, states that nature (with few exceptions) chooses the shortest direction to accomplish any transit in the least amount of time. To demonstrate the proof of this principle, Fermat needed an entire page of equations. The brilliant twelfth-century Arab mathematician— and hero of Alexandria—Alhazen had expressed Fermat's principle, but in a less-rigorous manner. We find in Leonardo's notebooks that he, too, had arrived at this fundamental principle of physics. He discussed its relation to light traveling through space and time, but his observation can be generalized to nearly all natural phenomena. Again, Leonardo's insights occurred nearly two hundred years before Fermat came to his conclusions.

The law of conservation of mass states that a given quantity of mass at the beginning of an experiment will exactly equal the amount of mass at the end. It is of no consequence how many transformations, deformations, or reformations the mass experiences during the experiment. Leonardo became intrigued with this subject when he met the geometer and mathematician Luca Pacioli when Leonardo was in his forties. Together they published a book about the principles of geometry in 1509, with Leonardo supplying the illustrations of Pacioli's principles and conclusions. It would be the only book Leonardo had a hand in publishing during his lifetime. Without stating the conservation of mass law as definitively as Newton did in his 1687 *Principia*, Leonardo realized that despite the many deformations of geometrical shapes moving through space, their mass always remained the same. Had he had the mathematical background, I am convinced that he would have also announced the conservation of mass law.

While working with Pacioli, Leonardo did in fact immerse himself in the study of mathematics and geometry. Leonardo toyed with an idea that became the heart of the integral calculus: "[S]pace is a continuous quantity and that any continuous quantity is infinitely divisible." Though he did not come up with the equations themselves, this is still impressive. One cannot overemphasize the important role that the discovery of integral calculus has played in the advancement of physics and mathematics

One of the disarming questions parents must address is the one posed by their young child: "Why is the sky blue?" Physicists have struggled to find the correct answer to what would seem at first glance to be a simple conundrum. Not until Lord Rayleigh in the late nineteenth century explained that it was due to the scattering of sunlight off atoms and molecules in the atmosphere did a scientist propose an explanation that appeared to lay the question to rest. Rayleigh won the Nobel Prize in Physics in 1904 for this work. Several decades later, Albert Einstein, using equations derived from his 1905 theory of special relativity, expanded upon Rayleigh's work, and produced the definitive explanation for why the sky was blue.

And, yet, the solitary Leonardo, using nothing more than his considerable powers of observation and deductive reasoning, arrived at the same conclusion as to why the sky is blue:

> *I say that the blueness we see in the atmosphere is not intrinsic color, but is caused by warm vapour evaporated in minute and insensible atoms on which the solar rays fall, rendering them luminous against the infinite darkness of the fiery sphere which lies beyond and includes it.*

Leonardo's foray into matters relating to the atmosphere, as well as his other observations concerning the nature of clouds, makes him the appropriate candidate for the title of history's first meteorologist.

Leonardo challenged the classical notions of Plato and Aristotle, who taught that the sun and the moon were perfect spheres. Using only deductive reasoning, Leonardo concluded that the blotchy complexion of

the Man in the Moon's face was due to surface mountains and valleys, and therefore the moon could not be a perfect sphere.

Again, using his keen sense of observation, he correctly surmised that the reason the portion of the moon hidden during the slivery appearance of a new moon remains faintly visible to observers on Earth is because sunlight reflects off of Earth's oceans and mountains' snowcaps and back into space, illuminating that darkened portion of the moon. Using deductive reasoning, and without the aid of any scientific instruments, Leonardo noted that the sunlight reflected off the moon's surface during its full phase is sufficient to venture out in nighttime and still discern the features of the earthly landscape. Michael Maestlin, Kepler's teacher, gave exactly the same explanation over one hundred years later.

Though he lacked algebraic language, as science historians point out, his explorations in geometry and his fascination with cartography led him to create some of the most arresting and accurate maps of his times.

Author Fritjof Capra outlines the story of Henri Poincaré, a mathematical genius, who had discovered a complicated principle concerning geometry that he called *topology* at the turn of the twentieth century. Earlier, in the seventeenth century, Gottfried Wilhelm von Leibniz had attempted to assemble these geometrical concepts, but did not complete his efforts. Then, in the nineteenth century, mathematical insights and important additions exploded, giving Poincaré the accessory information that would help him in his calculations. The Frenchman used delicate geometric inserts that could subtly influence the drawing of maps.

Capra, however, points out that in the Renaissance, Leonardo's map of the Val di Chiana [Fig. 15] used graphic sleight of hand that resembled the method outlined in Poincaré's equations. Leonardo's astonishing accomplishment would not be seen again for nearly half a millennium. In his map detailing the watercourses of the Val di Chiana, he distorted the map so as to highlight the salient features shown in the center of the map while scrunching the periphery in a clever and revolutionary manner. This distortion had the effect of making the map appear realistic yet more readable. Poincaré was unaware that Leonardo, five hundred years earlier, had expressed topological principles graphically.

Capra also points out that despite Leonardo's limited familiarity with sophisticated algebra, Leonardo, the civil engineer and painter, routinely used a kind of mental algebra to calculate proportions and loads for fulcrums, levers, and pulleys. This field of modern physics is known as *statics*. Leonardo accurately estimated lever arm length, position of fulcrums, and the amount of weights and accurate distances using his super-refined artistic sense of proportion. This should not be surprising, as he considered painting a science, and utilized his calculations concerning the correct proportions of objects to paint them faithfully.

Leonardo was not entirely unfamiliar with algebra and trigonometry. Leonardo the military specialist, without using the symbols of these complex forms of higher mathematics, was able to calculate the trajectories of cannon- and mortar-fired projectiles.

His study of water presaged the branch of physics called chaos theory (later renamed complexity theory). The Swiss mathematician Leonhard Euler in 1755 made the first attempt to express turbulence mathematically. Heinrich Helmholz, 350 years after Leonardo's initial observations, was the next physicist to study water vortices and their turbulence in a systematic fashion. Fluid dynamics initiated the field of complexity theory. Rarely do science textbooks mention Leonardo's primacy in this important modern field.

Leonardo's interest in fluid dynamics and his careful study of the manner in which water flows led him to one of his most dramatic discoveries concerning physics and its subfield of optics. He studied wave motion of water by scattering kernels of grain or bits of straw on the still surface of a pond. He then disturbed the surface by throwing pebbles into the pond and observed that, although the waves he created diminished in intensity the farther they traveled from the point of impact, the kernels and straw remained bobbing in the same location.

He thus was able to conclude that a wave moved through the medium of water in a manner that did not cause the water molecules (particles) to move. This was the critical observation that laid the foundation for wave theory. He then extrapolated from his study of water waves and proposed that invisible sound waves traveled through the air in the same manner. Leonardo wrote:

Just as a stone thrown into the water becomes the center and cause of various circles, sound spreads circles in the air. Thus every body placed in the light spreads out in circles and fills the surrounding space with infinite likenesses of itself and appears all in all in every part.

In an age when almost everyone believed that light transfer was instantaneous, his next daring leap was to proceed to light, and conclude that it traveled through space and time in a similar manner.

Two hundred years later, Newton proposed that light consisted of little bits of light he called "corpuscles," and there was an interval of darkness between each tiny piece of light. Because of his immense stature after his publication of *Principia*, Newton's view of the nature of light was generally accepted by the scientific community.

But two hundred years earlier, Leonardo had arrived at a very different conclusion concerning the nature of light. In 1690, the Dutch mathematician Christiaan Huygens published a paper on light that hit the scientific community like a thunderbolt. Huygens overturned the reigning belief that light was particlelike in nature. Huygens's remarkable contrarian view—that light was wavelike—has earned him an honored place in the annals of science. While Huygens proved that light moved through space as a wave, his description was incomplete. He failed to describe what happened when two waves intersect, giving rise to transverse waves. This phenomenon, however, was described by Leonardo.

In 1697, the Danish astronomer Olaus Roemer discovered that light moved through space with a finite velocity. This finding, coming quickly on the heels of Huygens's paper, overturned another cherished belief among those in the scientific community: that light did not have a particular speed because its transfer from the moment it emanated from its source was the precise moment it arrived at its destination. Roemer's calculation posited that it took a finite amount of time for light to travel from here to there.

In 1803, Thomas Young published a paper on the wave theory of light in which he extrapolated from water waves to light waves, just as Leonardo had done, and demonstrated in a series of experiments similar to those performed by Leonardo that light indisputably traveled through

space and time as a wave. For their work, science historians credit Huygens, Roemer, and Thomas with experimentally proving the wave theory of light conclusively.

Imagine how much more quickly science would have advanced had the community of investigators been made aware that a fifteenth-century genius had proposed that light moved through space in the form of a wave and, further, that it produced transverse waves upon intersecting with another wave form, traveling with a finite velocity.

Leonardo also took a lively interest in the comings and goings of celestial objects. He outright rejected astrology, calling it "that deceptive opinion by means of which (begging your pardon) a living is made from fools." His stand was, for its time, exceedingly nonconformist. The age was infected with a deeply ingrained belief that the positions of the stars determined whether undertaking earthly ventures on a particular date was propitious or foolhardy. He grasped that Earth was a spherical globe and not the flat tabletop imagined by so many of his contemporaries. One of his notebooks contains the entry "The sun does not move," strongly suggesting that he knew that the sun, not the Earth, was the center of the solar system. He had a grander vision of our place in the cosmos when he declared that "the Earth was but a speck in the universe."

Leonardo's interest included the age of the Earth, which he estimated was markedly older than the four thousand years that had been proposed by the followers of the Bible. Georges-Louis Leclerc, Comte de Buffon, a French naturalist writing in 1778, estimated that the Earth was 74,832 years old. His work influenced the young Scotsman, Charles Lyell, who published the *Principles of Geology* in 1830. Lyell calculated that geological processes were immensely older, and that the Earth was in the process of evolving.

The young Charles Darwin brought this book with him on his now-famous voyage on the HMS *Beagle*, during which he hit upon his grand idea concerning natural selection, which he laid out in considerable detail in his 1859 *The Origin of Species*. Lyell had provided the young naturalist with the missing piece. For Darwin's theory to be plausible, he needed the age of the Earth to extend far back into the distant past, so that species would have the requisite long stretches of time during which they could

adapt to changing environmental challenges and evolve into entirely new phyla and species.

But Leonardo had also speculated that the various species, like the Earth itself, were the product of ongoing processes. He rejected the view held for the subsequent four hundred years—that the Earth was unchanging and that an omnipotent Creator had lavished all the diverse species of plants and animals upon the Earth in just a few days.

A key attribute of life is the presence of mechanisms that allow an organism to correct any internal imbalances created by a changing environment. Physiologists name this self-correcting mechanism *homeostasis*—the state at which all the organisms' enzyme systems operate optimally. In the 1970s, James Lovelock, an independent scientist working with NASA, introduced a heretical idea. The sea, the mountains, the atmosphere, and all living organisms on Earth were part of a superorganism consisting of the whole Earth. He reached this hypothesis because he noted a close resemblance between the macrosystems that maintain the constancy of the mix of gases in the atmosphere, the temperature of the earth, and the salinity of the oceans and the homeostatic mechanisms that microscopic unicellular critters use. Lovelock's daring conclusion: The Earth was one gigantic self-sustaining organism. With the assistance of Lynn Margulis, he named his idea the Gaia theory, after the mythological mother of all the gods and living things. Radical for its time, it was dismissed by many in academia, and attacked by such luminaries as Stephen Jay Gould and Richard Dawkins. However, since its introduction, the Gaia theory has proven its predictive value in many experiments and is now considered mainstream science.

Leonardo had arrived at a conclusion similar to Lovelock's. He conceptualized the Earth as a single, exceedingly large, living organism whose forests, rivers, animals, mountains, and oceans each contributed to the planet's overall health. Leonardo adumbrated Lovelock by five hundred years. In the interim, no other significant thinker, philosopher, or scientist had embraced a similar holistic vision.

CHAPTER 12

Leonardo/Inventions

If they disparage me as an inventor, how much more they, who never invented anything but are trumpets and reciters of the works of others, are open to criticism.

—Leonardo da Vinci

So many of the insights and inventions of the notebooks prefigure the developments and discoveries of the following three hundred years. Had they been available to others in Leonardo's time, the progress of science and technology would have been accelerated dramatically.

—Bülent Atalay

The dead Master [Leonardo] is alive, and speaks to us, to me, directly, unmediated, his greatness confirmed once again because I, so different, so distant, separated by class, race, language, and above all by time, communicate directly with this great creator.

—Donald Sassoon

Leonardo's inventions prefigure a future that the inhabitants of the Renaissance could neither appreciate nor comprehend. As an apprentice in Verrocchio's studio, Leonardo learned how to grind lenses to such a high polish that they could be used to concentrate sunlight to generate the heat necessary to weld and anneal metals. But he also discovered that using a concave lens to focus light to a central focal point had the effect of transmitting a greatly enlarged image. In his words:

In order to observe the nature of the planets, open the roof and bring the image of a single planet onto the base of a concave mirror. The image of the planet reflected by the base will show the surface of the planet much magnified.

Reflecting telescopes are large, unwieldy devices. A debate currently smolders among science historians concerning who was the first person to invent the much-easier-to-use handheld telescope. The introduction of this simple tube fitted with lenses at each end brought distant objects closer. Considered one of history's transformative inventions, its profound effect on military engagements, commerce, astronomy, and world navigation cannot be overemphasized. The credit for its discovery generally goes to a Dutch spectacle maker, Hans Lippershey, who in 1608 applied for a patent for his device. There were several other northern Europeans whose names surface as having preceded Lippershey.

And yet, there remain tantalizing clues that link Leonardo with its invention. In one place, he wrote a reminder to himself to "make glasses to see the moon enlarged." His notebooks abound with detailed drawings of how light rays interact with objects, and how the absence of light creates penumbras and shadows. His interest in the subject led him to invent a prototype of the modern photometer, a device used to measure the intensity of light (not seen again until Robert Wilhelm Bunsen reinvented this device in 1844). He even devised a table lamp that could be adjusted for variable intensity. His suggestion of the possibility of contact lenses to correct distortions in the eye's cornea was half a millennium ahead of his time. He sketched an instrument to record the intensity of light that differed little from the one developed by Benjamin Thompson, an American, three centuries later.

Leonardo invented the first camera, and described its principles in his invention of the *camera obscura*. He invented an octagonal room, each surface of which contained a polished mirror. Sitting in the center of this room, a subject can visualize his or her three-quarter profile. Art historians speculate that the famous red chalk drawing of an old sage drawn from off center is a self-portrait of Leonardo, done while seated in his octagonal room.

As previously noted, most science historians credit Galileo with being the first real scientist. It is a supreme irony that Galileo went blind using his naked eye to look at the sun. He mused, over his predicament:

This universe, that I have extended a thousand times . . . has now shrunk to the narrow confines of my own body. Thus God likes it; so I too must like it.

Had he read Leonardo's recommendation, made a hundred years earlier—to view the sun through a pinprick made in a piece of thick paper—the "first scientist" would have not suffered the loss of his sight.

Leonardo took walks through the countryside and imagined a windmill that would serve as a power generator fifty years before the Dutch invented their picturesque but efficient windmills. He deduced the function of invisible oxygen: "Where flame cannot live, no animal that draws breath can live." Leonardo designed the first double-hulled transport ship; it was never built, but in the twentieth century, it became the standard design for oil tankers. He invented everything from common scissors to folding furniture and made significant contributions to civil engineering and city planning. He even put his mind to the field of landscape and garden design, creating the layout for some of the most stunning and innovative gardens in Europe.

Inventing weapons is not usually paired with fine-tuning innovative musical instruments. However, one of the contradictions of this complicated man was the celerity with which a youthful Leonardo could switch from designing the former to polishing the latter. As the city-states of Italy were in an almost constant state of war with each other, the young man's attempt to promote himself as an accomplished armament designer would have increased his value to his potential patrons.

Putting aside the gruesome purpose behind his military inventions and considering them for their sheer innovation, we witness another side of his genius. Leonardo invented the flamethrower, the machine gun, the first breech-loaded gun, a gun boring device, the first steam-powered gun, and a gigantic crossbow that required several men to operate. He

improved on catapults and mortars, and designed rope ladders to storm high walls. History's first tank appears among his drawings.

Considerable evidence has accumulated that he invented the wheel-lock firing device that permitted the miniaturization of the gun. Leonardo's invention of the wheel lock sent a miniature wheel made of flint (wound tightly beforehand by a spring mechanism) spinning when the gunner pulled the trigger. The whirling flint—striking a fixed post opposite the wheel, also made of flint—sent a shower of sparks into a much smaller-sized pan containing the gunpowder. The economy of this system made it possible for gunsmiths to reduce the size of the weapon to one that could be carried and fired in one hand—the pistol.

The scope of Leonardo's military inventiveness ranged from the minute to the grandiose. He could move from designing the miniaturized pistol to creating defensive and offensive plans that included diverting rivers from their natural beds to deprive rival city-states of their life-sustaining water. Later in his life, after serving with Borgia, he abandoned his interest in designing weapons. For example, he had invented the submarine, but did not want the plans known because he was convinced it would be used for warfare.*

Leonardo, the consummate musician, designed many innovative musical instruments. For a prospective patron, his facility at composing, singing, choreographing, and playing an instrument added considerable luster to his desirability as a potential employee. The primary reason that the Duke of Sforza initially hired Leonardo was for his musical talent. Leonardo made improvements to the most popular musical instrument of the day, the pianoforte. There remains a controversy in the Leonardo literature as to whether or not he invented the precursor to the violin.

From his notebooks historians know that Leonardo knew how to read and write musical notation. Demonstrating his agility with musical notation, in one place in his notebooks he uses rebuses (icons that represent words) to stand in for the symbols of the musical notes!

* According to researchers, Leonardo da Vinci inserted a series of deliberate flaws into his inventions, perhaps to prevent their being put to military use. "Da Vinci war machines 'designed to fail'" by Tom Leonard; *The Age*, December 14, 2002.

Always the scientist, Leonardo's interest in music led him to study how sound propagates through space and time. His detailed anatomical examination of the human larynx and its twin vocal cords led him to the origins of human speech and song. And his attention to the anatomy of the ear displayed his curiosity concerning how we hear.

His fascination with flight led him to invent the parachute, the glider, and the helicopter. The Russian-born inventor of the modern helicopter, Igor Sikorsky, acknowledges his debt to Leonardo, who half a millennium earlier had discovered the principle of flight, drawn the first propeller, and conceptualized the first helicopter.

The design for a bicycle and a spring-operated automobile appear among the pages of Leonardo's notebooks. He invented the universal joint that would become the critical component for the drivetrain of modern cars and conceived of the ball bearing to reduce friction and increase the speed and ease by which a land vehicle could continue to roll along. The Englishman Philip Vaughan obtained the first patent for the invention of ball bearings in 1791, nearly 350 years later.

Leonardo designed greatly improved pontoon bridges, collapsible bridges, and swing bridges. His most ambitious project was a bridge across the Bosphorous, designed for the Ottoman Empire. The Florentines were on friendly terms with the Turks when Leonardo was a young man. In his letter to the Sultan, Leonardo wrote: "I have heard that you intend to build a bridge from Galata to Constantinople but that you have not built it for want of a skilled master [architect]." Leonardo proposed building a bridge beneath which sailing ships could pass. The bridge would have been 766.7 feet above water. These dimensions are clearly fantastic. The largest bridge of this type at that time was over the Adda. Constructed from 1370 to 1377, it had a span of 235 feet and was 68 feet high. Five hundred years later, the Norwegians, using Leonardo's design, built a bridge that complies with his specifications.

Leonardo also turned his considerable attention to travel in, under, and on the water. He invented life preservers, webbed gloves, and the snorkel to improve the performance and safety of swimmers. For activity beneath the surface, he designed a diving suit and the mask to go with it (as well as the submarine). He greatly improved on the design

of paddleboats, and invented the first water lock, whose importance to modern river navigation cannot be overemphasized.

Had they been known at the time, Leonardo's inventions relating to hydraulics would have transformed the field. He designed greatly improved waterwheels and well pumps. His drawings of mechanical devices remain among the most beautiful renderings of machines and their components in all of art. Among his inventions were the spinning machine, treadle-operating lathes, file-making machines, mechanical saws, horizontal and vertical metal-boring machines, stone-cutting machines, and a clever rope-spinning device. He also invented the metal screw and the concept behind prefabricated buildings.

He measured the tensile strength of various materials, created novel designs for pulleys, and an innovative two-wheeled hoist. In his art we find the first rendering of a foundrylike factory and designs for improved cranes. He understood the potential of machines better than any of his contemporaries and constantly explored how mechanical contrivances could ease the burden of humans. In his many technological and engineering feats, Leonardo anticipated the machine-driven Industrial Revolution by 350 years.

He made robots that operated on computerlike programs to delight potential patrons. When the King of France visited Milan, Leonardo programmed a mechanical lion to walk down the aisle, approach the king, and then stop. Then, its chest opened to spill forth the fleur-de-lis. Both the lion and the flower symbolized the French throne. Mark Elling Rosheim, a modern expert on robots, has concluded that Leonardo's lion represented the first true robot.

To aid in his scientific endeavors, Leonardo invented many measuring devices. He greatly improved on the design of clocks. He invented meters to measure water flow and anemometers to gauge wind speed. The modern hygrometer, used to measure humidity in the air, was not invented until 1783 by the Swiss Horace-Bénédict de Saussure, but Leonardo had already made a working model several centuries earlier.

Among the many disappointments that Leonardo had to confront in his life was the fact that none of his innovative architectural plans ever came to fruition. Throughout his notebooks are many drawings for

buildings that contain novel ideas but, as best we know, not a single one of his concepts ever became a reality during his lifetime.

Because of the exceptional detail of Leonardo's anatomical drawings, his contributions to the fields of physiology, anatomy, and comparative anatomy are among his most familiar. As a result of his investigations, Leonardo made many groundbreaking discoveries and, in addition, left posterity some of the most beautiful renderings of the interior of the human body anyone has ever created.

Leonardo's desire to more accurately draw the human body increased his interest in studying how everything was integrated. He castigated Michelangelo's rendering of human musculature, writing that his rival's style resembled a "sack of walnuts." He felt that this other titan of his age had insufficiently studied the human body, and as a result rendered the muscles of his figures in an exaggerated and inaccurate manner.

Leonardo corrected the mistaken belief that the human heart contained two chambers. His dissections revealed all four, and he methodically described them, their interior, and their relationship to each other. He came remarkably close to uncovering the secret of human circulation, discovered by William Harvey in 1628. Harvey, like Leonardo, understood that the heart was a pump, but the lack of a microscope (a device that had not yet been invented) hampered both men's conceptualization. Neither could explain how arterial blood traversed over to the venous side because the capillaries that served as conduits were too small to see with the naked eye.

Leonardo, enamored with the idea that the human body was a microcosm of the larger Earth, believed erroneously that the blood ebbed and flowed rather than circulating in a continuous loop. Nevertheless, Leonardo's description of the heart, coronary arteries, heart valves, aorta, major arteries, and venous valves was truly groundbreaking.

Leonardo considered making a super drawing that would overlay the ten individual ones he had drawn of the foot, revealing the relations of the nerves, arteries, bones, muscles, and lymph nodes: "You could make the eleventh in the form of a transparent foot, in which you could see all the aforesaid things."

Leonardo's contributions to the field of neuroscience are sufficient to claim that Leonardo was history's earliest neuroanatomist. He was the first to describe in detail the ventricles of the brain and first to identify the crossing over of the portions of optic nerves to the opposite hemisphere in what is now known as the *optic chiasma*. He postulated that nerve impulses traveled as waves along a nerve's length. Although he was mistaken concerning the manner by which these waves propagated, his basic assumption was correct. His interest in ophthalmology led him to correctly identify how the lens of the eye inverts the image that we see on the retina upside down.

His amazement while contemplating the service that the eye performed led him to write passionately:

The eye, which is the window of the soul, is the chief organ whereby the understanding can have the most complete and magnificent view of the infinite works of nature.

Now do you not see that the eye embraces the beauty of the whole world? . . . It counsels and corrects all the arts of mankind. . . . It is the prince of mathematics, and the sciences founded on it are absolutely certain. It has measured the distances and sizes of the stars; it has discovered the elements and their location. . . . It has given birth to architecture and to perspective and the divine art of painting.

Oh, excellent thing, superior to all others created by God! What praises can do justice to your nobility? What peoples, what tongues will fully describe your function? The eye is the window of the human body through which it feels its way and enjoys the beauty of the world. Owing to the eye the soul is content to stay in its bodily prison, for without it such bodily prison is torture.

O marvelous, O stupendous necessity, thou with supreme reason compellest all effects to be the direct result of their causes; and by a supreme and irrevocable law every natural action obeys thee by the shortest process possible. Who would believe that so small a space could contain all the images of the universe . . .

Botany was another field in which Leonardo reigned as a master. His desire to accurately render various species of plants and trees in his

paintings encouraged him to begin to study the diversity of the plant world. Leonardo's consuming desire to solve the mystery of plants and flowers led him to make critical discoveries concerning the physiology of botany. He was the first botanist to recognize that a tree's *cambrium*, the layer lying just beneath the bark, is the most essential component of the plant. He also described how the tree's sap serves the same circulatory function that blood does in an animal: transporting nutrients and eliminating wastes. He described in detail the phenomenon of *phyllotaxis*, a complex theory about how the leaves are arranged on the stem of a plant. When he realized that one could assess a tree's age by counting its rings, he single-handedly founded the field of *dendrochronology*. He even speculated correctly that each ring contained information concerning the temperature and climate of any particular year of the tree's life by comparing the thickness of any one ring to the others.

Leonardo also investigated the beginnings of human life. He dissected the uterus of a recently deceased pregnant woman and methodically drew the position of the fetus in her womb. He identified the umbilical cord as the source of nourishment for the fetus and pronounced, contrary to the commonly held beliefs of his day, that "The seed of the mother has equal power in the embryo to the seed of the father." (Living in an extremely patriarchal society, this was an unusually generous egalitarian conclusion.) His interest in embryology resulted in his dissecting other dead pregnant animals to record the rates of growth of their fetuses. His studies cement his right to be considered history's first embryologist.

Leonardo was the first to diagnose arteriosclerosis. He attended an old man who died a gentle death before his eyes and then immediately conducted the first recorded modern autopsy, observing that the deceased man's aorta was clogged with plaque. He correctly deduced that a diminishment of blood flow secondary to constriction of the artery's inner diameter was the immediate cause of death. This single postmortem followed by the correct diagnosis qualifies Leonardo to be the founder of pathology. While Hippocrates and other classical physicians had made diagnoses based on symptoms correlated with physical findings, it is

doubtful that anyone before Leonardo had actually conducted a fresh autopsy to determine the cause of death.

At one point Leonardo spoke of 120 books he had composed on anatomy. Antonio de Beatis, secretary to the Cardinal of Aragon, reported that Leonardo da Vinci "wrote a remarkable work on the relation of anatomy to painting; he describes the bones, members, muscles, sinews, veins, joints, internal organs, in a word, all that is necessary for studying both the male and the female body, and which no one had done before him." And he added, "We ourselves saw this work."

Leonardo's interest in anatomy also led him to ponder the similarities between humans and other animals. He dissected a bear's hind limb and observed that the muscles and tendons were remarkably similar to those of a human. He concentrated his greatest efforts on an animal other than his own species in exploring the frame and musculature of the horse, prompted, no doubt, by his desire to cast in bronze the largest man-on-a-horse statue ever attempted. In preparation for this task, he made the first detailed studies of equine anatomy.

His observations concerning the close similarities between the anatomy of other higher animals and those of humans constitutes history's first foray into the field of comparative anatomy. When combined with his understanding that the Earth was exceedingly old, had he published his findings, they would most likely have dramatically sped the elaboration of the theory of evolution that had to wait more than three centuries for Darwin's grand insight.

Compounding all these achievements, we surely have a scientific genius the likes of which the world had never seen before or since. Leonardo foreshadowed future technologies by hundreds of years. He was the first and preeminent futurist.

CHAPTER 13

Emotions/Memory

If the body of every feeding thing continually dies and is continually reborn, how can that art be "most noble" which can engrave only a single moment?

—Leonardo da Vinci

The latter condition is demonstrated in an example offered by Goldstein, in which he described a patient who attempted to strangle herself with one hand and to release the strangling hand with the other. On postmortem examination it was found that she had suffered from a dissecting tumor of the corpus callosum.

—James S. Grotstein

There is a female human nature and a male human nature, and these natures are extraordinarily different. . . . Men and woman differ in their sexual natures because throughout the immensely long hunting and gathering phase of human evolutionary history, the sexual desires and dispositions that were adaptive for either sex were for the other tickets to reproductive oblivion.

—Donald Symons

In the late seventeenth century, the mathematician Blaise Pascal described two different mental operations. The first he characterized as the sudden grasp of knowledge leading to a total comprehension of all facets of a concept simultaneously; the other was patient analytical reasoning, proceeding in a sequential fashion. When he wrote, "The

heart has its reasons which reason knows nothing of," he was unaware that he was distinguishing between the kind of knowing that goes on in the emotional right brain and that which occurs in the cerebral left. Pascal was the first scientist to acknowledge the division between the right and left brain.

I will focus on the brain organization of someone who is right-handed and left-brain-dominant. I do not wish to dismiss the 8 to 12 percent of the population who are left-handed; rather, I wish to use the most universal model. The dysfunction that occurs as a result of left-brain injury in right-handers is so great that the left cerebral hemisphere has come to be known as the dominant lobe. Adopting this convention, I shall refer to the left brain as the dominant hemisphere.

If a right-handed person has a major stroke in the controlling left hemisphere, a catastrophic dysfunction of speech, motor activity, or abstract thinking will occur. Conversely, a significant stroke in the right brain can impair an individual's ability to solve spatial problems, recognize faces, or appreciate music.

The right side of the brain is the elder sibling. In utero, the right lobe of a human fetus's brain is well on its way to maturation before the left side even begins to develop. The old, wise, right side is more familiar with the needs and drives stemming from earlier stages of evolution than the younger left side. The right brain is largely nonverbal and has more in common with earlier animal modes of communication. It comprehends the language of cries, gestures, grimaces, cuddling, suckling, touching, and body stance. Its emotional states are under little volitional control and betray true feelings through fidgeting, blushing, or smirking. More than the left, the right expresses *being*—that complex meshing of emotions that constitute our existential state at any given moment.

The right brain generates the feeling-states that result from combinations of emotions. All feeling states are nonlogical. Feeling-states allow us to have faith in God, to grasp the subtleties of a joke, to experience patriotic fervor, or to be repulsed by a painting someone else finds beautiful. These states all possess a nondiscursive quality. Feeling-states overwhelm the brain's more recently evolved facility with words. No crisp nomenclature exists to describe them. When pressed to explain their emotional

experiences, people, in exasperation, commonly fall back upon tautology—"It is because it is!"

Emotions are predominantly located to the right of the Great Divide. The principal ones, such as fear, terror, love, hate, shame, disgust, envy, jealousy, and ecstasy are on this side. The only emotions that neuroscientists have identified to reside on the left are those associated with happiness, joy, and cheerfulness.

Feeling-states do not ordinarily progress in a linear fashion, but are experienced all at once. "Getting" the punch line of a joke results in an explosion of laughter. An intuitive insight arrives in a flash. Einstein reported that he envisioned the idea behind space-time this way, while sitting at his desk in the patent office in Bern, Switzerland; he called it the most ecstatic moment of his entire life. Kandinsky was shocked by his realization that an abstract image was equal to an illustrative one. Both of these are examples are what the poet Rainer Maria Rilke called a "conflagration of clarity." Love at first sight, such as what Dante experienced when he encountered Beatrice, happens in an instant. (She was eight years old, wearing a red dress.) Religious conversions, such as the one that overwhelmed Paul on the road to Damascus, strike like lightning.

The right brain perceives the world concretely. A facial expression is "read" without any attempt to translate it into words. The right hemisphere is also the portal leading to the realm of the spiritual. It entertains altered states of consciousness where faith and mystery and the rules of logic do not apply.

There is compelling evidence that dreaming occurs primarily in the right brain. People who have had a split-brain operation or who have had a stroke in the right brain report less vividness in the imagery of their dreams. On scanners, the right brain shows more activity during REM sleep, the period when dreaming is presumed to take place, than it does during other phases of sleep. Further evidence suggests that dreaming occurs principally in the right hemisphere, because split-brain and brain-injured patients—who verbalize only what is going on in their left brain—have reported a cessation of dreaming.

Image recognition is the right brain's forte. It can simultaneously synthesize incongruous elements and integrate the component parts in the

field of vision. The right hemisphere can take an entire tableau at a glance and make sense of the grand picture in a holistic manner. It can appreciate the relationship of parts to the whole, and it can also build up a complete picture from just a few fragments. The right side assimilates images as gestalts, which means seeing all at once. Whereas the name of a person is retrieved from the left brain, it is the right side that recognizes that person's physical being.

One demonstration of this right-brain skill is the ease with which people can recognize the faces of others. An old friend's countenance may be altered dramatically by the appearance of wrinkles and baldness, yet we are still able to recognize the childhood pal decades after we last saw him. We do not begin by analyzing his face, building it up from his nose, eyes, and ears. Instead, we recognize him in an instant.

When people find it necessary to express in words an inner experience such as a dream, an emotion, or a complex feeling-state, they resort to a special form of speech called metaphor—a unique right-brain contribution to the left brain's language capability.

The word metaphor combines two Greek words—*meta*, which means "over and above," and *pherein*, "to bear across." Metaphors have multiple levels of meaning that are perceived simultaneously.

We can describe, measure, and catalog the objective world with remarkable precision without resorting to metaphor. But to communicate an emotion or feeling-state, metaphors become necessary. To say one's heart is "trapped in ice" or "soaring like a bird in flight" expresses the synergy between the right brain's concrete images and the left brain's abstract words. Metaphors beget poetry and are essential to the parables of religion and the wisdom of folktales. Metaphor's cousins—similes, analogies, allegories, proverbs, and parables—each allow multiple means of interpreting a single set of words. Myths and dreams, both closely linked to metaphors, reside principally on the right side of the brain. Neurologists have identified right-handed, left-brain-dominant patients who have suffered a major left-lobe trauma that renders them nearly speechless but still allows them to recite poetry that they knew before their trauma.

The most compelling combination of metaphor and image is art. Great visual art is authentic, nonlogical, and nondiscursive. The artist

frequently uses visual metaphor to transport us to complex feeling-states, such as awe. When art metaphorically "bears" us "across and above," there are no transitions. It is an all-at-once quantum jump. When this happens, we somehow know we are in the presence of great art.

The same right-hemispheric area that enables us to recognize faces helps us to appreciate the subtleties of portraiture. Not only are the characteristics of visual art responsive to the right hemisphere's abilities, but also the single most common image found in Western art is the representation of the human face. As further evidence for the placement of art to the right, neurologist Théophile Alajouanine describes a prominent painter who suffered an extensive left-brain stroke, rendering the artist aphasic:

> *His artistic activity remains undisturbed; indeed, he has even accentuated the intensity and sharpness of his artistic realization, and it seems that in him the aphasic and the artist have lived together.*

Besides metaphor, the right brain can decipher the *tone* of the message. By listening carefully to the forms of speech while the left hemisphere is deciphering its content, the right hemisphere ferrets out hidden messages by interpreting inflection and nuance. It assesses the speaker's posture, facial expression, and gesture. Just below conscious awareness, it registers pupil size and hand tremors. Because it is almost impossible to describe how the right side deciphers nonverbal language, most people refer to this skill as "intuition."

Damage to the right brain, especially the right temporal lobe, produces *left hemineglect syndrome*. Patients become unaware of their left side. Women adorn themselves and comb their hair only to their right, ignoring the messy appearance on their left side. They eat only from the left side of the plate. Men miss shaving the left side, and both sexes frequently do not insert their arm into their left sleeve. They will talk to you if you stand to their right side, but they ignore everything on the left side of the room.

It is significant that lefties rarely suffer a *right* hemineglect syndrome. And no right-handers experience a similar syndrome when they suffer a

stroke in their left brain. The hemineglect syndrome almost always occurs only on the left, because it affects the right brain of the person.

Another major right-brain feature is its ability to appreciate music. Perhaps we can't all define it, but each of us is quite sure we can distinguish music from noise. Music is another example of the ability of the right brain to process information in an all-at-once manner.

During World War I, doctors observed many soldiers who had sustained traumatic injuries to their dominant left hemispheres and, as a result, could not speak a word. This select group could, however, sing many songs they'd known before they were injured. Alexander Luria, the Russian neurologist, reported the case of a composer who created his best work after he was rendered speechless by a massive stroke in his left hemisphere.

Other notable examples of this division include French composer Maurice Ravel, who suffered a stroke in his left hemisphere that left him unable to speak, write, or read musical notation. Yet, he could sing and play on the piano from memory any piece he had learned before his stroke. Carl Orff, choirmaster of the famed Vienna Boys' Choir, seems to have understood this dichotomy in brain function intuitively; he would not accept a child into his choir who had learned to read and write.

Doreen Kimura convincingly demonstrated the separation of music and speech centers in the brain in experiments performed on commissurotomy patients. Examining patients who had had their corpus callosum divided in split-brain surgery, she had her researchers play a recording of a song and then ask the patient what they had heard. Their left brain could flatly repeat the lyrics of the song but could not hum its melody. The right brain could hum the melody but could not sing the lyrics. A conversation can be understood only when one person speaks at a time. One's right brain can listen to the sounds of a seventy-piece orchestra and hear them holistically.

On an MRI brain scan of someone devoid of musical training, the right parietal lobe lights up more than other areas when he or she is listening to music. If, however, he or she is a musician who plays only by ear, then the right-parietal and right-frontal lobe activates. If the individual

has learned musical notation—a form of writing—then both areas continue to light up, but the left-parietal lobe will also show considerable activity.

Another example of how speech and music are evenly distributed to either side of the brain is found in the research findings concerning prosody. Speech has two components: One is the content of speech, and the other is the manner in which it is spoken. Inflection, tone, and emphasis are all important clues regarding the interpretation of speech. The area in the right brain that is the mirror image of Broca's area is responsible for adding this critical component to speech. *How* one says something can be almost as important, if not more important, than *what* one says. It lends an emotional tenor to language. Music is a function that resides principally in the right hemisphere. Orpheus, the poet-musician, holds court in the nondominant right side.

The right brain processes *being, images, metaphor,* and *music* in a holistic manner and functions best in a visuospatial context, correlating parts to a whole while intuiting diverse relationships among them. The right side is better at appreciating spatial dimensions and judging distances. Driving, skiing, and dancing are its province. This side of the brain merges multiple determinants, multiple emotions, multiple meanings, multiple images, and multiple sounds into holistic states.

The left brain's primary functions are complementary to the right's. While the right side manages the state of *being,* the left is primarily action oriented and concerned with *doing.* The left lobe controls the vital act of *willing.* Its agent, the right hand, picks berries, throws spears, and fashions tools. The trait that made us *Homo faber,* the toolmaker, depends on ordering a sequence of steps that exist in time.

The left lobe knows the world through its unique form of symbolization—speech. Language is action oriented. Words are the very essence of the action mode; with them, we abstract, discriminate, analyze, and dissect the world. A vocabulary is the set of tools we use to do this.

Whereas the right brain is the great synthesizer, left-brain analysis reduces everything to its component parts. This key left-brain task depends upon *linear* progression, in contrast to the *holistic* perception of the right brain. Abstract thinking is the ability to process information

without resorting to images; it is the opposite of metaphorical thinking. Words substitute for images, and the mind can use these units of speech to build more complicated concepts. Similar to the way children assemble LEGOs, the mind arranges words as image substitutes, building concepts that allow us to think about *freedom*, *economics*, and *destiny* without needing to conjure up images for these words. Using language alone, the mind can rearrange these concepts and solve problems. To be able to leap from the *particular* and *concrete* to the *general* and *abstract* has allowed us to create art, logic, science, and philosophy.

When humans went beyond thinking in pictures, they made a transformative evolutionary leap. Meaningless phonemes generated by the early humans' larynxes became the words of speech and the tools of abstract thought. Later, when they combined the meaningless letters of alphabets or ideograms, they formed visual words to represent the world. In the process, they created the first abstract art form: the written word.

Logic is not holistic. It click-clacks along the left brain's linear railway of sequence. If–then syllogisms, the basis of logic, have become the most reliable method of foretelling the future. They have all but replaced omens, visions, and intuition. The rules of logic form the foundation of science, education, business, and military strategy.

Along with *doing*, *speech*, and *abstraction*, the fourth characteristic unique to the left hemisphere is *numeracy*. Although the ability to count began in the visuospatial right brain, the ability to permutate larger numbers allows the left brain to build towering computations. The close association between abstract speech and abstract numeracy is evident among small children who learn the alphabet and learn to count at the same stage of development. Time and sequence are the very crux of the language of numbers; it is impossible to think of arithmetic outside its framework.

All the innovative features of the left hemisphere—*doing*, *speech*, *abstraction*, and *numbers*—are linear. To develop craft, logic, strategy, and arithmetic, the mind must range back and forth along the line of past, present, and future. The survival and success of humans required that evolution set aside an area in the newly enlarging brain in which the concept of time could be contemplated free of the holistic spatial perceptions of the earlier mammalian and primate brains. The ability to fashion a tool

with the right hand issues out of the left brain, and depends heavily on the ability to memorize a series of steps in sequence. The dominant hand is a specialized limb that is an extension of the sequential left hemisphere. An appreciation of linear time was the crucial precondition for linear speech. Sequence is the very crux of the language of numbers; indeed, a series of numbers is a sequence.

The left hemisphere represents a radical new sense organ designed by evolution to perceive time. The left lobe processes time and keeps track of dates. Only humans can experience, or even understand, "birthdays." It also can objectify the world. Instead of being part of nature, we can step back and see that nature is "over there." And the left hemisphere is where we experience everything as *separate from ourselves*. We see trees as separate entities. If we go one level under the ground, we would see that all the trees are part of one gigantic organism, the forest. We'd see each tree is but an antenna for the organism and that all are connected by their root system. Radioisotopes injected in one tree will show up far away in another tree as the forest attempts to distribute the supply of sunshine. Trees that are in the sun share their good fortune with trees that are in the shade. But we do not see any of this because we are focused on the individual tree. The left brain sees only the discrete trees, not the entire forest.

Being, metaphor, image, and music are the essence of art. Doing, reason, abstract thinking, and numbers are the crux of science. Art lives principally to the right, science to the left. Despite this division, only a handful of individuals in all of history were able to bridge this split. But, the stunning realization is that only one person in all of history was able to *excel* in both of these fields to achieve a unique synthesis.

CHAPTER 14

Space and Time/Space-Time

The water you touch in a river is the last of that which has passed and the first of that which is coming. Thus it is with time present.

—LEONARDO DA VINCI

The reason why our sentient, percipient, and thinking ego is met nowhere in our world picture can easily be indicated in seven words: because it is ITSELF that world picture. It is identical with the whole and therefore cannot be contained in it as part of it.

—ERWIN SCHRÖDINGER

Although all knowledge begins with experience, it does not necessarily all spring from experience.

—IMMANUEL KANT

IN THE EIGHTEENTH CENTURY, PHILOSOPHER IMMANUEL KANT PRESENTED a series of prescient theories about the structure of consciousness. He could not have known at the time that modern neuroscientists would later confirm his hunches. Kant's ideas provide a framework within which it is possible to understand how Leonardo's brain's unique structure fostered his creativity.

In his cave analogy, Plato likened humans to a group of prisoners chained to a low wall. Above and behind them, the hurly-burly of community life went on. A large fire cast the shadows of these activities onto the wall. The prisoners' shackles prevented them from turning around and seeing what was going on above the wall. Thus, the prisoners thought these flickering shadows *were* the real world.

Building on Plato's famous cave metaphor, Kant proposed that humans were similarly condemned to know the world only from a perch inside our skulls. We peer out through the chinks of our senses and perceive something we call "external reality." We make a conscious distinction between "in here" and "out there." Kant lamented the fact that we can never know for sure what is out there, an entity he called *das Ding an sich*—"the thing in itself."

Despite being confined behind our foreheads, we humans have certainly made a good go of trying to comprehend the outside world. Our facility with language allows us to do this. Resembling the four bases of DNA, we use a mental quaternary code to project our version of what is "out there" from inside our minds. The four elements are matter, energy, space, and time.

Matter and energy are the two central characters in every sentence we utter. *Matter* roughly translates into "things." *Energy* roughly translates into "actions." Nouns (matter) and verbs (energy) are the backbone of our thoughts. Space and time are crucial qualifiers that add flesh to sentences, orienting the action taking place. Space is the stage upon which all verbal action takes place, and time sets the pace of the narrative. Because speech trips off our tongues one word after another, time is the critical dimension that channels all the words we speak into a single file.

Kant's role in the Leonardo story was his proposal concerning where these four constructs of reality arose.

Recognizing that we humans had to start somewhere in our imagining of reality, Kant rooted his theory of human consciousness in what he called *a priori* assumptions, a phrase in Latin that means *from the earlier*. He proposed that we are born with an innate conception of two separate dimensions: space and time. Keeping time and space separate has been the key to *Homo sapiens'* success. Whereas some animals may have developed a keen sense of their place in space and can navigate through this dimension (think of swallows, bats, and monkeys), very few animals can appreciate the complementary dimension of time.

Through the work of Nobel laureate Eric Kandel, we now know that extremely primitive organisms such as sea slugs can hold the past within their rudimentary nervous systems. A *proto memory* is the key to

anticipating what might happen. While there are many animals that can remember past events and have learned to distinguish friends from foes, there is only one that can easily roam along a line connecting past, present, and future, and it is us.

We are born with two internal super-sense organs charged with collating information from our five external sense organs that enable us to understand our place in space and time. My argument is that Leonardo was an individual who had an altered perception of these two coordinates, and it was this that contributed to his extraordinary creativity.

Kant's hunch, hemispheric specialization, and Leonardo's creativity are all related. We are born with the capacity to easily maneuver in three vectors of space, a feat we share with many other creatures. But we can also imagine three durations of time. Our unique capacity to do this comes from something that occurred when Natural Selection split our brain in two.

The split brain created an X axis of space and a Y axis of time. Humans plot the "real" world on this graph. Natural Selection designed human brains to appreciate space and time as two distinctly separate domains. Their separation gave us the enormous advantage in the competition for resources.

In 1905, Albert Einstein added a new wrinkle to the space and time debate when he solved a problem that had pestered physicists since Newton. When Newton developed his grand theory concerning gravity, he was at a loss to explain the nature of the force that would attract two objects separated in space. To solve the problem, he imagined a clear, gelatinlike substance that permeated the universe. He called it the *luminiferous aether*. Because his reputation was so great, and the idea of two billiard balls in space being attracted to each other with nothing in between seemed absurd, Newton's hypothesis was accepted with very few objections.

Young Albert published a paper in the prestigious German journal, *Annals of Physics*, which has become commonly known as Einstein's theory of special relativity. In arachnid equations crawling across the pages, he mathematically proved that light could travel through space and time, unsupported by any medium at all!

Newton believed that space and time were invariable. Space was an inelastic container of the universe, and time was a river that flowed at a

constant rate of speed. Einstein stood Newton's formulation on its head. According to Einstein's theory, both space and time were extremely malleable; only the speed of light was invariable. Einstein proposed that the speed of light remained constant, at 186,000 miles per second. Space and time deformed in such a way as to accommodate light so that its speed would always remain the same.

Einstein was so in awe of the genius of Newton that he felt obligated to compose a letter of apology to the long-dead English physicist for having to destroy a keystone in the massive arch of Newtonian mechanics. His theory of special relativity was necessary, he wrote, only to explain phenomena that approached the speed of light. Fortunately for the rest of us, Newton's laws remained in effect in the familiar world in which we lived and traveled.

The system that Einstein proposed so challenged conventional wisdom and common sense that many scientists refused to accept his new conception concerning the relationships among space, time, and light. There was one, however, that maintained an open mind. Hermann Minkowski had been Einstein's professor at the Eidgenössische Polytechnikum. Minkowski later admitted that he had considered Einstein a mediocre student and was quite surprised to find his former student's paper in his monthly physics journal. After studying Einstein's equations, he had one of the science's true eureka moments. In a frenzy of intellectual ferment, Minkowski set about with paper and pen to construct equations that proved beyond a doubt that there existed a higher dimension beyond space and time.

Speculation about a higher dimension had been rife throughout the artistic and scientific communities of the late nineteenth century. Artists, philosophers, mathematicians, and physicists each speculated about the existence of a fourth dimension. All of them conceived of this higher dimension as one of space, as another perpendicular added to the three familiar ones that formed the intersecting lines we commonly call height, length, and breadth. But there remained one significant problem: how to conceptualize or visualize this higher spatial dimension. The predicament can be easily re-created by glancing at the ceiling corner of the room in which you are sitting. Observe the triple juncture of two walls meeting

at the corner converging neatly with the ceiling. Where in this compact arrangement could one insert another plane? How could one imagine a *fourth vector of space?*

Minkowski's remarkable insight was that the fourth dimension did not comprise a fourth vector of space, but rather was the recombining of space *and* time. He conjoined the three vectors of space—height, length, and width—with the three durations of time—past, present, and future—and coined a new phrase, *the space-time continuum,* to identify his new fourth dimension. In words worthy of a dramatist, he began his address to a distinguished physics colloquium in 1908 thus: "Gentlemen! From henceforth, space by itself, and time by itself, have vanished into the merest shadows, and only a kind of blend of the two exists in its own right."

Only a handful of people could understand Minkowski's innovation. Space-time would be a useful concept when, in his next bold move in 1919, Einstein joined together the original four cardinal essences that Kant had defined as comprising the everyday world—matter, energy, space, and time.

Because the idea of space-time was so dense and non-commonsensical, it remained an impenetrable knot to the public. Most had to take it on faith. Their trust has been justified by subsequent scientific achievements that have been both dramatic and convincing. Scientists used Einstein's relativity theory and Minkowski's formulation to calculate everything from NASA's interplanetary explorations to the interpretation of the photos sent back by the Hubble telescope.

The reason so few can envision a fourth dimension is because the human brain was designed to deal with speeds at which the quirks of relativity and the space-time continuum are not apparent. Nothing in anyone's immediate environment requires him or her to think in terms of 186,000 miles per second.

In *October the First Is Too Late,* astronomer and science-fiction novelist Fred Hoyle wrote:

You're stuck with a grotesque and absurd illusion . . . the idea of time as an ever-rolling stream. . . . There's one thing quite certain in this business: the idea of time as a steady progression from past to future is

wrong. I know very well we feel this way about it subjectively. But we're the victims of a confidence trick.

Another profound insight came as a result of advances in quantum physics. Here was evidence that logical certainties and the spatial concept of locality were illusions. Quantum physicists made a series of pronouncements that the rest of us have not yet assimilated. For example, quantum physicist Eugene Wigner wrote, "The laws of quantum mechanics cannot be formulated without recourse to the concept of consciousness." Many other quantum physicists have attempted to explain what it is that they have discovered, but because of the organization of our brains, we have difficulty with the concept of nonlocality and ESP. Nevertheless, the combination of quantum physicists and promoters of relativity theory changed the perceptions of those who could understand them.

And this is where the story of the organization of Leonardo's brain begins. Did he have a brain capable of achieving an altered state of consciousness? Could he access the fourth dimension? Did his brain possess a means to access the quantum state?

CHAPTER 15

Leonardo/Remote Viewing

Science is the observation of things possible, whether present or past; prescience is the knowledge of things which may come to pass, though but slowly.

—LEONARDO DA VINCI

The artist is always engaged in writing a detailed history of the future because he is the only person aware of the nature of the present.

—WYNDHAM LEWIS, ART CRITIC

Quantum theory indicates that there are no such things as separate parts in reality, but instead only intimately related phenomena so bound up with each other as to be inseparable.

—HENRY STAPP, QUANTUM PHYSICIST

HUGE GEOGLYPHS, OSTENSIBLY CREATED BY ANCIENT INHAIBTANTS, HAVE appeared in numerous countries, including Egypt, Malta, Chile, Bolivia, the United States (in Mississippi and California), and in other countries built by ancient peoples. Among the most famous and mysterious are those on the Peruvian plains of Nazca, outside the city of Cuzco. On this flat, barren tabletop, ancient Incas (or Nazcans) drew enormous figures by scraping the rock away from the underlying chalk. Because the rainfall in the area is so scant, unlike other geoglyphs, these are extraordinarily well preserved. There are some twenty-six of these huge earth drawings. Many of them are stylized animals, birds, and plants; a number of them are geometrical designs. No one knows why the natives in the area constructed

them, or what purpose they served. As ancient tribes scratched their way into history, their drawings reached several hundreds of yards in diameter. Any present-day visitor who walks among them would not be able to comprehend their design.

Somehow, these ancient people were able to create these designs because they could visualize the figures as if they were looking back down at them from a remote point high in space. Only individuals so positioned could appreciate the extremely large outlines of spiders, monkeys, whales, hummingbirds, plants, or geometrical designs. Scientists have tried unsuccessfully to come up with an explanation for the Nazca Lines. The one that is most likely, and often dismissed, is that the people who made these large displays were capable of what is called "remote viewing."

In the 1960s, physicist Hal Puthoff, director of the Cognitive Sciences Program at the Stanford Research Institute (SRI), wondered whether or not quantum effects could be observed in the realm of what we consider "the normal world" and proposed a modest experimental grant to find out. His experiment involved remote viewing, which is the skill to see something that is impossible to see given your location. (Many ordinary people claim to have this skill.) He was contacted by a New York artist named Ingo Swann, who had participated in similar experiments and wanted to join this one.

Puthoff had access to a well-shielded magnetometer that was so precise and delicate in its measurements, it could detect the decay of atoms. It was situated in a basement vault and shielded by MuMETAL (an extra-thick, high-efficiency magnetic alloy) and a copper and aluminum container. Swann was asked to perturb the operation of the magnetometer. Amazingly, he was able to deflect the magnetometer's needle and stop the field charge altogether for roughly forty-five seconds. He did this while located on a different floor from the magnetometer, and with purely mental activity. Then he drew a close approximation of the interior of the apparatus.

Swann's "remote viewing" was significant enough that Puthoff presented it at a conference, resulting in a visit from two CIA agents a few weeks later.

In 1972, along with another physicist named Russell Targ, Puthoff began a twenty-four-year, $20 million research project designed to investigate the phenomenon of remote viewing. Subjects were asked to identify and describe distant "targets" hidden from their view. By the end of their collaboration, they had published 266 papers in scientific journals.

The general procedure Puthoff and Targ followed in the early experiments was straightforward. They would send someone they called a "beacon" to a series of locations some distance from SRI, randomly selected from a huge list. The beacon would spend thirty minutes at each site. Meanwhile, the remote viewer was sitting back at SRI in a locked room, drawing the site and offering verbal impressions of where he imagined the beacon to be. The whole procedure was double-blind: Neither the experimenters nor the viewers were given any information about any of the sites where the beacon was—usually a series of six to ten sites in any given trial.

Then they gave a list of that trial's target sites to outside judges, who had nothing to do with the experiment, and asked them to go to each site in the series. While there, they were to match up the viewers' drawings and descriptions with the series of sites, pair for pair, based on how closely they resembled each other. At that point, they would look to see if the resulting matches were more accurate than chance would predict. What emerged from these early experiments in remote viewing was that the most accurate information often came from viewers asked to draw their impressions, which were consistently more accurate than straight verbal descriptions.

Their results soon found their way into the popular press, after which they were contacted by Pat Price, a retired policeman from Burbank, California. He told them that he had had ESP all his life, and had used it in his work as a police commissioner with spectacular results. The CIA asked the researchers to test the subject's ability to remote-view a particular site when given only the longitudinal and latitudinal coordinates of the site.

They gave the coordinates to Pat Price and he immediately sent in a five-page report describing the area. At first he described a few log cabins

and a couple of roads, but then added, "Oh, over a ridge there's this really interesting place. That must be the place you're interested in." He went on to describe in great detail a military site he identified as highly sensitive and surrounded by the heaviest security. Price came up with code names that all centered on the game of pool, along with other information about what was going on there, and the personnel involved. They sent the verbatim transcripts back to the CIA for confirmation. They also asked former test subject Ingo Swann to focus on the same coordinates and sent his report off along with Price's.

The CIA's first reaction was that the viewings were way off. The coordinates had been provided by an officer from the Office of Scientific Intelligence (OSI), and pinpointed the location of a staff member's vacation cabin in West Virginia. So a high-security military site seemed wildly inaccurate. But the CIA officers noted a striking correlation between the two independent descriptions from Price and Swann. That seemed unlikely enough to send the OSI officer out to the site itself.

What he discovered was that, unknown to the staff member that owned the cabin, just over the ridge was a highly sensitive underground government installation. The guy's vacation cabin was indeed there, but so were other elements of the viewing, and they were top secret—a total surprise to the officers looking at the data. Some of the details were wrong, but a lot were right, even stunningly precise, like the fact that the labels of each file folder in a locked file drawer inside the underground building were all designated by pool terms: cue ball, cue stick, and so on. Price had even come up with the actual code name of the site: Haystack.

I propose that Leonardo was a remote viewer who possessed a trait similar to that exhibited by Ingo Swann and Pat Price.

During his employ with Cesare Borgia, Leonardo produced a highly detailed map of the town of Imola that was also very beautiful. The vantage point that he achieved was about the same height as that of the Incas in Nazca. Roger D. Masters, one of Leonardo's biographers, waxed rhapsodic over the magnificent jewel of a map [Fig. 16]. The drawing indicates every street and building in the town in fine detail and includes the features of the surrounding countryside. Masters observed that Leonardo paced off

the distances between every street and house, recorded his findings, collated them, and then transposed them to another dimension. Only by this means, Masters conjectured, could the artist have achieved such an astonishing degree of accuracy.

Leonardo did indeed make notes indicating that he wanted to ensure the accuracy of the measurements of the town (although he also included the surrounding river system, for which it is unlikely that he made notes). This was his first map, however, and I believe that one of his goals was to be sure of his remote-viewing ability.

Biographers fall into the trap of repeating each other's descriptions of this magnificent aerial map as a "bird's-eye" view. The altitude at which he drew this map exceeds 6,000 feet, or more than mile. No bird flies at this height. Later, Leonardo made maps of areas from much higher altitudes. He re-created the topographical features of the landscape of northern Italy with stunning accuracy; no one would see maps like this again until satellites beamed back high-definition photographs five hundred years later.

Somewhere around the year 1502 the leaders of Florence approached Niccolò Machiavelli and Leonardo, who were working together in the employ of Cesare Borgia. The delegation beseeched them to come up with a plan that would diminish the power of their archrival, the city-state of Pisa. Leonardo devised an audacious design. It was so spectacular that Machiavelli sold the idea to the governing body of Florence, known as the Signoria.

The Arno River flowed through the center of Florence and then continued on its way to empty into the Mediterranean, at Pisa on the coast, about sixty miles to the east of Florence. The scheme called for the diversion of the Arno River from the city of Pisa. Leonardo also hoped that his innovation would irrigate the entire Val di Chiana, which, at the time, was an arid region. What really caught the attention of the members of the Signoria was the added benefit of seagoing vessels trading with Florence directly. A series of locks would make it possible to journey up the Arno and dock at Florence, bypassing Pisa altogether.

Before any of these plans could be instituted, an accurate map of the entire river system had to be created. Leonardo drew the entire length of

the Arno River as seen from a height that would have to be thousands of feet, or even several miles, above northern Italy [Fig. 17]. Given his jammed schedule, it is highly unlikely that he surveyed the river system himself or had any assistants help him.

The project ultimately failed because of improper engineering at the jobsite. Leonardo's plans were poorly carried out, and bad weather intervened. The Arno River has been subsequently tamed just as Leonardo envisioned it—minus the diversion from its bed at Pisa.

Among Leonardo's maps is one that he drew of the Pontine Marshes. He performed this service for the city of Rome, and the Pope who wanted to drain these infested marshes. The detailed map is drawn from a height that is only achieved by satellites.

Leonardo drew many other detailed maps besides these. No one has developed a credible theory of how a man on the move, who was engaged in many other scientific and artistic endeavors, could have surveyed the landscapes of so many different locales. Comparing Leonardo's topographical maps to those of other fifteenth-century cartographers reveals how much more refined and accurate Leonardo's maps were.

Adding to the mystery concerning how Leonardo constructed his aerial maps is the strange case of his "Armenia letters." These missives were addressed to, among others, a potentate in the far-off land of Syria and the head of the state of Armenia. Some of them contain whimsical stories, but they always contain details about the terrain. Whoever would have received these letters would have already been familiar with these descriptions, because they lived in that region, yet for some reason Leonardo felt compelled to write with detail about geographical places that he apparently had never visited.

The letters have been a constant source of puzzlement to the many interpreters of Leonardo's manuscripts. Some posit the theory that he wrote them to encourage a flight of imagination for the purpose of stimulating his production of distant landscapes in his art—that somehow, describing a place he had never seen would allow him to imagine scenes that he aspired to draw. Another theory is that they are Leonardo's attempt to write down in literary form a description of far-off places about which travelers had told him.

A third theory is that Leonardo was engaging in fantasy. Yet, there is nothing in any of his writings to suggest that he wanted to engage in fantasy. His scientific writing consistently railed against people who described something secondhand and did not personally investigate the phenomenon they were describing.

Leonardo described Etruscan funeral mounds and the structures that sat atop of them that are only located on the island of Sardinia. He accompanied the verbal description with a drawing. Edward MacCurdy, who wrote the comprehensive work, *The Mind of Leonardo da Vinci*, tries to come up with an explanation, but also expresses his uneasiness:

> *The description of the temple on folio 285r.c raises a question to which the answer as yet has been found. It is precise and circumstantial. "Twelve flights of stairs," he says, "led up to the great temple which was the circumference of eight hundred braccia and built on an octagonal plan. At the eight corners there were eight large plinths, a braccia and a half in height, and three wide and six long at the base, with an angle in the middle, and upon these were eight great pillars twenty-four braccia high. . . ." Can this description refer to any temple he had seen? If so, on what occasion? Or are we to assume that despite the exactness of the dimensions, twice stated, the whole passage is merely an exercise of the constructive imagination testifying to Leonardo's interest in architecture of the grandiose type and to nothing else?*

Another puzzle: At the conclusion of a passage which contains an elaborate description of a temple of Venus, Leonardo adds, "[S]etting out from the coast of Cilicia towards the south you discover the beauty of the island of Cyprus," and on the reverse of the same sheet he affirms the visibility of Cyprus from the southern shores of Cilicia.

Leonardo's descriptions of Egypt, Ethiopia, and Arab lands are also uncannily accurate:

> *The Egyptians, the Ethiopians and the Arabs when crossing the Nile are accustomed to attach two bags to the sides of the bodies of their camels, that is wine-skins of the shape shown underneath.*

The sketch included in the text depicts "five camels thus equipped crossing a river, the last with a rider," according to MacCurdy.

Leonardo was also familiar with the way the sands drifted in Egypt and Arabia to make their enormous sand dunes.

To explain these anomalies, Jean Paul Richter in 1888 proposed that Leonardo may have slipped away from Florence before assuming his duties in Milan and journeyed to these places. Adding Sardinia and then Egypt to the itinerary, however, would have been a stretch. MacCurdy struggles to make these hypotheses fit with the other detailed information we have on Leonardo's whereabouts at the time.

MacCurdy also puzzles over the fact that:

> On the cover of Manuscript L of the Institute, which, as time references show, was written in the year 1502, is a note: "Rhodes has in it five thousand houses." Where and when Leonardo obtained this knowledge is a matter in which there is nothing to sustain conjecture. The second reference occurs on folio 10b of the Leicester Manuscript, where it is stated that in "eighty-nine" there was an earthquake in the sea of Atalia near Rhodes, which caused the bed of the sea to open, and that such a torrent of water poured through this opening that it was more than three hours before the sea returned to its former level. On the assumption, which seems an entirely reasonable one, that by the year "eighty-nine" Leonardo meant [1489], Richter directs attention to the evidence in an unpublished Arabic manuscript at Paris of the occurrence of a terrible earthquake in the year 867 of the Mohammedan Era, which corresponds to the year 1489.

As before, there is nothing to sustain conjecture as to how Leonardo acquired this knowledge. Perhaps, as it has been suggested, Leonardo was writing these as fantasies. MacCurdy examines this view:

> The theory that Leonardo was trying his hand at a romance in these letters that describe imaginary travels is unlikely, as the letters do not seem to be couched in this vein at all. They are too matter of fact, beginning as they do with excuses for the non-performance of official duties and proceeding with descriptions . . .

According to MacCurdy, geographer Douglas Freshfield has disputed Richter's conclusions regarding the Armenia letters, characterizing Leonardo's sketch map of the sources of the Tigris and Euphrates as "very rough but, for the time, accurate."

MacCurdy goes on to write:

> *So following on the lines which his own researches in geology among the rocks and river cuttings in the regions of the Arno had revealed, he envisaged in a passage of sustained descriptive power at the commencement of the Leicester Manuscript a time when, as is shown by the fact of shells and bones of great fishes being found in the sides of mountains, the waters of the Black Sea covered much of what is now the valley of the Danube and much else of Eastern Europe and Asia Minor. He then mentions the spurs of Mount Taurus and also Mount Caucasus, and again on the folio 31a of the same manuscript, Mount Taurus and the mountains of Armenia.*
>
> *The manuscript in which these passages occur was written from twenty to thirty years after what would be the latest possible date for the composition of the Armenian letters, if it were admitted that they were records of the writer's own experiences. There is, however, no word in either passage, which can be construed as indicating any firsthand knowledge, or anything that would serve to indicate that any record of these scenes was graven upon the tablets of memory.*

Richter, Freshfield, and MacCurdy never consider the possibility that perhaps Leonardo had the skill to enter a space-time consciousness, discard the rational left brain, and acquire a quantum look at the world. Perhaps he *never* physically visited these places. Perhaps his ability to *remote-view* the world extended into the past as well.

Art critic Kenneth Clark proposed that Leonardo had a "super fast eye." Clark marvels at the phenomenon, mentioning it several times throughout his book, *Leonardo da Vinci*. Highlighting examples to illustrate Leonardo's quickness of sight, Clark dwells on two. In the first, Leonardo was able to slow down the rapid fluttering of a bird's wings in his mind's eye and carefully draw the sequence of winged flight. In the

second, Leonardo could gaze at falling water and, with his "super fast eye," freeze the image of the water in mid-fall and then draw its flow, arrested for an instant. But Leonardo went even further. He made a drawing that showed water falling into a pond, and then included in his image how the falling water roiled the *undersurface*! No other artist in history has ever been able to accomplish either of these feats.

Leonardo also made a drawing of a pendulum that included multiple images of its swinging. In an uncannily correct representation, if a strobe light were concentrated on the pendulum, there would have been more images of the pendulum as it swung faster at its base than at its extremities. Leonardo personified this increase in images, indicating that the pendulum is swinging faster as it nears its fulcrum than when it extends near its extremities.

Instead of ascribing to Leonardo a "super fast eye," perhaps we need to think of him as someone who perceived time differently. If he was capable of achieving a space-time consciousness, then he should have been able to draw a bird's trajectory in slow motion or stop time to accurately portray water caught in midair. He could then complete the work by revealing how it appeared under the water as well.

Leonardo was capable of thinking in extended reaches of time as well as space. For centuries, stonemasons were aware that trapped in rocks retrieved from quarries high in the mountains were fossilized creatures from the depths of the sea. Yet no one ever seriously questioned how or why the fossils of sea creatures could be found high in the rocks of mountains, far from water. The accepted explanation was the flood described in the Old Testament. That this huge amount of water carried these fossils inland seemed a satisfactory answer to everyone—except for Leonardo.

The insight that the rocks were immeasurably older than the biblical reckoning would have required a perspective about time unimaginable for anyone living in fifteenth-century Europe. He or she would have had to imagine that the tops of mountains were once the seabed, and that the present seabed once formed—in a very distant past—the peaks of mountains somewhere else.

Leonardo was the first person in the historical record to suggest that the Earth was much older than anyone had previously imagined.

His opinion preceded those of two geologists by three hundred years: Georges-Louis Leclerc, Comte de Buffon, who first posed that the Earth was seventy-five thousand years old; and then Charles Lyell, who proposed that it was billions of years old. Did a space-time consciousness play a role in Leonardo's ability to conceive of immense passages of time?

Other peculiarities of Leonardo's life and work habits begin to make sense if we think of him as an early space-time traveler. (Leonardo's perception of time may explain why he thought that it was nothing out of the ordinary to deliver the second version of *Virgin of the Rocks* to the friars, who had been dissatisfied with his first version—some twenty-five-odd years later!)

Start and *finish* are words that belie the ingrained notions we have about linear time. The fact that Leonardo started but abandoned so many works makes more sense if we think of him as an artist who did not necessarily see things in terms of standard time. This may provide an alternative explanation for a puzzling trait that has given centuries of biographers conniptions trying to explain it.

Leonardo was the first artist to use an "exploded" view when depicting the relationships of the organs and muscles of the human body to one another. By showing the upper layer stripped away from the next layer, but still hovering a respectable distance above the layer below, he was able to convey relationships of one part to another that would be difficult to understand if viewed in only one perspective. He also used cross-section and exploded views to illustrate his many engineering drawings. Similarly, he was the first to supply a view of the body from multiple different angles simultaneously, as if the viewer were moving around the stationary object.

Leonardo's ability to see the Earth as viewed from space may have helped Copernicus to overturn the Ptolemaic Earth-as-center-of-the-universe type of medieval thinking. Copernicus asked: How would the sun appear from the vantage point of Mars instead of Earth? He initiated his revolutionary theory based on the answer to this novel question. It was a perspectivist question that Leonardo was prone to ask.

CHAPTER 16

Leonardo's Brain

In women, the measurements of the corpus callosum, measured as a whole or for specific measurements of any seven subdivisions of the callosum, are larger.

—H. STEINMETZ ET AL.

Leonardo understood that the creative process was predominantly a female process. The male part of procreation was short, easy, and beyond his power of analysis. The female part was long, complex, and a possible subject for investigation.

—KENNETH CLARK

"It's a fine day, let us go out and kill something!" cries the typical male instinctively. "There is a living thing, it will die if it is not cared for," says the average woman almost equally instinctively.

—OLIVE SCHREINER, FEMINIST

LET US CONSIDER THE DIFFERENCES AMONG THE BRAINS OF STRAIGHTS, gays*, women, and left-handers. Amplifying the functional results of these quirks of brain arrangement is the recent finding that there are differences in the relative size of the corpus callosum between right-handed heterosexual males (hereafter referred to by the acronym RHHM) and left-handed

* The word *homosexual* is emotionally freighted and unclear. The *homo* is the Greek prefix for "same," rather than, as most people would assume, "man." The term is inexact, sometimes including bisexuals and transgenders. I prefer to use the term *exclusive same sex preference*, or ESSP. I will refer to homosexual men (ESSP) as gays, homosexual women (ESSP) as lesbians, and heterosexual men and women as straights. I will also identify bisexuals when I am discussing them.

heterosexual men, women, gay men, and lesbians. The corpus callosum is the largest single structure in the human brain, containing over 200 million connecting neurons. It coordinates the differing feelings, desires, proclivities, opinions, and sensory experiences of the two hemispheres, so that the entity called "I" can present a unified, coherent response to the outside world. The corpus callosum consists of several anatomically distinct component cables, the largest of which is the anterior commissure.

In recent studies, neuroscientists have revealed that the "standard" brain arrangement present in the majority of straight, right-handed, nonmusician males has many exceptions. Shuttling back and forth between Renaissance descriptions of Leonardo's eccentricities and these modern neurological findings provides a scaffold upon which to begin to erect the diagram of his particular brain. But first we must examine the most common wiring diagrams present in the average human.

The most dichotomous brain—that is, where the two hemispheres are the most specialized—belongs to a right-handed heterosexual male. Approximately 97 percent of key language modules reside in his left hemisphere, making it unequivocally his dominant lobe. This extreme skewing is not present to the same degree in women, both right- and left-handed; gays and lesbians; and left-handers of both sexes.

All of the above statements refer, of course, to bell-shaped distribution curves. There will always be some lefties, women, and gays who have more specialized brains than most right-handed straight men; and there will be some right-handed straight men who have less-lateralized brains for language and handedness. But in general, these characteristics of brain anatomy tend to hold true for the population at large.

Females, right- or left-handed, have a more even distribution between the lobes regarding language and brain dominance. Right-handed women still have the large majority of their language modules in their left brains, but whereas an RHHM would most likely have 97 percent of his wordsmithing skills concentrated in the left lobe, a woman would be more likely to have a lesser percentage (about 80 percent) in the left brain, and the remaining 20 percent in the right brain.

The import of these differing arrangements becomes manifest when an RHHM has a significant stroke, injury, or tumor in his left brain. The

resulting handicap precipitates a profound social catastrophe. He loses his ability to communicate and experiences a devastating paralysis on his dominant side. His opposite arm, forearm, and hand—as well as his thigh, leg, and foot—lack dexterity, resulting in a gross loss of maneuverability. The same size defect in a right- or left-handed woman, left-hander, or a gay or lesbian will not produce the same degree of disability. Further, a member of any of the three subgroups would recover from the left lobe's affliction sooner than would the afflicted RHHM. Amplifying these results is the recent finding that there are differences in the relative size of the corpus callosum between RHHMs and right- and left-handed women, left-handed heterosexual men, and gays and lesbians.

Although among neuroscientists there smolders a low-level controversy over these findings, the weight of evidence in the scientific literature supports the finding of Sandra Witelson and others, who studied the MRI scans of numerous men and women and discovered that the anterior commissure of women can be as much as *30 percent larger* than that of men. Also, its shape differs. Further studies indicate that the size of the anterior commissure in gay men is half again as large as the difference from women and straight men; that is, if women are 30 percent larger than men, then the corpus callosum—along with the anterior commissural—in gays is, on average, 15 percent larger than straight men. And to add an arabesque to Witelson's findings: Recently she has reported that these two entities, in both left-handed men and women, are larger than in right-handed men.

These two discoveries—more specialized brains, and smaller anterior commissures in RHHMs when compared to women, gays, and lefties—are related. Each quirk exaggerates the significance of the other.

The only emotions that have drifted over to take up residence to the left of the corpus callosum are happy ones. Joy, optimism, cheerfulness, and a sense of well-being paradoxically seem to have taken leave of the more-negative emotions associated with the right brain to find a home in the left frontal lobe. Even laughter resides on that side, according to neuroscientist Antonio Damasio. All of these emotions are in close proximity to the Great Decider, the Executor. So, too, are they separated from

the emotions that have to do with sex and nurturing small children that reside on the right side. The division between emotions to the right and to the left is most extreme in RHHMs when compared to the three subgroups of women, gays, and lefties.

The asymmetry in the emotional functions of the two hemispheres, combined with the left brain's hegemony over words, leads to the inescapable conclusion that individuals with larger connections containing more neurons between the left and right brain should translate into a facility to express emotions. More neurons means more links between feelings and words. And more emotional centers located in near proximity to language modules would also increase emotional expressiveness.

As this information has leaked out through the popular media, the response among women and men has been predictable. Women apprised of the disparity and made aware of their larger anterior commissures discussed these revelations among themselves. Some encouraged the sisterhood to feel compassion for emotionally impoverished men. No wonder, they said, that so many men are emotionally barren and have such a difficult time experiencing various emotional states.

The men, in contrast, heaved a sigh of relief. Here, at last, was confirmation that it was okay to groan, take a deep breath, and affect the deer-in-the-headlights expression whenever a woman announces that it is time to have a discussion concerning their relationship: a moment traditionally dreaded by the males. The stereotype that women are more "in touch" with their emotions had some basis in experience, and now it had basis in science.

These recent findings concerning brain organization give us substantial clues in deciphering the wiring arrangement of the subject of this book: the particular brain of a possibly gay, left-handed, nearly ambidextrous, and singularly creative Renaissance male. The outlier, Leonardo da Vinci.

The question of Leonardo's sexuality is pertinent. Members of this one select group, ESSPs, did not conform to the standard model of the RHHM. In fact, they represented the complete opposite.

In *Sex, Time, and Power,* I put forth my Theory of Eights: 8 percent of human males are ESSP; 8 percent of males are left-handed. (Only 5

percent of human females figure into this statistic.) Another most peculiar percentage: 8 percent of males are born with the gene for color blindness, or color deficiency. (Less than .01 percent of females are burdened by this abnormality.) And finally, 8 percent of males are bald in their prime. (Rarely does a woman lose her hair.)

Researchers Robin Dunbar and Leslie C. Aiello have estimated that a prehistoric human community would be economically viable if it contained between 150 and 225 individuals. Considering the number of women, children, disabled, and aged, the hunting party would have consisted of nine to twelve men in their prime. Society is organized on this principle. There are eleven on a football team, nine on a baseball team. In ancient Greece twelve deities formed the Golden Circle. There were twelve Christian disciples, and eighteen Lohan in Chinese Buddhism to carry Shakyamuni's message over the Himalayas. There are ten in a Jewish prayer *minyan*, twelve on a jury, and twelve on a board of directors. One man out of twelve equals the percentage of 8 percent.

If the hunting group was lucky enough to bring down a large mammal and one of the twelve was an ESSP, he would not have the obligation to bring his share home to feed his woman and children. Consequently, there would be 8 percent more meat to distribute to the remaining women, children, and elderly at the home base.

One hunter out of twelve who was color-deficient would be better able to see lurking predators or prey blending in with the background. In World War I and II, armies on both sides sought out color-deficient soldiers because they could see right through camouflage.

Prey would be hunted so that they could be chased to the right of the hunters, giving them a spear-throwing advantage. But occasionally the prey turned left. One hunter out of twelve who could throw more accurately to the left than the right would be a considerable asset to eleven right-handers. (Watch the awkwardness of a right-handed quarterback trying to throw the ball to his right to see why hunters needed a left-hander.)

And the strange loss of hair only on the top of their head in 8 percent of men in their prime would make it easier for hunters to stalk and confuse game.

The interrelationship of ESSP, color blindness, left-handedness, and baldness can be ascertained by the increased incidence of each trait within the other. More ESSPs are left-handed compared to straight males. More ESSPs are color-blind than straight males. ESSP-ness indicates a profound difference in brain anatomy.

I proposed my Theory of Eights more thoroughly in my earlier book in an attempt to explain why only the human species expresses homosexuality so floridly. Originally, it was common to believe that ESSP was peculiar to humans, but then this type of behavior was identified within the animal community. Creatures large and small seem to indulge in same-sex sexual behavior. To date some two hundred species of animals have been observed to manifest what to ethologists might be considered homosexual behavior. However, it can never be known for certain that the animals are not merely engaging in displays of dominance.

In some of the more complex animal species, both males and females will occasionally use sex to defuse tense social situations, gain advantage, make allies, and barter for food. Bonobo chimps of both sexes engage in behavior that could be construed as homosexual, but the animals involved do not limit their sexual advances to members of the same sex. When the females enter their estrus period, they will only mate with males—100 percent of the time. This points out the uniqueness of humans. It appears we have a higher percentage of ESSP than any other species.

But what would be the explanation? A critical reason: No other species exists with such enormous responsibilities to ensure that the next generation survives to reach the reproductive age. The addition of gays and lesbians are a means of helping to make that happen. Having an uncle or aunt that does not have the burden of raising his or her own children is an asset to a child. ESSP may have originally served the function of putting more meat in the mouths of mothers and babes, but its purpose has evolved into something else.

From an evolutionary point of view, ESSP is a supreme paradox. If one assumes it is driven by genetics, one would quickly conclude that the gene controlling it guarantees the trait's extinction. How could a homosexual gene survive if the person possessing it does not desire to reproduce? A

nonreplicating "unselfish" gene is an oxymoron. In theory, such a gene should be winnowed from the genome within a few generations.

There is something about a feminine nature in men and a masculine nature in women that aids in creativity. Mihaly Csikszentmihalyi commented in his book, *Creativity: Flow and Psychology of Discovery and Invention*, that these traits were related:

> *In all cultures, men are brought up to be masculine and to disregard and repress those aspects of their temperament that the culture regards as feminine, whereas women are expected to do the opposite. Creative individuals to a certain extent escape rigid gender role stereotyping. When tests of masculinity/femininity are given to young people, over and over one finds that creative girls are more dominant and tough than other girls, and creative boys are more sensitive and less aggressive than their peers.*
>
> *This tendency toward androgyny is sometimes understood purely in sexual terms, and therefore it gets confused with homosexuality. But psychological androgyny is a much wider concept, referring to a person's ability to be at the same time aggressive and nurturant, sensitive and rigid, dominant and submissive, regardless of gender. A psychologically androgynous person in effect doubles his or her repertoire of responses, and can impact the world in terms of a much richer and varied spectrum of opportunities. It is not surprising that creative individuals are more likely to have not only the strengths of their gender but those of the other one too.*

In 1993, researcher Dean Hamer and his colleagues identified a gene that they believe plays a critical role in determining homosexual behavior. Research in the field is still in its infancy, but increasingly scientists have arrived at a consensus that one's genes determine whether a male or female will be homosexual.

Richard Schwab, a Dutch researcher, believes he has pinpointed a clump of cells (called the BSTc) within the amygdala of the brain that may determine sexual orientation. Straight men have a larger BSTc than

straight women, and this area is half again as large in women than it is in transsexual women (who believe they are women trapped in a man's body). Smaller still is this minute portion of the nervous system in gay men. Simon LeVay, a gay neuroscientific researcher, has also claimed progress in identifying where in the hypothalamus "gayness" resides. Hamer may provide an answer as to the question of "how" and Schwab's and LeVay's research may give us insight as to the "where" of ESSP, but neither provides a compelling evolutionary theory of "why."

For many years, it was commonly held that psychological factors played the leading role in sexual preferences. Many theorized that a disconnected father and an overbearing mother caused boys to become gay. Recently, this Freudian view has been stood on its head. Instead of being the *cause* for why boys become gay, some have speculated that it may be the *result* of boys expressing their gayness. Many fathers, observing that their sons are less manly than they expect them to be, distance themselves emotionally. The boys' mothers, to compensate, become more protective. Blaming mothers for deficient nurturing has been a convenient excuse that fathers have often used to deflect from themselves any possible responsibility for their sons' sexual orientation.

Many in fundamentalist religions believe homosexuality is a sin, and that gays will be punished by a God who is displeased by what they consider to be an offense against nature and religion. Because fundamentalists claim that their God is omniscient and omnipotent, it is not clear from their arguments why a deity who possesses such power and foresight would create mortals who were born to sin against Him. The Renaissance humanist Erasmus considered this line of reasoning to represent the direst blasphemy. He believed that such a God would be a monster, unworthy of worship. The tortured argument used by many fundamentalists to justify their intolerant public denunciations of gays and lesbians proves only that the Dark Ages have not entirely been dispelled.

Until relatively recently, the gay and lesbian lifestyle was considered to be a mental disease in Western societies. Not until 1973 did members of the American Psychiatric Association, in an exceedingly contentious session, vote to remove homosexuality from its list of pathological mental conditions.

If we try to analyze Leonardo's brain, there is little that we can know with complete confidence. However, there is much circumstantial evidence on this delicate subject that has been provided by contemporary accounts, Leonardo's own writings on the subject, and clues that abound in his many drawings. We are confronted by both the enormous variety of skills that he possessed and, at the same time, evidence that he did not fit into the standard ESSP profile. When approaching the extraordinary creativity of a man like Leonardo, we must take into account his unconventional attitudes about sexuality.

We know from the descriptions of others that the handsome Leonardo was an extrovert who wore fashions that challenged the strict rules of the culture. While most wore long cloaks in somber colors, Leonardo wore bright, short tunics. His behavior would be described as exhibitionistic.

He was sought after as a companion; he was by all accounts agreeable, a charming conversationalist, and an accomplished singer, musician, and songwriter. Hanging out with Leonardo at this time in his life must have been similar to Hemingway's description of his youth in Paris—a "movable feast." The difference being that with Leonardo, there was a notable absence of women.

And then a setback. Leonardo's attitude toward sex was likely affected by the episode in which he and five others were charged with sodomy and spent some time in prison while awaiting the verdict. The charge was never decided either in his favor or against him. We do not know whether this had an impact on his feelings about sexual intercourse, or whether he had an aversion to it in the first place.

Later in his life, he convinced the father of a ten-year-old boy, Giovanni, to let the boy live with him. It was not the boy's talent that attracted Leonardo but his exceptional beauty. There are many portraits and profiles of a young man drawn in Leonardo's hand that were surely this boy; he seems to have been consumed with the boy's looks. Salai ("little devil"), as he called the boy, stole from him and caused him no end of troubles. It is not clear, however, whether Leonardo indulged his homosexual inclination. "He who cannot control his desires is no more better than a beast," he wrote.

It is not clear from the record whether or not Leonardo ever engaged in heterosexual intercourse. There is a suggestion in the literature that he did not. He made anatomical drawings of the genitalia of both sexes, and a singular drawing of a couple engaged in the act. Unlike his other anatomical drawings, some of which are masterpieces of art, the one he devoted to understanding sexual intercourse contains a number of inaccuracies that are uncharacteristic. He drew the male sexual organs with greater detail and greater accuracy than he did the organs of the female. Unlike the male, who was fully drawn, he completed only the female's pelvis and breast. The image also had distortions that were strange for an artist with such a keen eye and sense of proportion.

The most striking thing about this drawing is that the couple is using an upright stance for intercourse. The world over, couples making love have preferred a recumbent position, more natural for enjoyment. In those few examples in Hindu art in which the couples are shown standing, the legs are arranged in a position to achieve maximal penetration, and the participants wear expressions of ecstasy and appear to be thoroughly enjoying themselves.

Not so in Leonardo's depiction of the act. We can draw no conclusions about whether the female is experiencing pleasure or not. We can, however, surmise what the man is experiencing; Leonardo chose to depict his eyebrows knitted in a grimacing expression, his mouth turned downward to indicate that he was not experiencing bliss. Adding to the confusion of this drawing is the fact that the man's head is adorned with long curly locks that extend far down his back. If only the top half of this figure were to be viewed, most would surely identify the figure as a woman.

Another feature indicating Leonardo's disdain for the feminine was the unpleasing manner in which he chose to draw the woman's breast. He also included an inaccuracy that could be forgiven in an age of ignorance about anatomy, but is difficult to explain in a man whose insatiable curiosity drove him to personally scrutinize the objects of attention. If he examined the nipple of a lactating woman, he would have noted that the milk issues from many small ducts rather than one large one. If he was too shy to ask a woman to closely examine her breast, then he could have easily

LEONARDO'S BRAIN

examined the nipple of a cow or a horse, something he did not hesitate to do when it was difficult for him to find specimens to dissect.

In a cadaver, the intensity of Leonardo's interest did not extend to this feature of female anatomy. He imagined the milk coming from a single duct connected to the womb, an inaccuracy difficult to explain in a man who was the first to discover the connection between nerves, muscles, and other objects of anatomical dissections.

Leonardo devotes considerable attention to drawing the male's testicles, spermatic cord, and the tiny epididymus that sits on top of the testis. In comparison, he drew the vagina and uterus of the female with a noticeable lack of detail. Leonardo's many examinations of interior of other animals would have afforded him the opportunity to see the relationship of these two organs which he drew with startling inattention.

The clumsiest blunder, however, occurs when he positioned the lower extremities of the two lovers. Keeping in mind that the big toe is always on the inner side of the foot, Leonardo appears to have drawn the foot in the opposite position. Some have attempted to explain this mistake by claiming that the legs in this drawing are part of another drawing, but it is a weak argument, because the legs do appear to belong to the intertwined lovers. That Leonardo would make this mistake is a good indication that the drawing was an emotionally charged subject for him, and one he found difficult to portray accurately.

There is more. His notebooks do not contain a single reference to a friendship or relationship with a woman. "The act of procreation," he wrote, "and everything connected with it is so disgusting that mankind would soon die out if it were not an old established custom and if there were not pretty faces and sensuous natures." Accompanying a drawing of two bodies twined as though proceeding from a single trunk represents a contest between virtue and envy. From the accompanying comment we are led to judge that he did not think much of women:

In the moment when virtue is born the woman gives birth to envy against herself, and a body shall sooner exist without a shadow than virtue without envy.... She is made with a mask upon her face of fair seeming.... She is made lean and wizened because she is ever wasting

in perpetual desire. She is made with a fiery serpent gnawing at her heart. She is given a quiver with tongues for arrows because with the tongue she often offends, and she is made with a leopard's skin, since the leopard from envy slays the lion by guile. She is given a vase in the hand full of flowers, filled beneath with scorpions and toads and other venomous things. She is made riding upon death, because envy, never dying, has lordship over him; and death is made with a bridle in this mouth and laden with various weapons, since these are all the instruments of death.

And this from the man who painted the Mona Lisa's smile, the love of a mother for her child, and a woman's beauty.

Among the most prominent features of Leonardo was his left-handedness. Continuing from the Middle Ages, the Renaissance authorities would strike a child's left hand when he or she tried to use it. The common prejudice in nearly all Christian societies toward left-handers manifested itself by the Church declaring ominously that the left hand was the agent of the devil. So how did it occur that a natural leftie was allowed to maintain his inclination? Did he not receive a formal education in a Catholic school? If so, was the teaching in the country more lenient than it was in the city? Or was his natural inclination toward the left side so powerful that he resisted the treatment he received? The sources are too incomplete to answer these questions. At any rate, Leonardo entered his early teenage years a committed left-hander. His earliest drawings indicate he had retained his strong inclination.

Throughout history, a higher percentage of artists have been left-handed. If the general population is only 8 to 10 percent leftie, then art schools represent a skewed percentage of 30 to 40 percent left-handers. Also, a higher percentage of ESSPs are left-handers, which accentuates the difference in brain organization between RHHMs and ESSPs. In addition, ESSPs and left-handers exhibit a greater tendency toward ambidexterity, indicating mixed brain dominance.

There is also a new finding that left-handers have a larger corpus callosum than right-handers. Leonardo was left-handed but also

ambidextrous. This means that although he preferred his left hand, he was near equally accomplished in using his right hand in carrying out fine-motor tasks. Most people who are right-handed do not let their left hand become involved with fine-motor movements. It is simply too clumsy.

Leonardo was the only historical figure we know of who wrote backward. There have been many theories about why he employed his unusual method of writing, but the simplest remains the best: He did not want the ink to smear when he wrote. Left-handers must employ hook handwriting to avoid this distressing trait when they write from left to right. Using a right-to-left orientation and writing backward solves this problem. Leonardo never thought his notebooks would be read by anyone else, or if he did, that they would take the time to hold them up to a mirror to read them. He wrote them in a style that was convenient for him but confusing for others.

Occasionally a word that was written in the conventional manner would be inserted into his right-to-left orientation, an indication of his ambidexterity.

Neurologists distinguish among lefties and righties as to their preference for eye, ear, hand, and foot. The percentage of pure righties—that is, those who preferentially sight a gun with their right eye, hold a phone to their right ear, throw a ball with their right hand, and kick a can with their right foot—falls when compared to the overall percentage of people who consider themselves right-handed.

The number of pure right-handers is about 88 percent compared to the figures for those who consider themselves right-handers, which average about 92 percent worldwide. These seemingly minor subcategories can be very significant. For example, during basic training, drill instructors quickly weed out those recruits who sight a gun with their left eye while steadying it primarily with their right hand and arm, because the recoil of the gun will injure their left chest and shoulder, rendering them ineffective potential infantrymen.

The difference between left-handers and right-handers is more extreme than we realize. Even the diseases to which they are susceptible are different. Left-handers are more prone to develop autoimmune

diseases, such as rheumatoid arthritis and multiple sclerosis. RHHMs are relatively protected from these afflictions, but are prone to develop more heart attacks and other vascular diseases.

Leonardo was an accomplished musician, who learned to play the many instruments he designed, and also sang "divinely," according to witnesses. This indicates a musical lobe in the great thinker's brain. MRI scans of people listening to music who do not play music activates their right parietal lobe. If they are musicians who can play instruments by feel, but do not know how to read musical notation, then the right parietal and right frontal lobes activate. However, if they possess the skill to *read* music, the skill includes a marked shift to the left hemisphere. Music is clearly rooted in the right hemisphere—except reading musical notation, which is a left-brained function. Leonardo could do all three.

For a composer to write the scores for the individual pieces of the orchestra, he or she needs the sequential, analytic left hemisphere. It is similar to solving a complex mathematical problem. Yet, we find that many of Leonardo's works were composed in rebuses or symbolic puzzles. Talented composers, unlike the general public, possess large tracts of fibers connecting their left and right hemispheres. Or alternatively, they must have a brain that has more equally distributed language and music into each of the hemispheres. There is evidence that musicians are much more attuned to remote viewing than are nonmusicians. In one study, fifty music students from the Juilliard School were given several tasks to perform, all of which involved remote viewing. The students' results topped the best results from the general population.

The form of language that Leonardo used was highly metaphorical. He posed riddles and buried metaphors in his paintings. For this to occur, he had to have had a large connection of corpus callosum fibers between his right hemisphere and his left. The form of language based on metaphor—poetry, for instance—exists in the right hemisphere, even though language is primarily a left hemispheric function. To accomplish the task of the poet, a significant connection must exist between the parts of the right hemisphere, and, furthermore, there must be many interconnections between the two hemispheres. These fibers must be solidly welded to the

language centers in the left hemisphere so that poetic metaphors can be expressed in language. Leonardo used the metaphor in his writings extensively—another example of connected hemispheres.

Although he actively engaged in metaphoric phrasing that bordered on poetry, Leonardo considered poetry inferior to painting. He claimed that he was able to render in a single image the emotions that would take a poet pages of words to evoke. Whereas poetry is the mixture of right and left, images are perceived almost exclusively on the right. When we see something, we identify it with our right brain, and then we find the name for it with our left brain.

Leonardo had all the characteristics of the brain that would allow for an increased sensibility to aesthetics, harmony, and creativity. They were present as the result of differences in the organization of the possibly gay, left-hander's, musical, backward-writing, ambidextrous brain.

And what are we to make of Leonardo's determination, at some point, to live as a vegetarian? This was a time when falconry, hunting parties, and meat-laden festivals were the standard. Poor people who did not have access to meat longed for it; those who could afford it threw elaborate feasts where meat was the premier food on the menu. Leonardo did not choose to be a vegetarian for dietary reasons. Rather, he opposed the killing of any animal for the benefit of his digestion. He believed that plants did not have a nervous system and could not feel pain, but he felt that crabs, ducks, fish, and boars all experienced pain the same way he did.

Leonardo's stance was so exceptional for its time that a number of his associates commented on it. But Leonardo's position on the interconnectedness of life on this planet resonated with the position held by a large number of mystics, gurus, shamans, and the Buddha, those who saw the world as one large interconnected community. These types were located in high concentrations in the East. In the West, where alphabets dominated, the type of thinking that would encourage the belief in interconnectedness was largely discouraged. Leonardo belonged to the small but exceptional group of Westerners who visualized the interconnectedness of all life.

The left brain sees the world from a survivalist point of view. Everything is divided into "I" and "not-I." The ego lives in the left hemisphere. The right brain sees the interconnections between all living things. Ordinarily, the right brain is suppressed by the left brain. Reading and writing an alphabet reinforces this attitude of us versus them, and inside versus the outside. Marshall McLuhan summed it up:

> *We must once again accept and harmonize the perceptual biases of both [the left and right brain] and understand that for thousands of years the left hemisphere has suppressed the qualitative judgment of the right, and the human personality has suffered for it.*

Reading and writing encourage the growth of religions that glorify a Creator, instead of the awareness that the Creation *is the manifestation of the Creator*. Leonardo's feeling of connection with all living things was the reason he practiced vegetarianism. His right brain must have had a larger influence on his consciousness than what is considered normal in a Western society.

Leonardo painted the ceiling of the Sala delle Asse in the Sforzesco Castle in a most unusual manner. At first, it appears as a lush, covered herbiage with many vines competing with each other for space. Only after some real concentration does it become clear that the vines are not separate, but rather consist of one lengthy vine that only appears to interlace with itself. This drawing is a realistic portrayal of Leonardo's worldview. He was putting forth in a complicated diagram what was for him a truth: *All of life is interconnected.*

Four hundred years later, hardheaded, no-nonsense physicists would turn the physics community on its head when they issued mathematical proofs with the basic premise that the world was interconnected and that human consciousness had to be calculated into the equation. Butterflies flapping their wings *do* relate to hurricanes. Quantum theory and complexity theory (chaos theory) bear this out. When added to the fourth dimension, which includes the three vectors of space—height, length, and depth—and the three durations of time—past, present, and future—their conclusions challenge our common perceptions of reality.

This was the idea that Heisenberg, Bohr, Pauli, Bohm, Bell, and many others theorized, and what Puthoff and Targ established at SRI when they performed their remote-viewing experiments. Leonardo anticipated these insights. Leonardo's brain was so complex that it had significant implications for the human species.

CHAPTER 17

Leonardo/Asynchrony

*In view of his uniqueness, it would seem that Leonardo blazed forth
as a mutant, androgynous model of psychotechnical, right- and left-
hemisphere integration. He passed on before he could be fully compre-
hended—even by himself.*

—José Argüelles

*All evil leaves sadness in one's memory, except the supreme evil, death,
which destroys memory along with life.*

—Leonardo da Vinci

*It takes sixty years of incredible suffering and effort to make a unique
self-conscious individual, and then he is good only for dying.*

—André Malraux

Leonardo's exceptional creativity resulted from his ability to
access a different way to think. His ESSP-ness put him somewhere between
the masculine and the feminine. His left-handedness, ambidexterity, and
mirror writing were indications of a nondominant brain. His adherence to
vegetarianism at a time when most everyone was eating meat suggests a
holistic view of the world. The equality between his right and left hemi-
spheres contributed to his achievements in art and science, unparalleled
by any other individual in history. His unique brain wiring also allowed
him the opportunity to experience the world from the vantage point of a
higher dimension. The inexplicable wizardry present in both his art and his
science can be pondered only by stepping back and asking: Did he have

mental faculties that differed merely in degree, or did he experience a form of cognition qualitatively different from the rest of us?

I propose that many of Leonardo's successes (and failures) were the result of his gaining access to a higher consciousness. What kind of human at the turn of the fifteenth century would come up with two advanced versions of space (remote viewing) and time (predictive accuracy)?

The Tigris passes through Asia Minor and brings with it the water of three lakes, one after the other, of various elevations: Munace, then Pallas, and the lowest, Triton. And the Nile again springs from the three very high lakes in Ethiopia, and runs northward, toward the sea of Egypt, with a course of four thousand miles, and by the shortest and straightest line it is three thousand miles. In his notebooks, Leonardo writes:

> *The bosom of the Mediterranean, like a sea, received the principal waters of Africa, Asia, and Europe; for they were turned toward it and came with their waters to the base of the mountains which surrounded it and formed its banks. And the peaks of the Apennines stood up in this sea in the form of islands surrounded by salt water. Nor did Africa, behind its Atlas mountains, as yet reveal the earth of its great plains some three thousand miles in extent; . . . and above the plains of Italy where flocks of birds are flying today, fishes were once moving in great shoals.*

This is astonishing. The sources of the Nile had never been explored by Europeans, and were not known in Europe until they were discovered and described by John Speke in 1858. And yet 350 years earlier, it is described with reasonable accuracy by Leonardo. His stance on what occurred during prehistoric times could not have arrived via a traveler.

I realize that what I'm about to make is a highly speculative claim, bordering on the "woo woo." But, there are missing explanations for important events and facts that do not fit with our perception of quotidian reality. What follows are just a few of them.

Rupert Sheldrake is an Oxford-trained biologist who has conducted ESP experiments on humans and animals. In his book *The Sense of Being*

Stared At, he describes how his findings indicate that most people possess some degree of ESP. For example, in one simple experiment, he asked one of four people to call a target person at a specified time. None of the four knew which one of them was to make the call until an envelope was torn open in each of their respective houses. One individual out of the four was selected to make the call.

When the phone began to ring, the person receiving the call would have to guess who was calling. The odds should have been one in four, or 25 percent correct guesses. Instead, there were some people who guessed correctly over 60 percent of the time. The results were not random, either. The relationship between the individuals strongly affected the outcome. Mothers and daughters had the closest connection. Distance did not matter in the least; some phone calls were made from as far away as New Zealand to Britain. The point of his experiment was that some individuals are endowed with an extrasensory perception that allows them to collapse space.

Envisioning space in a manner that differs from the norm extends to another special group. What are we to make of mental abilities of certain chess masters who have been able to play multiple games of chess simultaneously while blindfolded, winning most or all of them? In Philadelphia in 1902, at the age of twenty-eight, Harry Pillsbury simultaneously played twenty opponents while blindfolded and defeated them all. He toured the United States, covering forty thousand miles, and demonstrated his skill at blindfolded, simultaneous chess games, leaving people to marvel at his amazing feat.

Blindfolded chess masters have continued to baffle onlookers throughout the intervening years. In 1925 blindfolded Richard Réti played twenty-nine opponents simultaneously in Sao Paulo. After the exhibition, he left for home but forgot his suitcase. When somebody reminded him about it, Reti exclaimed, "Thank you very much. My memory is so bad ..."

Modern neuroscientists are unable to describe the mental process by which the blindfolded chess masters accomplished these feats. When the chess masters were asked how they could keep track of the multiple boards, most replied, if they could verbalize it at all, that they envisioned all the boards at once in their mind's eye. In other words, they saw them

holistically. If you or I were to attempt this tour de force, we would begin by trying to remember the configuration of all the boards *in sequence.* Within the first few moves this strategy would fail, and we would be unable to win or draw any game. We would be hard-pressed just to remember which board had what configuration.

People possessed of Pillsbury's and the other blindfolded chess masters' skill envision space and time differently from the rest of us. And it is not just a matter of degree, but something more. How they accomplish this feat is unfathomable to the rest of us, who see the world in three dimensions of space and observe the linear passage of time.

Autism is a form of congenital mental illness characterized by a child being "mindblind," a phrase that indicates he or she is unable to empathize with others. Humans and other higher animals, such as chimpanzees and bonobos, possess something called "theory of mind." We can often place ourselves into the mind of others and imagine how they are thinking or feeling. This gives humans and other higher mammals the ability to empathize and sympathize with the plight of others.

Some autistic individuals on the end of the disability spectrum cannot do this. They tend to deal with objects more comfortably than with people. Outwardly, they seem to possess a very limited inner mental life, without much introspection or internal dialogue. High-functioning autistics can be cared for at home but require considerable attention. Severe cases must be institutionalized.

On rare occasions among the population of autism sufferers, individuals appear who possess extraordinary mental talents. These autistic *savants,* as they are called, stump neuroscientists, who remain unsure how to explain their extraordinary abilities. Psychiatrist Darold Treffert in his book *Extraordinary People* has collected all the recorded cases of this phenomenon. He separates them into four different types: the lightening calculators; eidetic or photographic memorizers; those who have an uncanny musical memory; and the last and most rare, those possessed of artistic abilities that they could not have learned in the conventional way.

Lightning calculators can tell you—in seconds—upon what day of the week May 10 of the year 3067 will fall. Eidetic memorizers can look at a page of print once and have it stay in their memory indefinitely. Those with

the special musical talent can sit down and play any piece of music they have heard only once, and again, do so indefinitely. Kim Peek, the high-functioning autistic savant who served as the model for Dustin Hoffman's portrayal in the movie *Rain Man*, can recite back any book he has read flawlessly and play any piece of music he has ever heard, without needing a score. Most interestingly, Kim Peek did not have a connection between his right brain and left brain—he was missing the corpus callosum.

The last and most inexplicable form of autistic savants are those rare individuals who can draw at a level of artistic refinement that typically only trained artists with years of experience are able to accomplish. The child, studied intensely by psychologist Lorna Selfe, was a young girl named Nadia who lived early in the twentieth century. Nadia began expressing her extraordinary talents at the age of three and half, and by age five, had moved on to produce artistic masterpieces that can compare to many of the drawings of the mature Leonardo. The interesting thing about Nadia was that she was mute when born. Her language skills were so primitive that she could only make crying sounds. She was taught language, and gradually, as her speech improved, her art deteriorated. By nine, she had lost the special skills she had exhibited from ages five to seven.

In her prime as an artist, she could not talk intelligibly, made little eye contact, and was generally passive and disinterested. She was relatively helpless and needed assistance in the most basic human functions, such as dressing herself and tying her shoes. These extreme disabilities, however, fell away when she was provided with pen and paper. Left-handed, she could draw galloping horses with a rider in three-quarter views, using the correct perspective. No possible theoretical or other scientific explanation for how she could have acquired this skill exists. The acquisition of artistic skills proceed in time.

Child psychologist Jean Piaget detailed how children acquire their perceptions of representational art. First, they draw stick figures; then, more details, such as hands and feet, are added. Then as they get older they make steady progress toward more sophisticated forms of drawing. Five-year-olds, for example, do not know how to draw a neck.

Experienced artists take years to learn how to draw a person with the proper anatomical details in correct perspective. How was a

five-year-old—a mentally dysfunctional child, in fact—able to draw this horse? Did she tap into a collective unconscious source of knowledge that only exists in the space-time continuum? Nadia presents a taxing mystery. Traffert speculates that she tapped into a form of space-time consciousness that was not available to the rest of us.

Because examples of the space-time consciousness and quantum nonlocality phenomenon violate causality and the limits of space and time, the left brain—and the scientific community—has dismissed these abilities as an anomaly. No one can explain them. Having lumped paranormal phenomena together with UFO sightings and the Shroud of Turin, most scientists assure themselves that the phenomena do not exist. They feel more comfortable working within the confines of science, preferring to focus their attention on what can be proven. Yet, there are too many examples in our culture of abilities that defy our supposed rational world. Sooner or later we will have to let them in.

When pondering Leonardo's brain we must ask the question: Did his brain perhaps represent a jump toward the future of man? Are we as a species moving toward an appreciation of space-time and nonlocality?

There are other questions that we must ponder. Why do we have such an advanced brain that grew so fast compared to all the other animals? Why is it the only one that is divided? Why are we the only animal that assumes an erect position when all the other animals do not? Why are we alone among the primates in our loss of fur?

Why are there left-handers?

Why are we capable of killing each other?

In response to these questions, perhaps Leonardo's solitary presence is but a single link in the immense drama of the ongoing evolution of our species.

CHAPTER 18

Evolution/Extinction

It will seem as though nature should extinguish the human race, for it will be useless to the world and will bring destruction to all created things.

—Leonardo da Vinci

When the universe has crushed him, man will still be nobler than that which kills him, because he knows he is dying, and of its victory, the universe knows nothing.

—Blaise Pascal

That brings up again the eternal question: Is the whole world of life visible to us, or isn't it rather that in this side of death we see with one hemisphere only?

—Vincent van Gogh

WE ARE IN A TRANSITIONAL STAGE OF EVOLUTION. A THEORY CALLED the anthropic principle attempts to delineate this. Generally, scientists are reluctant to discuss this principle because it replaces the randomness of the development of the universe with a hidden purpose. Eight mathematical constants exist in this universe. No one understands why they are constants. Newton's gravity constant, the speed of light (always 186,000 miles per second), the planck constant, and five other abstruse mathematical phenomena make up the list. If there were any variations of even a trillionth of difference one way or the other, then atoms could not form into the stable elements they are, and stars would be unable to generate

heat and light. Molecules could not link to form atoms, and the chain of advances culminating in consciousness would never have occurred.

Quantum physicist Hugh Everett proposed that one of the implications of quantum theory is the presence of parallel universes. Why, some scientists ask, do we occupy a universe that just so happens to make it possible for us to ask the question, *Why are we here?* Why do we have a brain that seems so large, so overly complicated, and so much more advanced than what was needed to survive on the savanna?

There have been enormous advances in identifying where in the brain the specific areas dedicated to various tasks are located, yet the search for the center of consciousness has eluded them. We have evolved to the point where we can look around and look back and ask *Why?* Emerging from living matter comes a new property: the ability to reflect on the universe.

In his book *The Fourth Dimension,* scientist and philosopher Rudy Rucker put it nicely:

I am, as it were, an eye that the cosmos uses to look at itself. The Mind is not mine alone: the Mind is everywhere.

Given how extraordinary each of these evolutionary steps has been, can human imagination conjure what the next step might be? How about all those evangelicals who are convinced the human species is going to hell in a handcart, or that the end of the world is nigh, and that when Jesus reappears on Earth, Armageddon will occur and the sinful and non-believers will disappear down a rabbit hole, at the bottom of which is a Boschian nightmare?

Islamic revolutionaries sacrifice their lives because they believe they will be greeted by seventy-two virgins in paradise. Some Orthodox Jews want to dress in the same outfits that the Orthodox wore in the Middle Ages. Centuries ago, Shakespeare brought uncertainty to orthodoxy when he had Hamlet admonish his closest friend, "There are more things in heaven and earth, Horatio, than are dreamt of in your philosophy."

Supposing a modern pollster had canvassed the people of Europe at the end of the fourteenth century concerning their expectations for the new

century. The fourteenth century had been one of the most dreadful centuries of Western civilization. Europe was marred by the Hundred Years War and pummeled by three successive waves of the bubonic plague that decimated the population by over a third. Very few significant social, political, religious, or scientific advances had the opportunity to make their mark.

An aura of pessimism hung like the pall of smoke rising from pillaged villages dotting the European landscape. Reading how contemporary writers assessed the future, one thing becomes clear: Not a single chronicler, historian, courtier, nobleman, philosopher, or artist understood that the Renaissance was just beginning to blossom. Or that it would transform society.

Similarly, in the 1790s, Europe was facing its first energy crises. The main fuel at the time was firewood, but the readily accessible great stands of trees had been felled, and axmen had to venture farther away from the population centers into the forests to locate adequate supplies. This made the cost increasingly expensive.

Not one of the Enlightenment's great thinkers anticipated that the most revolutionary social transformation of human society since the crossover from the hunter-gatherer lifestyle to agriculture thousands of years earlier was about to begin. Coal was about to fuel Bessemer furnaces and fire the factories that would reconfigure the landscape of Europe. Mass migration of populations from farms to cities began. No one alive in the 1790s anticipated that the Industrial Revolution was beginning.

The physicists of the *fin de siècle* were confident that all they had to do was to solve the two central problems in physics, both of which pertained to properties of light. Michael Faraday's discovery of electromagnetism in the 1820s ended with the Clerk Maxwell equations mathematically working out the relationships in 1876. This spanned a supremely creative period involving many different physicists from every country in Europe, and across the Atlantic in America. American physicist Albert A. Michelson announced triumphantly in the late nineteenth century, "The most important fundamental laws and facts of physical science have all been discovered, and these are now so firmly established that the possibility of their ever being supplemented in consequence of new discoveries is exceedingly remote."

But there remained two puzzling problems concerning light. The distinguished Lord Kelvin delivered a speech at the end of the century in which he predicted the solution to these two minor problems would come soon. Physicists could then proudly close the book on physics just as anatomists had done on anatomy several hundred years earlier. After such an intense creative period, they planned "mopping up" maneuvers that could be used to arrange the new discoveries more tidily.

No art critic or physicist alive at that time had any inkling that both their worlds were about to be turned topsy-turvy. The new art movements in the opening decades of the twentieth century—Cubism, Fauvism, Futurism, Dada, Surrealism, and Expressionism—put to rest any talk about the wellsprings of creativity going dry. Physicists were stunned to discover that two entirely new branches of physics, relativity and quantum, both arising from those two unanswered questions, were revolutionizing their fields. The balance of logic was shifting to combination thinking. Long ago Aristotle had proclaimed what would become a lodestone of rational belief: *If A is A it cannot be B.*

Well, maybe, said the quantum and relativity physicists. Perhaps A and B combined to form a both/and entity instead of an either/or one. Physicist Fred Alan Wolf, in paraphrasing Shakespeare, nailed it: "To be or not to be is not the question; it is the answer."

Here we sit at the beginning of the twenty-first century, and once again the future can only be seen through a glass darkly. What chutzpah to think we can knowingly anticipate what is next. I believe we should sit back and enjoy the unfolding of a story about which we haven't a clue as to the ending.

Let us review the sixteen unanticipated steps up the ladder:

1. The Big Bang—something out of nothing
2. Atoms—stability out of chaos
3. Stars—conglomerations of zillions of tiny motes forming gigantic entities
4. Galaxies—star organization
5. Hydrogen fusion—light where there had been darkness

6. The beginning of the periodic table—elements created in the internal heat of stars from the fusion of hydrogen into carbon, nitrogen, etc.

7. Supernovas—exploding stars creating the heavy elements above iron

8. Molecules—atoms so configured that they conveniently begin combining with other atoms

9. Water—a combination of two improbable atoms, hydrogen and oxygen

10. Self-replicating molecules—DNA, the building block of life

11. Cells—highly organized molecules arranged in a division of labor

12. Organisms—cells joining to cooperate to make ever more complex organisms

13. Sex and death—revolutionized the process of evolution

14. Meta-qualities unexpectedly emerging from life—sentience, alertness, consciousness, and self-aware consciousness

15. Language—the first entity that did not need a carbon-based benzene ring

16. The splitting of the human brain into functionally different lobes, generating the first example of Mind—the ability to reflect on the meaning of it all

The two central questions that continue to generate awe are: How did life emerge out of inert matter, and how did consciousness emerge to contemplate these questions. Current complexity theory (formerly known as chaos theory) explains how order can emerge from disorder—how the "impossibilities" occurred.

If we take the long view, the division of our lobes and the dominance of the left brain over the right may be but a stage in the development of thought. Perhaps this was a necessary stage to pass through to develop language and the skill to complete complex serial actions. Mysteries remain. Our brain is three times as large as we would expect for a primate of our build. David Premack wonders at the "missing links," remarking that "Nature provides no intermediate language, nothing between the lowly call system and the towering human language."

Sophocles once warned, "Nothing vast enters the life of mortals without a curse." There can be little dispute that in terms of survival of the fittest, the adaptation of human language was the most significant event to have occurred in the evolution of life . . . so far. No other life form has used it to investigate the origin of the very adaptation it has acquired. Insects can signal, some animals can inform, but only a human, thanks to language, can ask a question and, further, dispute the answer.

But what is the curse that accompanied this vast expansion? Is the dedication of opposite lobes to a coordinate—space (right brain) and time (left brain)—a factor that is now preventing humans from achieving a space-time awareness? Has the vaunted language fluidity of the left hemisphere become an *obstacle* to accessing a different form of consciousness?

Alfred North Whitehead affirmed this view:

The misconception which has haunted philosophic literature throughout centuries is the notion of independent existence. There is no such mode of existence. Every entity is only to be understood in terms of the way in which it is interwoven with the rest of the universe.

Here, then, is both the majesty and the tyranny of language. The ability to describe reality reveals a weakness in the scheme: the propensity to objectify. By having an entire cerebral lobe wired for processing linear language, we have inadvertently torn ourselves free from the matrix of nature. Humans gained enough distance from this matrix to look back upon it and decide that we were no longer part of it. Unity cracked and duality emerged. We are "here" and nature is "there." But new information has upended the idea that there is a "there."

With the discovery of quantum mechanics, physicist John Wheeler summarized what mankind should understand, "There is no *out there* out there." We gained objectivity but lost our sense of connectedness to the universe. We are presently embarked on a massive destruction of nature because *we cannot visualize our role in it*. Werner Heisenberg identified the problem thus,

In classical physics, science started from the belief—or should one say, from the illusion?—that we could describe the world, or least parts of the world, without any reference to ourselves.

The objective stance resides in the power of naming. In the Bible, God first taught Adam to name. He did not attempt to teach Adam how to make a fire, which would have been more practical. (The Greeks opted for fire, as the Prometheus myth implies.) Instead, God made Adam name all the animals, thus gaining control over them. That is what naming does—confers control.

The universe is itself a marvelous thing, and to have a consciousness that can perceive the universe, an amazement. Might it be possible that the ultimate purpose of life was to develop an organism that could see the universe?

According to Wheeler, Mind and Universe are inextricably integrated. The Talmud expresses this subtle relationship in an apocryphal story of a dialogue between God and Abraham. God begins by chiding Abraham, "If it wasn't for Me, you wouldn't exist." After a moment of reflection, Abraham respectfully replies, "Yes, Lord, and for that I am very appreciative and grateful. However, if it wasn't for me, You wouldn't be known."

The ability to accomplish this feat, however, would disappear tomorrow if our brains had not split into two, able to construct the notions of extensible space and linear time. The former creates the illusion that every "thing" occupies its own place, and as Euclid declared, that two points cannot occupy the same space simultaneously. But the minutest particles are an exception to this commonly held belief. As Werner Heisenberg reminds us of the inherent strangeness of quantum physics:

[Atoms] are no longer things in the sense of classical physics, things which could be unambiguously described by concepts like location, velocity, energy, size. When we get down to the atomic level, the objective world in space and time no longer exists.

Linear time creates the complementary illusion that events progress along a moving conveyor belt that begins in the past, appears for an instant

in an evanescent present, and then continues into the impenetrable mists of a future that has not yet occurred.

These two mental fictions are the direct result of the arrangement of the human hemispheric specialization, left and right brains. This arrangement served us exceedingly well in our long days in the Ice Age, but it has deceived us into believing that we are confined within a theater, watching a play. Fidgeting in our seats, many of us are troubled by the knowledge that something very large but nebulous remains hidden from view. Nevertheless, so convincing are the players and objects before us that most scientific materialists claim that the play is all that there is. Despite advanced and logical arguments, a considerable number of people continue to have a disquieting certainty that a larger stage exists behind the visible one. Albert Einstein held this view:

> *It is very difficult to elucidate this [cosmic religious] feeling to anyone who is entirely without it. . . . The religious geniuses of all ages have been distinguished by the kind of religious feeling, which knows no dogma. . . . In my view, it is the most important function of art and science to awaken this feeling and keep it alive in those who are receptive to it.*

The splitting of the right brain from the left brain was a great boon. It created in the mind of early humans the axis of space and the abscissa of time. We plot the "real" world on this graph. Despite the many exceedingly intelligent animals that populate the planet—dolphins, dogs, whales, and chimpanzees, for example—not one among them can maneuver in the dimension of time to the extent humans can.

The brain's division of space from time and right from left sets the conditions for the emergence of logical thinking based on cause-and-effect reasoning, which in turn is dependent on language. The addition of writing and reading accentuated the process. So huge was this advantage for humans that the left brain, the seat of reason and verbal communication, gained considerable power over the more primitive, mystical right brain. The ego's throne room is located in the left brain, where it remains arrogantly certain that it controls events. Because of its subservient position

in the right brain, its lack of language to express itself, and its control over the clumsy hand rather than the accomplished one, the id has difficulty getting the respect it deserves. Yet, this may be simply a stage in evolution.

The life span of a higher species varies between 1,000,000 to 1,200,000 years, before it either experiences extinction or transitions into a new species. *Homo sapiens* are 150,000 years old, which means we are approximately twelve to fifteen years old in the life span of a species. This is about right. We are becoming stronger, and are capable of harming one another in a more deadly fashion. Yet, we are becoming more aware of our strength and the desire to restrain it. This is also the age when puberty begins and we have a rapid change in our physiology.

Are we entering a period in which we are changing? The immature state in which we are born and the exceptionally long period in which we are raised encourages the implanting into our psyche of a host of erroneous thoughts and beliefs. The absence or presence of creativity determines what we believe. Tell me what you imagine, and I will tell you who you are. Let me tell you what to imagine, and I will tell you what, gradually, you will become. Many people approach the world not as logical adults, but as individuals seeking the camaraderie of the group that denigrates other belief systems as wrong, or even evil. It does not occur to them that they are mistaken—that their system is just one of many whose premises were faulty.

The three Abrahamic religions should be brotherhoods. They worship the same god, and yet they are torn asunder by petty ideological points. In the East, one is free to believe in Shintoism, adhere to the tenets of Buddhism, and practice Taoism. But in the West, one cannot practice being a Jew, a Christian, and a Muslim simultaneously without causing confusion or contempt.

The curse of war between tribes, communities, and states has always been a prominent feature of humankind. Nationalists, fascists, communists, imperialists—it matters not what they are called; the right to go to war is built into the human genome. This constitutes a curse. Animals of the same species rarely kill each other. They may have tremendous dominance fights in which the combatants come away injured, but large-scale war between members of a higher species is extremely rare.[*]

[*] Chimpanzees, genetically the closest to humans, do engage in raids on other chimps.

Humans are also singular in their failure to have a breeding signal to inform the members of the species that they are overpopulating an area. Rabbits, deer, and all other animals intuitively know that breeding should abate, as the resources available cannot support an increase in population. But we continue to have babies, overpopulating the world. From the middle of the twentieth century, when the population hovered around three billion, we have ballooned to nearly 7.2 billion, despite the horrible wars in which millions expired.

The crowding of the planet has increased the anxiety of the ego and the superego, which reside on the left side of the brain. The dominance of the left hemisphere over the right ensures a continuance of the survivalist mode.

Adding these two traits—willingness to go to war and the destruction of nature—to overpopulation will cause the early extinction of the human race. Unless we change. But where will change come from? The appearance of Leonardo in the gene pool gives us hope. He lived in an age when war was accepted. Yet, later in life, he rejected war and concentrated on the search for truth and beauty. He believed he was part of nature and wanted to understand and paint it, not control it.

As we enter the first half of the twenty-first century, deeply immersed in the annealing of technology and life forms, who can possibly anticipate what might come next? We cannot see what is in store for us, just as we could not have foreseen the other amazing developments in our history and prehistory. Perhaps we will develop into an improved version of *Homo sapiens* as more of us become less interested in power and more interested in matters of the heart. We humans are undergoing a profound metamorphosis as we transition into an entirely novel species. For those who doubt it is happening, remember: For millions of years dogs traveled in packs as harsh predators, their killer instinct close to the surface. Then humans artificially interfered with the canine genome beginning a mere six thousand years ago. No dog could have predicted in prehistoric times that the huge, snarling member, faithful to a pack, would evolve into individual Chihuahuas and lap-sitting poodles.

Carbon, the basis for all life forms, is one of the most common elements on the planet. Another element found in abundance is silicon. When

combined with oxygen, in the form of silicon dioxide, it forms sand and dirt. The silicon atom had always played a minor role in the health of the individual, being one of the trace elements necessary to maintain homeostasis. And then, in the early half of the twentieth century, clever humans discovered that silicon dioxide possessed a property that would allow it to conduct an electrical current. People crowded into theaters to watch early movies that were transmitted by silicon lightbulbs. Then silicon dioxide in the form of glass vacuum tubes began to transmit messages around the world. But it was in the middle of the twentieth century that silicon dioxide became the basis of the modern transistor. Transistors began to appear in increasing numbers in all electrical appliances. Every device—radios, televisions, cell phones—shrunk in size.

Silicon compounds possess an additional property that makes them simpatico with flesh. They are the *only* atom that fails to arouse the ever-vigilant immune system. *How unusual!* On the other hand, perhaps the failure of the immune reaction is really an invitation to join with silicon. Encasing silicon dioxide transistors in a silicone sleeve gave physicians the ability to place sophisticated mini-machines into the human body: Cardiac pacemakers, insulin and morphine pumps, and transistor-based arrays to let the blind see and the deaf hear have become increasingly routine.

As the amount of silicon increases in relation to the amount of carbon in a person's body, it is possible that Darwin's theory of natural selection will have to be revised once again as humans morph into what could be called "cyborgs" (*cyb*ernetics+*org*anic). Partially inorganic and partially organic, humans already have begun to constitute an entirely new life form.

The efficiency and ubiquity of computers also improved as a result of silicon dioxide. The speed with which new advances are occurring is breathtaking. Increasingly, humans are living more productive lives because of cell phones, computers, and the Internet.

The interrelationship of silicon and carbon has revised Darwin's theory to include a life form that incorporates both carbon *and* silicon. The computer and the Internet have begun a transformation that is not yet finished.

The brain is the body's most energy-consuming component. It demands reinforcements, requiring molecules to come and go. The brain's constituency is always in a state of flux. American physicist Richard Feynman put it thus:

> *The atoms that are in the brain are being replaced; the ones that were there before have gone away. So what is this mind of ours: what are these atoms associated with consciousness? Last week's potatoes! They now can remember what was going on in my mind a year ago.*

These atoms enable us to make the devices that probe the universe and the satellites that communicate, measure, and survey. We are made of carbon, but the "machines" depend on silicon. One of the intriguing side effects of combining silicon with carbon has been the de-emphasis of the left brain and the rise of the right brain.

For a very long time humans experienced *speaking and listening* as the only means of communication. Both sides of their brain were active and involved. The introduction of *reading and writing* around five thousand years ago completely reoriented the brain's hemispheres, providing the left side with a dominance it did not have in the speaking and listening mode. Speaking and listening required both cerebral lobes. The expressiveness of body language and the inflection in the speaker's voice became less prominent. In its place was the isolated written word. Marshall McLuhan commented on the collision:

> *Of all the great hybrid unions that breed furious release of energy and change, there is none to surpass the meeting of literate and oral cultures. The giving to man of an eye for an ear by phonetic literacy is, socially and politically, probably the most radical explosion that can occur in any social structure.*

The objectification of the world and other people massively amplified as reading, writing, and the number of books dramatically increased. The emphasis on learning to do these things has taken over the schoolroom.

Murray Gell-Mann, who won the Nobel Prize in Physics, observed:

Since education is effective only insofar as it affects the working of the brain, we can see that an elementary school program narrowly restricted to reading, writing, and arithmetic will educate mainly one hemisphere, leaving half of an individual's high-level potential unschooled. Has our society tended to overemphasize the values of an analytical attitude, or even of logical reasoning?

With the addition of silicon, a shift away from this trend has finally occurred. At the turn of the twentieth century, if we wanted to see a motion picture, we had to squeeze ourselves into a dark theater. By the middle of the twentieth century, vacuum tubes made out of glass powered the television. Television has introduced many stark visualizations; it speaks to both sides of the brain. The televised Vietnam War produced an outrage that would have been much slower had it been described only in print.

Now, as the silicon revolution advances, we carry our phones and computers in our pockets and purses. When President Obama gives a speech to the public, the number of handheld cameras recording his words resembles a waving field, each camera trying to achieve the proper height, distance, and angle.

The publishing business is in decline. Newspaper subscriptions have fallen off a cliff. But the enrollment in classes that emphasize graphic design and filmmaking are burgeoning. The Internet and its various platforms have markedly increased the volume of graphics. Images are replacing text.

Organized religion is in decline as more people become aware that the multiplicity of beliefs tends to challenge the belief in any one of them. The number of agnostic and atheist voices has increased. Sam Harris and Richard Dawkins assume an exalted position unheard of in earlier days.

Silicon has increased the importance of the right lobe. As more people access the holistic mode—abandoning the "I" versus "them" way of thinking—a desire to honor the planet, rather than conquer it, has spread. As we shift back to the right hemisphere based on image information, we are entering what I call the *Iconic Revolution*. More people on the planet are being interconnected using the iconic mode.

In *The Last Supper*, one would expect Leonardo to have chosen the center of Jesus's forehead as the point that perspective begins. But he chose to center the perspective of his painting at a point over Jesus's right brain. Was he trying to tell us something, or was it just an accident? For a painting that does not contain any "accidents," what was this extraordinary genius, this exceptional *Homo sapiens*, trying to tell us?

Leonardo intuited that image gestalts processed by the right brain were superior to the written word. "Your tongue will be paralyzed . . . before you depict with words what the painter shows in a moment," he wrote. As with so many other things, he was prescient with this statement, as well. Images are ascendant in this new age, and they reveal in a moment what a wordy description can only attempt to do.

He would be very gleeful today to know that the rest of the world is finally catching up with his vision.

Acknowledgments

Our father would normally write a detailed, poetic, and loving list of all the people who had helped him on the journey to complete a book. However, he never had the time to do this—so we are hoping if you are reading this, and you helped him in any way, that you know your name would be here.

We are very grateful for the dedicated team that helped bring this book to life: from Robert Stricker introducing us to our fantastic new agent for this book, Andy Ross, and editor Ann Patty, and to our great editor, Jon Sternfeld at Lyons Press, who cared just as much as we did about bringing this book to life.

Kimberly, Jordan, and Tiffany

Notes

Preface Epigraphs

x. *"Great art . . ."*: T. S. Eliot, "Dante" (1929), paraphrased by George Steiner in an interview with Bill Moyers in the PBS series, *Bill Moyers Journal*, January 1981.

x. *"It seems to me that . . ."*: David Bohm and Lee Nichol, eds., *On Creativity* (London: Routledge, 1998), p. 33.

x. *"The artist is the antennae . . ."*: Marshall McLuhan, *Understanding Media: The Extensions of Man* (New York: New American Library, 1964), p. xi.

Chapter 1 Epigraphs

1. *"The good painter has to . . ."*: Martin Kemp, *Leonardo on Painting* (New Haven: Yale University Press, 2001), p. 144.

1. *"The true mark of genius . . ."*: Arthur Koestler, *The Act of Creation* (New York: Macmillan, 1964), p. 402.

1. *"Both science and art form . . ."*: Werner Heisenberg, *Physics and Philosophy: The Revolution in Modern Science* (New York: Prometheus Books, 1999), pp. 108–09.

Chapter 1

4. *"One science only will . . ."*: Alexander Pope, "An Essay on Criticism," in *The Complete Poetical Works of Alexander Pope*, Aubrey Williams, ed. (Boston: Houghton Mifflin, 1969), p. 39.

5. *"human beings, not human doings"*: Candace B. Pert, PhD, *Molecules of Emotion: Why You Feel the Way You Feel* (New York: Simon & Schuster / Touchstone, 1999), p. 286.

5. *"Beauty is the first test"*: G. H. Hardy, *A Mathematician's Apology* (Cambridge: Cambridge University Press, 1992), p. 328.

6. *He left posterity with some fifteen:* Laura Allsop, "Are There More Lost Leonardo Paintings Out There?," CNN Living, November 11, 2011 (http://www.cnn.com/2011/11/11/living/hunting-lost-leonardo-paintings/).

Chapter 2 Epigraphs

9. *"When besieged by . . .":* Edward McCurdy, ed., *The Notebooks of Leonardo da Vinci* (London, 1904), p. 66.

9. *"Leonardo created a kind of space . . .":* Andre Malraux, *La Psychologie de l'Art,* Book 2 (Geneva: Skira, 1947), p. 150.

9. *"The real voyage of discovery consists . . .":* Thomas Lewis, MD, Fari Amini, MD, and Richard Lannon, MD, *A General Theory of Love* (New York: Random House, 2000), p. 165.

Chapter 2

10. *"From the child of five years":* Paul Biryukov, *Leo Tolstoy: His Life and Work* (St. Petersburg, 1911), p. 47.

11. *"The man who has intercourse":* Serge Bramly, *Leonardo: The Artist and the Man,* translated by Sian Reynolds (New York: Penguin, 1988), p. 41.

13. *"They will say that because":* Ibid.

14. *"trumpets and reciters . . . better a small lie":* Charles Nicholl, *Leonardo da Vinci: Flights of the Mind* (New York: Viking Penguin, 2004), p. 55.

14. *He referred to himself:* Ibid., p.54.

15. In a *"soft light.":* Giorgio Vasari, *Stories of the Italian Artists from Vasari,* p. 147.

17. *the Germans used the word Florenzer:* Bramly, p. 129.

17. *"Things got worse in 1484":* Nicholl

17. *"He wore a rose-coloured":* Martin Kemp, *Leonardo: Revised Edition* (Oxford University Press, 2011).

17. "He had a clear empathy": Edward McCurdy, *The Mind of Leonardo da Vinci* (1928) in *Leonardo da Vinci's Ethical Vegetarianism.*

18. *"He would not kill a flea":* Ibid.

18. *"He took an especial delight":* Nicholl, p. 43.

Chapter 3 Epigraphs

19. *"If the painter wants..."*: Robert Zwijnenberg, *The Writings and Drawings of Leonardo da Vinci* (Cambridge: Cambridge University Press, 1999), p. 71.

19. *"But of all other stupendous inventions..."*: Giorgio de Santillana and Hertha Von Dechand, *Hamlet's Mill: An Essay Investigating the Origins of Human Knowledge and Its Transmission through Myth* (Boston: David R. Godine, 1969), p. 10.

19. *"Of all the great hybrid..."*: Eric McLuhan and Frank Zingrone, eds., *The Essential McLuhan* (New York: Basic Books / Harpers Collins, 1995), p. 175.

Chapter 3

20. *"He was by nature"*: A. Richard Turner, *Inventing Leonardo* (Berkeley: University of California Press, 1992), p. 62.

20. *"He was very attractive"*: Nicholl, p. 127.

20. *"Take fresh rosewater"*: Bramly, p. 115.

22. *"It vexes me greatly"*: Ibid., p. 283.

26. *"The sculptor's face is so"*: Ibid., p. 261.

27. *It is another of the many paradoxes*: Ibid., p. 340.

29. *"An ill-wisher hindered"*: V. P. Zubov, *Leonardo da Vinci* (New York: MetroBooks, 2002), p. 35.

29. *"Leonardo's physical condition is that"*: MacCurdy, p. 148.

Chapter 4 Epigraphs

31. *"Iron rusts from disuse..."*: MacCurdy, p. 205.

31. *"The theme of duality..."*: Stuart J. Dimond and David A. Blizard, eds., "Evolution and Lateralization of the Brain," in *Annals of the New York Academy of Sciences*, Vol. 299 (1977), p. 397.

31. *"Time and Space are Real Beings..."*: William Blake, *The Complete Writings of William Blake*, Geoffrey Keynes, ed. (Oxford: Oxford University Press, 1966), p. 614.

Chapter 4

34. *"I observe . . . the brain"*: Chris McManus, *Right Hand, Left Hand: The Origins of Asymmetry in Brains, Bodies, Atoms, and Cultures* (London: Weidenfeld & Nicolson, 2002), p. 348.

Chapter 5 Epigraphs

43. *"The dragonfly flies with four wings . . ."*: Leonardo's observation had to wait until it was verified (questionably) by the development of high-speed photography, at 2,900 frames per second: Jean Paul Richter, *The Notebooks of Leonardo da Vinci*, Vols. 1 and 2 (New York: Dover Publications, 1970), p. 103.

43. *"This book is not concerned . . ."*: Kenneth Clark, *Leonardo Da Vinci*, revised and introduced by Martin Kemp (New York: Viking, 1988), p. 240.

43. *"Ted Williams, the legendary baseball . . ."*: Bülent Atalay, *Math and the Mona Lisa: The Art and Science of Leonardo da Vinci* (Washington, DC: Smithsonian Books, 2004), p. 277.

Chapter 5

50. *wrote an authoritative essay on* The Last Supper *in which*: Leo Steinberg, *Leonardo's Incessant Last Supper* (New York: Zone Books, 2001), p. 26.

51. *In this case, they adopted*: Atalay, p. 162.

Chapter 6 Epigraphs

55. *"If the body of every . . ."*: Zubov, p. 68.

55. *"He was like a man . . ."*: Sigmund Freud, *Leonardo da Vinci and a Memory of his Childhood* (New York: Dodd Mead, 1932), p. 138.

55. *"There is in great art . . ."*: John Russell, *The Meanings of Modern Art* (New York: Harper & Row, 1974), p. 271.

Chapter 6

55. *He announced to his startled friends*: Georges Bataille, *Manet* (New York: Skira/Rizzoli, 1983), p. 64.

59. *Picasso responded, "Isn't she"*: Tor Nørretranders, *The User Illusion: Cutting Consciousness Down to Size,* translated by Jonathan Sydenham (New York: Viking Penguin, 1998), p. 188.

61. *"In such walls the same thing happens"*: E. H. Gombrich, *Art and Illusion*, 6th ed. (London: Phaidon Press, 2003), p. 159.

Chapter 7 Epigraphs
67. *"O writer, with what words . . ."*: Antonia Vallentin, *Leonardo Da Vinci* (New York: Viking Press, 1938), p. 394.
67. *"As soon as we start putting . . ."*: Calvin Tompkins, *Duchamp: A Biography* (New York: Henry Holt, 1996), p. 38.
67. *"Really, we can speak . . ."*: John Russell, *The Meanings of Modern Art* (New York: Harper & Row, 1974), p. 371.

Chapter 7
72. *"Again and again, whether in"*: Steinberg, p. 137.
73. *"As a drug it's probably"*: Calvin Tomkins, *The Bride and the Bachelors: Five Masters of the Avant-Garde* (Middlesex, England: Penguin Books, 1983), p. 18.

Chapter 8 Epigraphs
75. *"We have seen that central . . ."*: Mihaly Csikszentmihalyi, *Creativity: Flow and the Psychology of Discovery and Invention* (New York: Harper-Collins, 1996), p. 326.
75. *"The desire to know is natural . . ."*: Bramly, p. 109.
75. *"[Leonardo] had a very heretical state of mind"*: Giorgio Vasari, *The Lives of the Most Excellent Painters, Sculptors, and Architects* (New York: Modern Library, 2006), p. 559.

Chapter 8
82. *"It is a most delicate"*: Clark, p. 251.
82. *"Leonardo had a very heretical"*: Vasari, cited in Nicholl, p. 483.
82. *"I see Christ once more"*: Bramly, p. 275.

Chapter 9 Epigraphs
85. *"There is a paucity of interhemispheric . . ."*: Marilee Zdenek, "Right Brain Techniques: A Catalyst for Creative Thinking and Internal

Focusing in Hemispheric Specialization," *The Psychiatric Clinics of North America* (September 1988), p. 430.

85. *"Often we have to get"*: Robert S. Woodworth, *Experimental Psychology* (New York: Holt, 1938), p. 173.

Chapter 9

90. *"The test of a first-rate intelligence"*: "F. Scott Fitzgerald," *Encyclopedia Britannica.*

90. *"In the fields of observation"*: Louis Pasteur Lecture, University of Lille (December 7, 1854).

Chapter 10 Epigraphs

95. *"Lust is the cause . . ."*: MacCurdy, p. 175.

95. *"[Leonardo's art is an] interfusion . . ."*: Sherwin B. Nuland, *Leonardo da Vinci* (New York: Viking Penguin, 2000), p. 161.

Chapter 10

104. *Goodall's team concluded that Flo's*: Jane Goodall, *The Chimpanzees of Gombe: Patterns of Behavior* (Cambridge, MA and London: Belknap Press of Harvard University Press, 1986).

106. *He pointed out that if the pelts*: Desmond Morris, *The Naked Ape* (New York: McGraw-Hill, 1967), p. 14.

Chapter 11 Epigraphs

109. *"Science is not a heartless . . ."*: Atalay, p. 90.

109. *"The earth is not in the center of . . ."*: Zubov, p. 147.

109. *"More than any other . . ."*: Walter J. Ong, *Orality and Literacy: The Technologizing of the Word* (London: Routledge, 1982), p. 77.

Chapter 11

110. *"Before Copernicus or Galileo . . ."*: MacCurdy, p. 199.

110. *One source credits Leonardo*: Fritjof Capra, *The Science of Leonardo* (New York: Doubleday, 2007), p. 53.

111. *Extrapolating from what remains*: Barbara Witteman, *Leonardo da Vinci* (Masterpieces, Artists, and Their Works) (Mankato, MN: Capstone Press, 2003), p. 17.

113. *Leonardo wrote in his notebook, "Nothing . . ."*: I. B. Hart *The Mechanical Investigation of Leonardo da Vinci* (London: Chapman and Hall, 1925).

113. *"All movement tends to maintenance"*: Martin Kemp, *Leonardo da Vinci: The Marvelous Works of Nature and Man* (Oxford: Oxford University Press, 2006), p. 122.

113. *His explication was actually*: Mark A. Runco and Steven R. Pritzker, eds. *Encyclopedia of Creativity, Vol. 1* (San Diego, CA: Academic Press, 1999), p. 501.

113. *"See how the wings, striking the air"*: Capra, *The Science of Leonardo*, p. 18.

114. *Similarly, he grasped the principle of flight*: Kemp, *Leonardo da Vinci*, pp. 249, 314.

116. *"I say that the blueness we see"*: Richter, p. 161.

116. *Leonardo's foray into matters relating*: Michael White, *Leonardo: The First Scientist* (New York: St. Martin's Press, 2000), p. 52.

117. *Michael Maestlin, Kepler's teacher*: Zubov, p. 153.

117. *Author Fritjof Capra outlines the story*: Fritjof Capra, *The Web of Life: A New Scientific Understanding of Living Systems* (New York: Anchor Books/Doubleday, 1996), p. 126.

117. *This distortion had the effect of*: Capra, *The Web of Life*, p. 127.

119. *"Just as a stone thrown into"*: MacCurdy, pp. 69–70.

120. *"that deceptive opinion"*: Capra, *The Web of Life*, p. 225.

120. *One of his notebooks contains*: MacCurdy, p. 701.

120. *He had a grander vision*: Zubov, p. 149.

120. *Georges-Louis Leclerc, Comte de Buffon*: Walter Gratzer, *Eurekas and Euphorias: The Oxford Book of Scientific Anecdotes* (Oxford: Oxford University Press, 2002), p. 197.

Chapter 12 Epigraphs

123. *"If they disparage me . . ."*: Kemp, *Leonardo on Painting*.

123. *"So many of the insights . . ."*: Atalay, p. 215.

123. *"The dead Master [Leonardo] is alive . . ."*: Donald Sassoon, *Becoming Mona Lisa: The Making of a Global Icon* (Boston: Houghton Mifflin Harcourt, 2001), p. 5.

Chapter 12

124. *"In order to observe"*: Atalay, p. 211.

124. *In one place, he wrote*: Bramly, p. 263.

125. *"This universe, that I have extended"*: Will and Ariel Durant, *The Age of Reason* (New York: Simon & Schuster, 1961), p. 612.

125. *Leonardo took walks through*: Vallentin, p. 300.

125. *He deduced the function*: Bramly, p. 263.

125. *Leonardo designed the first double-hulled*: Atalay, p. 193.

125. *Leonardo invented the flamethrower*: "Triple-Barrelled Cannon Found in Croatian Fort is 'Machine Gun' Forerunner Designed by da Vinci," MailOnline, *Daily Mail*, June 10, 2011 (http://www.dailymail .co.uk/sciencetech/article-2002102/Leonardo-Da-Vincis-forerunner -machine-gun-confirmed.html).

126. *Considerable evidence has accumulated*: Vernard Foley, Steven Rowley, David F. Cassidy, and F. Charles Logan, "Leonardo, the Wheel Lock, and the Milling Process," *Technology and Culture*, Vol. 24 (3), (July 1983), pp. 399–427.

127. *The Russian-born inventor*: Bramly, p. 286.

127. *His most ambitious project*: Atalay, p. 10.

127. *The largest bridge of this type*: Zubov, p. 27.

128. *He also invented the metal screw*: Capra, *The Science of Leonardo*.

128. *Mark Elling Rosheim, a modern*: Ibid., p. 125.

129. *He castigated Michelangelo's rendering*: Alessandro Vezzosi, *Leonardo and the Sport* (Athens, Greece: Cultural Centre, 2004), p. 41.

129. *Leonardo considered making*: Zubov, p. 60.

130. *"O marvelous, O stupendous"*: Richter, pp. 110–11.

131. *He identified the umbilical cord*: Charles O'Malley and J. B. Saunders, *Leonardo da Vinci on the Human Body* (New York: Henry Schuman, 1952), p. 484.

132. *"We ourselves saw this work"*: Zubov, p. 72.

Chapter 13 Epigraphs

133. *"If the body of every..."*: Zubov, p. 260.

133. *"The latter condition is demonstrated..."*: James S. Grotstein, MD, "The 'Siamese Twinship' of the Cerebral Hemispheres and of the Brain-Mind Continuum in Hemispheric Specialization," *The Psychiatric Clinics of North America* (September 1988), p. 401.

133. *"There is a female human nature..."*: Steven Pinker, *How the Mind Works* (London: Penguin, 1997), p. 461.

Chapter 13

133. *"The heart has its reasons"*: Blaise Pascal, *The Thoughts, Letters, and Opuscules of Blaise Pascal*, translated by O. W. Wight (New York: Hurd and Houghton, 1864), p. 236.

134. *The right side of the brain is*: N. Geschwind and A. M. Galaburda, *Cerebral Lateralization: Biological Mechanisms, Associations, and Pathology* (Cambridge, MA: MIT Press, 1987), p. 427–28.

135. *"a conflagration of clarity"*: Rainer Maria Rilke, *Letters on Cezanne*, translated by Joel Agee (New York: Fromm International, 1985), p. ix.

135. *Love at first sight, such as*: Camille Paglia, *Sexual Personae: Art and Decadence from Nefertiti to Emily Dickinson* (New York: Vintage Books, 1991), p. 121.

135. *Further evidence suggests that dreaming*: M. W. Humphrey and O. L. Zangwill, "Cessation of Dreaming after Brain Injury," *Journal of Neurology, Neurosurgery and Psychiatry*, Vol. 14 (1951), pp. 322–25.

137. *"His artistic activity remains"*: Robert E. Ornstein, *The Nature of Human Consciousness* (San Francisco: W. H. Freeman, 1968), p. 106.

138. *Alexander Luria, the Russian neurologist*: A. R. Luria, L. S. Tsvetkova, and D. S. Futer, "Aphasia in a Composer" (V. G. Shebalin), *Journal of Neurological Science*, Vol. 2 (3) (May–June 1965), pp. 288–92.

138. *Yet, he could sing and play*: Ornstein, *The Nature of Human Consciousness*, p. 106.

138. *he would not accept a child into his choir*: Marshall McLuhan, *The Gutenberg Galaxy* (Toronto: University of Toronto Press, 1965), p. 40.

138. *The right brain could hum:* Doreen Kimura, "Left-Right Differences in the Perception of Melodies," *Quarterly Journal of Experimental Psychology,* Vol. 16 (1964), pp. 355–58.

Chapter 14 Epigraphs
143. *"The water you touch in a river . . .":* Zubov, p. 221.
143. *"The reason why our sentient . . .":* R. Fischer, ed., *Interdisciplinary Perspectives on Time* (New York: New York Academy of Science, 1967), p. 16.
143. *"Although all knowledge":* Max Jammer, *Concepts of Space* (New York: Harper & Row, 1960), p. 136.

Chapter 14
144. *"we now know that extremely primitive organisms":* Nancy Touchette, "How Sea Slugs Make Memories," Genome News Network, January 9, 2004 (http://www.genomenewsnetwork.org/articles/2004/01/09 /memories.php).
147. *"Gentlemen! From henceforth, space by itself":* J. R. Newman, *The World of Mathematics* (New York: Simon & Schuster, 1956).
147. *"You're stuck with a grotesque":* Fred Hoyle, *October the First Is Too Late* (London: William Heinemann, 1966), p. 254.

Chapter 15 Epigraphs
149. *"Science is the observation . . .":* Richter, p. 288.
149. *"The artist is always engaged . . .":* McLuhan, *Understanding Media,* p. 70.
149. *"Quantum theory indicates . . .":* Russell Targ, *Limitless Mind: A Guide to Remote Viewing and Transformation of Consciousness* (Novato, CA: New World Library, 2004), p. 77.

Chapter 15
150. *It was situated in a basement vault:* Harold Puthoff, "CIA-Initiated Remote Viewing Program at Stanford Research Institute," *Journal of Scientific Exploration,* Vol. 10, No. 1, Spring 1996 (http://www.biomind superpowers.com/Pages/CIA-InitiatedRV.html).

151. *Subjects were asked to identify*: Ibid.
152. *Price had even come up with the actual code name*: Targ, p. 31.
155. *"Or are we to assume that despite"*: MacCurdy, p. 189.
155. *Another puzzle: At the conclusion*: Ibid., p. 233.
156. *The sketch included in the text depicts*: Ibid., p. 244.
156. *"Leonardo meant [1489]"*: Ibid., p. 245.
156. *"They are too matter of fact"*: Ibid., pp. 253–54.
157. *characterizing Leonardo's sketch map*: Ibid.
157. *"There is, however, no word in either"*: Ibid., p. 241
157. *Highlighting examples to illustrate*: Clark, p. 100.

Chapter 16 Epigraphs
161. *"In women, the measurements . . ."*: H. Steinmetz, L. Jancke, A. Kleinschmidt, G. Schlaug, J. Volkmann, and Y. Huang, "Sex But No Hand Difference in the Isthmus of the Corpus Callosum," *Neurology*, Vol. 42 (1992), pp. 749–52.
161. *"Leonardo understood that the . . ."*: Sassoon, p. 116.
161. *"It's a fine day, let us go out"*: Olive Schreiner, *Women and Labour* (London: Virago, 1978), p. 176.

Chapter 16
162. *Right-handed women still have the large*: Stanley Corwin, *The Left-Hander Syndrome: The Causes & Consequences of Left-Handedness* (New York: Vintage Books, 1993), p. 102.
163. *Even laughter resides on*: Antonio Damasio, *Looking for Spinoza: Joy, Sorrow and the Feeling Brain* (San Diego, CA: Harcourt, 2003), p. 75.
165. *Researchers Robin Dunbar and Leslie C. Aiello:* Leslie C. Aiello and Robin I. M. Dunbar, "Neocortex Size, Group Size, and the Evolution of Language," *Current Anthropology*, Vol. 34 (2), (1993), pp. 184–93.
167. *"In all cultures, men are brought up to be"*: Csikszentmihalyi, pp. 70–71.
167. *In 1993, researcher Dean Hamer and his colleagues*: Dean H. S. Hamer, V. L. Hu, N. Magnuson, and M. L. Pattatucci, "A Linkage between DNA Markers and the X Chromosomes and Male Sexual Orientation," *Science* (1993), pp. 1405–09.

167. *Straight men have a larger BSTc than*: Frank Kruijver, Jiang-Ning Zhu, Chris Pool, et al., "Male to Female Transsexual Individuals Have Female Neuron Numbers in the Central Subdivision of the Bed Nucleus of the Stria Terminalis," *Journal of Clinical Endocrinology and Metabolism*, Vol. 85 (5) (2000), pp. 2034–41.

168. *Simon LeVay, a gay neuroscientific researcher*: Simon LeVay, "A Difference in Hypothalamic Structure between Heterosexual and Homosexual Men," *Science*, Vol. 253 (1991), pp. 1034–37.

168. *He believed that such a God:* Ernst F. Winter, *Discourses on Free Will*, translated and edited by D. Erasmus and M. Luther (New York: Frederick Ungar, 1961), pp. 88–90.

169. *"He who cannot control"*: MacCurdy, p. 23.

171. *"The act of procreation"*: Freud, p. 16.

171. *"In the moment when virtue"*: MacCurdy, p. 196.

172. *There is also a new finding*: S. Witelson, "The Brain Connection: The Corpus Callosum Is Larger in Left-Handers," *Science* 229 (4714) (1985), pp. 665–68.

174. *In one study, fifty music students*: Marilyn Jean Schlitz and Charles Honorton, "Ganzfeld Psi Performance within an Artistically Gifted Population," *The Journal of the American Society for Psychical Research*, Vol. 86, No. 2 (April 1992).

176. *"We must once again accept"*: Marshall McLuhan and Bruce R. Powers, *The Global Village: Transformations in World Life and Media in the 21st Century* (Oxford: Oxford University Press, 1989), p. 4.

Chapter 17 Epigraphs
179. *"In view of his uniqueness . . ."*: José Argüelles, *The Transformative Vision: Reflections on the Nature and History of Human Expression* (Boston: Shambala, 1975), p. 21.

179. *"All evil leaves sadness . . ."*: Bramly, p. 406.

179. *"It takes sixty years of . . ."*: Andre Malraux, *Man's Fate*, 50th Anniversary Edition (New York: Random House, 1984), p. [72].

Chapter 17
180. *And the Nile again springs*: Richter, p. 264.

180. *"The bosom of the Mediterranean"*: Zubov, p. 232.

180. *In his book* The Sense of Being Stared At: Rupert Sheldrake, *The Sense of Being Stared At and Other Aspects of the Extended Mind* (New York: Crown, 2003).

181. *In Philadelphia in 1902*: See generally Eliot Hearst and John Knott, *Blindfold Chess: History Psychology, Techniques, Champions, World Records, and Important Games* (Jefferson, NC: McFarland, 2008).

182. *Psychiatrist Darold Treffert*: Darold A. Treffert, MD, *Extraordinary People: Understanding Savant Syndrome* (New York: Authors Guild, 2006).

Chapter 18 Epigraphs

185. *"It will seem as though nature . . ."*: Zubov, p. 206.

185. *"When the universe has crushed . . ."*: Blaise Pascal, *Pensées* (Everyman's Library Series, EBLA) (London: Falcon, 1973), p. 347.

185. *"That brings up again . . ."*: Argüelles, p. 167.

Chapter 18

186. *"I am, as it were"*: Rudy Rucker, *The Fourth Dimension* (Boston: Houghton Mifflin, 1984), p. 247.

187. *"The most important fundamental laws"*: Corey S. Powell, *God in the Equation* (New York: The Free Press, 2002), p. 51.

188. *"To be or not to be is not the question . . ."*: Fred Alan Wolf, *Taking the Quantum Leap* (San Francisco: Harper & Row, 1981), p. 176.

189. *David Premack wonders at*: P. F. MacNeilage, M. G. Studdert-Kennedy, and B. Lindblom, "Primate Handedness Reconsidered," *Behavioral and Brain Sciences* (1987), pp. 247–303.

190. *"Nothing vast enters"*: Timothy Ferris, *Coming of Age in the Milky Way* (New York: William Morrow, 1988), p. 387.

190. *"The misconception which has"*: Robert Hughes, *The Shock of the New* (New York: Alfred A. Knopf, 1982), p. 32.

190. *"There is no out there"*: Nørretranders, p. 354.

191. *"In classical physics, science"*: Heisenberg, *Physics and Philosophy: The Revolution In Modern Science* (New York: Harper, 2007), p. 55.

191. *The Talmud expresses this*: Leonard Shlain, *Art & Physics: Parallel Visions in Space, Time, and Light* (New York: William Morrow, 1991), p. 23.

191. *"[Atoms] are no longer things"*: Werner Heisenberg, *Physics and Beyond* (New York: Harper & Row, 1971), p. 113.

192. *"It is very difficult to elucidate"*: V. S. Ramachandran, MD, PhD, and Sandra Blakeslee, *Phantoms in the Brain: Probing the Mysteries of the Human Mind* (New York: William Morrow, 1998), p. 174.

196. *"The atoms that are"*: Nørretranders, p. 326.

196. *"Of all the great hybrid"*: McLuhan and Zingrone, p. 175.

197. *"Since education is effective only"*: Robert Ornstein, *The Right Mind: Making Sense of the Hemispheres* (Orlando, FL: Harcourt Brace, 1997), p. 170.

198. *"Your tongue will be paralyzed"*: Steinberg, p. 53.

INDEX

About the Author

Leonard Shlain was a best-selling author, inventor, and surgeon. Admired among artists, scientists, philosophers, anthropologists, and educators, Shlain authored three best-selling books: *Art & Physics*, *Alphabet Versus the Goddess*, and *Sex, Time, and Power*. He delivered stunning visual presentations based upon his books in venues around the world including Harvard, The New York Museum of Modern Art, CERN, Los Alamos, The Florence Academy of Art, and the European Council of Ministers. His fans include Al Gore, Norman Lear, and singer Björk. Shlain died in May 2009 at the age of seventy-one from brain cancer shortly after the completion of this book.

His legacy continues with his children who helped bring this book to publication: Kimberly Brooks, artist and founding editor of the Arts and Science Section of the *Huffington Post*, Jordan Shlain, doctor and founder of Healthloop.com, and Tiffany Shlain, filmmaker, founder of The Webby Awards, and director of the Sundance documentary *Connected*, about the ideas in *Leonardo's Brain*, as well as Leonard Shlain's final year. Visit leonard shlain.com.